FLEET

The Town Of My Youth

by
Geoffrey Edwards

Anecdotes of progress and individuals who
assisted with the advance of Fleet from 300
inhabitants to a population of 30,000

Revised Edition

Published by
FOOTMARK PUBLICATIONS: Hampshire

First edition 1987
Revised edition 1993

Copyright Geoffrey Edwards © 1987

ISBN 0 9515738 3 7

Published by Footmark Publications,
12 The Bourne,
Fleet,
Hampshire GU13 9TL

Typesetting by Distinguished Data Ltd,
Floods Farm Cottage,
Dogmersfield,
Hampshire RG27 8TD
Tel: 0252 850311

Printed by Gazette Newspapers,
Pelton Road,
Basingstoke,
Hampshire RG21 2YD
Tel: 0256 461131

Contents

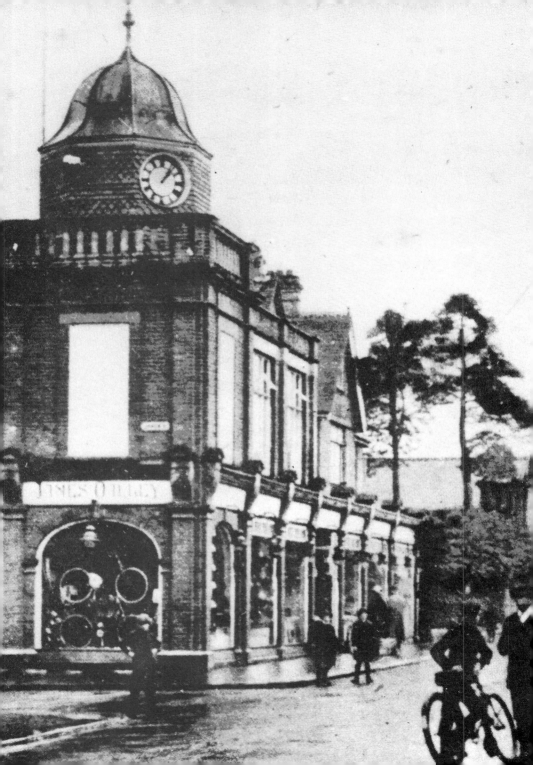

Illustrations

The Tower Building, Fleet.

Introduction

Geoff Edwards was born in Fleet early this century spending his life in the town and he has seen it grow from a small tight-knit community to its present size. We are fortunate that he has a remarkable memory of local events and people which he recorded in anecdotal notes first published in 1987.

This revised edition of his book takes readers through various aspects of life in Fleet during this century and indeed earlier times from his recall of discussions in his youth with his family and older residents. No attempt has been made to record the changes since the first edition, many have occurred and show the pace of change now is rapid. New material is included on Geoff's memories as a pupil at the Church of England School in Albert Street. This school is now closed and its future uncertain. A chapter on Harold Maxwell Lefroy born at Itchell Manor, Crondall has been added with acknowledgements to his niece Helen Lefroy and Rentokil Ltd. Available old photographs have been used with acknowledgements to the *Fleet News* and Roe & Kitteridge. My thanks to Ted Blackman for his evocative drawings.

I have only known Geoff for a few years, but I am fortunate to enjoy his company and I was delighted when he asked me to help with republishing his book. His anecdotes are fascinating and his pithy comments on life 'then and now' throw light on changes - not all for the good! Undoubtedly in the headlong rush for development we have lost much of the 'old fashioned' service taken for granted and pride in the community.

I am sure you will enjoy reading his account of life in Fleet as much as I did.

Bob Rose Fleet 1993

Chapter One
Early Days In Fleet

Fleet was part of Crondall. The Crondall Hundreds were tracts of land of about 5 acres. It is not recorded who mapped out the Hundreds, but they were defined by straight line ditches with banks of earth. Several ran parallel with Kings Road: one at the top of Pinewood Hill, another about 70 yards parallel and beyond Avondale Road. Sixty years ago, these banks and ditches were much in evidence in Pondtail and in the parts of Church Crookham close to Fleet.

Roads

Brakes Estate In 1878, Mr. H. W. Brake bought most of the land in Fleet and had the land and roads plotted and mapped out. The roads were to average 40 feet wide and the land all in 20 feet wide plots, either 100 feet or 200 feet in depth. The roads were defined each side by a 12 inch ditch (hence many roads are now 42 feet wide). Each plot of land was defined by a 6 inch Vee cleft cut in the land, so every 20 foot plot was actually 20 feet 6 inches. The marking out of the roads and plots of land were remarkably accurate and two men were busy for several years.

A wooden Estate Office stood in Fleet Station yard and the first plots sold for ten shillings per foot frontage. Gradually, the price increased to £1 per foot frontage. Fleet Road plots were always double the cost of any other plots. Plots could be purchased for £5 down and monthly payments of £1 per month. As soon as the Fleet Urban District was formed in the first few years of the 1900s, the land increased in price, that in Fleet Road soon to be £10 per foot frontage.

Until the Council became active, the new roads plotted out by the Brakes Estate were just marked out and left. Some large trees were cleared, but apart from the main roads all the roads in Fleet were just original tracks, many with growths of heather and young fir trees. Inhabitants picked their way along dry ruts in summer and at the edge of the road in winter. Many people found gravel just below their gardens and this was strewn along the path and road opposite their houses.

A. & W. Goddard owned and sold many loads of gravel from their pits in Albany Close for those who could afford to improve the road frontage. The National Church Schools in Albert Street was situated in and surrounded by unmade roads. The road to the Parish Church and to Fleet Hospital was usually in a dry state, but was unmade well into the 1900s.

Brakes Bridge In 1880, Kings Road was almost impassable in the winter because the ford between Kent Road and Kenilworth Road became very swollen during the winter and bicycles had to be carried across. Mr. Brake became a local benefactor by providing a stout and strong concrete bridge with 1 foot wide concrete parapet walls 3 feet high on each side. For several years, the local inhabitants named the bridge 'Brakes Bridge'. However, within a few years a considerable crack occurred in the concrete, so that the inhabitants changed the name to 'The Broken Bridge'. However, the bridge lasted until after the 1914 War, when the Fleet Urban District Council rebuilt it with iron railings at either side (still in existence).

Winchfield Union In 1880 Fleet had several 'through' roads, Fleet Road, Reading Road, Kings Road, Elvetham Road and Hitches Lane. Fleet Road (previously Mill Road) and Reading Road were maintained in a very poor condition by the taskmaster and road surveyor attached to Winchfield Union, the workhouse. Mr. Sisterson, who lived in Fleet, was the first road surveyor. He used a pony and trap to cover a large area.

Tramps were admitted to the workhouse at 6 pm, given a wash, food and a bed. Early next morning (to pay for their lodging) they were conveyed in a horse and cart to work on the roads. Heaps of stones and flints lay at intervals beside the roads. The tramps sat beside the stones with a hammer to break the stones to a suitable size. Then where large ruts and puddles needed attention, the mud was shovelled to the side of the road. The broken flints and stones were well-hammered to make a passable condition. Bread and cheese were eaten at mid-day. At 3 pm, the tramps were free to go, but not back to Winchfield Union. From 3 pm it was considered that there would be sufficient daylight to walk to another workhouse, preferably out of the county.

Off Reading Road, at the bottom of the Avenue leading to the Chapel cemetery, stood a very old thatched house with a lean-to portion at its rear. Roughly it was estimated that this cottage was half-way between Hartley Row and county boundary near the top of Beacon Hill. At this cottage, shovels, picks, rammers and sledgehammers were kept for the use of road repairs. The groups of working tramps were under the control of the man who lived in the cottage. This all meant that the main roads were always in a dire condition.

Houses

The Oatsheaf Hotel had been in existence long before the Basingstoke Canal was completed in 1794.

Although the Parish Church was not yet built, the then unmade road, heavily shaded by mature pine trees led to the very old residence known as

Peatmoor. The cottages opposite the proposed hospital are very old and were mostly occupied by people employed at Peatmoor. One was living accommodation for the gardener of Peatmoor. The cottagers were energetic people who often had printed advertisements in the *Fleet Reporter* during the late 1800s:

1. Comfortable apartment to let suitable for two ladies or single gentleman: an invalid not objected to. Apply John Dallman, 3 Dell Villas, Sunnyside.
2. Firewood (bavins) for sale at The Homestead, Sunnyside.
3. R. Long, Licensed chimney sweep. All orders punctually attended to, Sunnyside, Fleet.

The original Fleet builder, W. Page and Sons, built most of the very old houses in Church Road and Avenue Road. This area then became developed by very large residences such as Lismoyne and the now demolished Broom House. Each residence occupied several acres, either for grazing cows or carriage horses. A very old house is still in occupation and retains its original name — Stanton Lodge. This house and the two houses in Fleet Road, near Stockton Avenue (one a dentist's) had flooring of stone slabs in the main entrance halls, also stone paving in the kitchens.

The north west side of Fleet Road — Church Road, Branksomwood Road and Victoria Road, all owe their original existence to the building of large houses such as Inglewood and Thurlston. Victoria Road became established as a way to Thurlston House and before that to the very old house, St. Claude. It was also the approach to the Baptist Cemetery, now more than 100 years old.

By 1900, many large houses had been built on the outskirts, in Guildford Road, Broad Street and Wood Lane, and especially near the railway station. Fleet Road now had large houses on the north side from opposite the Station Hotel up to and close to Stockton Drive. Elvetham Road had several large houses from the hotel to Church Road. More important houses were also built, Stockton House, Wood Norton and The Views. In Church Road, Woodlands House and Peatmoor being the oldest. Stanton Lodge, The Firs, Lea Wood and North Hants House were self-supporting, each with a meadow or several fields fully in use for grazing cows and resting carriage horses. Church Crookham had several extremely large houses, Dinorben Court, Baron Nugent's, Sir Richard Morton's and Basingbourne House. Several others have not been mentioned.

Prior to the 1914 War, these houses each had at least four domestic indoor servants, probably two or more gardeners, a coachman and a groom. Also, one or two agricultural labourers. The houses mentioned had at least a total of 20 cows and 20 horses, excluding polo ponies and children's ponies. 'Tradesmen' afterwards 'shopkeepers' and 'dairymen'

needed another dozen horses for horse-drawn deliveries. No large or important houses, then called 'establishments' ever sent anyone whatsoever to 'go shopping'. Household goods, food, meat and drink were delivered daily. Sometimes unexpected guests arrived at the large houses and the shopkeepers were called upon for a second delivery, often in the evening, entailing the use of a pony and trap for a two-mile journey. The pony had to be fed, watered and bedded down, work thus finishing about 8 pm. This occurred in summer and winter.

Wells

As Fleet was at that time without main water, nearly every house had a brick lined well. About three men, each with a labourer dug several hundred wells in Fleet and Church Crookham. Before any house was built, the site was cleared of scrub and the house marked out with wooden pegs. Everything then stopped for the well to be dug because water was necessary for building work.

The skilled well-digger arrived with his well curb. This was something like an open-ended and straight-sided barrel constructed of elm without nails. Most carefully, a round hole was dug and the curb sunk below ground. This had to be upright and necessitated much side trimming of the hole with a trowel and a plumb bob. The first 10 feet of the well was dug with a shovel and the dirt thrown out. Great jubilation occurred if the excavated soil was sand suitable for use in building. Several hundred best quality hand-made local bricks were delivered by horse and cart. These bricks fitted perfectly in a circle upon the well curb, just touching each other on their inside edge. A temporary well top with a wooden barrel and cranked iron handle was placed over the well top. A long iron chain attached to a bucket then enabled the well to be gradually lowered by continuous careful digging below the timber curb. The excavated soil was 'windlassed' by the well-digger's mate. The whole curb and brickwork were gradually sunk until the curb was below water level. The owner had then to provide his own apparatus for obtaining *all* his daily water requirements.

The wells varied in depth, according to the spring water level. In the lower parts of Fleet, wells were about 10 to 12 feet deep. Those at The Beacon and Thurlston House, on Victoria Hill, measured just over 90 feet in depth. All the large houses added a long handled pump to raise water to tanks installed in their roofs. The under gardener or handyman often worked for half-an-hour morning and evening to fill and maintain the water level in the tanks until water from the overflow pipe told that the tank or tanks were full. This was extremely hard work as sometimes it was required to raise water 140 feet. Very large houses with stables and horses conserved as much rain water in tanks as possible, but many man-hours must have been spent working a very stiff and heavy 6 foot long cast iron

pump handle.

The cottages, often with one well to several households, raised the water bucket either to fill storage tanks, but mostly enough buckets of water for a whole day's use was placed in the kitchen.

Water closets

Some readers may be interested in the following: A certain Mr. Jennings who owned a fire-clay factory in the Midlands, retired and built himself a substantial residence close to the now Beacon Hill Hotel. The front facade of the house has its gable built of special terra-cotta fire-clay blocks as an architectural feature and can be seen to this day, although built in the 1800s. In Victorian times, water closet pans had an outlet only 1½ to 2 inches in diameter. Mr. Jennings successfully designed a lavatory pan with an exit measuring 4 inches diameter. Mr. Jennings increased his fortune by manufacturing his pans which swept the market and became the standard design for all lavatory pans. By looking about houses and other places, built between 1880 and 1912, lavatory pans may be found with the name 'THE JENNINGS' in blue print on the white china surface.

Shops

Voller's In 1800 Mr. Voller began to build the first shop in Fleet and house with a bakery, flour loft and stabling at the west corner of Church Road and Fleet Road. With Fleet increasing in population and by much enterprise, Voller's shop, now with daily bread sales, was originally accepted as the centre of Fleet. Mr. Voller's bread carts delivered daily (a new idea quickly followed by milk roundsmen), going far and wide over rough roads with fresh bread, even delivered to adjacent farm houses and farm cottages at Elvetham via Pale Lane.

Blacksmiths The road junction opposite Voller's consisted of a horse pond and an open piece of land where horses and traps could stand and turn about. Mr. Voller tells that a blacksmith from Hartley Wintney bought a portable forge to stand beside the pond. On a certain day each month, he would come prepared to shoe any horse for 3 shillings per set of shoes. There was a horse pond in Kings Road and another in Aldershot Road. Fifty years later, there were many shoeing smiths in Fleet: one in Avondale Road, one in Kings Road at Pondtail, one in Connaught Road (west-end). Prior to this, the only forge was at Pilcot. Stevens Forge opposite the Black Horse, Crookham Street, became very busy shoeing most of the horses in Crookham and Ewshot.

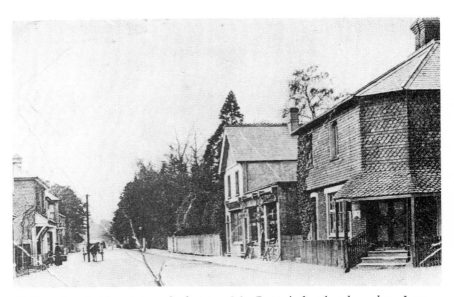

Vollers shop (with steps), and adjoining, Mr. Rutter's first butchers shop. Last occupant, Bretts Greengrocery. Demolished 1987.

Oakley's Mr. Ernest Oakley had built a large and imposing shop and house with outbuildings and stables. This first large shop was built early in the 1860s. It did not sell provisions, but it did obtain the very first off-licence for the sale of wines and spirits. The turret striking clock and weathervane were thought to epitomise progress especially in that area. Furnishings, drapery and ladies clothes, including stockings and gloves, were only part of what was then a very vast stock.

Princess Beatrice visited the shop and therefore it displayed a Royal Warrant for many years. Ewshot and Crookham Army Camps had just been established and this enterprising firm secured the custom for supplying wines, spirits and beers to the officers' and other messes. This valuable trade expanded to several Aldershot Army Messes. A horse and van made deliveries throughout the district, especially to the larger houses.

To make full use of the horse, Mr. Oakley advertised for a cabinet maker capable of making coffins. Charles Harris came to Fleet from London, and for several years carried out these aforesaid duties. However he soon set up his own business in Albert Street. The third generation of Harris's are still carrying on the cabinet and upholstery business.

Mr. Oakley became a prominent business person and, although never a councillor, his views were much respected. In 1918 he made way for his two sons to carry on the business, but before he retired he presented

Oakley Park to the people of Fleet as a thanksgiving for the signing of the Peace Treaty ending the 1914 War in 1918.

Market Place

Oakley's stores became a focal point in Fleet Road and adjacent business properties were built. It was expected that the vicinity was to be called the Market Place. This name never caught on.

Mr. Willmot In 1870 Mr. Willmot built a large shop and house complete with a brick-built bakehouse, flour loft and stables. This was purposely built opposite Oakley's on the corner of Fleet Road and Victoria Road. He died in 1902 leaving the bakery, cake and confectionery shop and restaurant to his three sons. They each wanted to start personal enterprises so the business was sold to the flourishing bakery business of Darracots of Aldershot. This firm carried on the shop and restaurant, delivering bread throughout the district by horse and bread van for nearly 70 years.

Rising Sun Stores Encouraged by Mr. Oakley and Mr. Willmot, Mr. Pratt, who had grocery businesses established in neighbouring villages, began to build adjacent to Mr. Willmot (now Crooks). He built what was then something quite new. To the Fleet Road frontage was a pair of large imposing iron gates 10 feet high. Upon the red brick archway above the gates was the emblem and name, The Rising Sun Stores. During shop hours the gates remained open. On either side of the central walk were displays of goods for sale. The shop (as now) was of a good depth and it all looked very much like an indoor market. Business was successful for many years, but the grocery and greengrocery business was closed soon after the end of the war in 1918.

The Bonds The Market Place, close to Oakley's Emporium, was now confined from expansion by large residences on all four corners. Next to Mr. Pratt's greengrocery market, The Rising Sun Stores, there was a fairly large residence built close to the road. The house, built by Herbert Pool, was occupied by the Bond family. Their home was a truly Victorian abode. The whole family were exceedingly genteel, the ladies dressing the part with their clothes sweeping the ground, stiffened blouse collars high in the neck and prominent buns of hair at the top or back of their heads.

When the parents died they left the property to their two daughters. The Miss Bonds surprised the local inhabitants by having a rather small shop window inserted to the front of their house with a shop door above two steep steps. It was assumed that their status was now somewhat impoverished as the only servant was a girl of poor intellect. The shop was

7

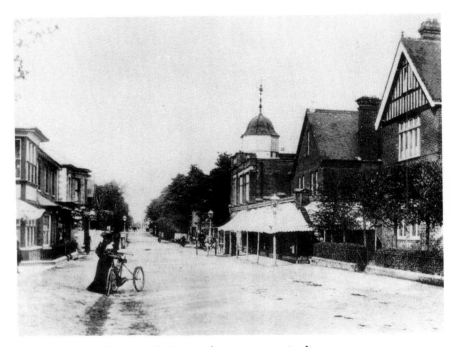

Fleet Road "Market Place". Unpopular name soon in disuse.

stocked with items which soon multiplied and overcrowded the whole area. At the rear of the shop a dense cane and beaded screed led to a room, where the lady gentry were politely ushered and given full attention.

The stock of the shop commenced with local postcards, all kinds of stationery, water-colour paint boxes, knitting needles, lace-making requirements, beads for necklaces, children's nursery books. Eventually, a shop assistant who had just left school, was employed at a very skimped wage. Although the shop became a well-known establishment with an extremely diversified stock, even fish hooks, it eventually closed, with the ageing of the Miss Bonds who tried to be over efficient, even snapping at children who were told to keep their fingers off the goods. The whole shop and residence is now the Electricity Showrooms.

Caley's Harnessmaker The oldest shop and business nearby to the Market Place was from the earliest days of Fleet, Caley's Harnessmaker, also selling and making all kinds of leather goods. This shop is now the site of Dewhurst butchers.

The Caleys employed a jolly round faced and skilled worker by the name of Dick Froud, who walked to and from his home near the Black Horse, Crookham. The work of making horse harnesses including saddles was always brisk and the enterprise flourished. On a very hot day Dick would sit on a stool in the open shop door, working away using the tools of the day, brad-awls, pigs bristle needles and specially shaped knives. He never stopped work, persons who wished to gossip received a smile and nothing more. When I was a very small boy, I bought a leather dog lead and waited while a dog collar was fitted to my Cairn dog: cost 1 shilling. If Dick was sitting in the shop doorway it was said to be a guarantee of a hot sunny day.

Barbers There was no hairdresser's shop, but Mr. Youngs built a barber's shop in 1910, close to Blacknells Yard and shop. Often a carriage, after proceeding to Fleet Station, would stop at Mr. Youngs and the driver request the hairdresser to call at a certain gentleman's establishment on the morrow at a certain time. Mr. Youngs would close his shop and either walk or bicycle to the residence. If, for his services, he received a bounteous tip, he went home for the rest of the day. Six haircuts a day would be his usual lot, thereafter he stood waiting for customers to buy tobacco or cigarettes.

Before this shop was built, several men taught themselves how to cut hair, thus providing a little extra money for living expenses. As a small boy, I remember going with my brother to Mr. George Cooper in Hope Cottage, Albert Street. The haircut was 2d each. One boy had his hair cut while the other held a lighted candlestick. A deep, gruff, bass voice would tell the candleholder to: "Put it where I can see, keep it upright and don't waste the candlegrease." The haircutting took place in the scullery, but if the gentry should call and request a haircut, they would be conducted into the parlour and charged 6d.

9

The Oatsheaf.

Chapter Two
Fleet Urban District Council

Prior to 1904, before Fleet Urban District Council was formed, the roads were in a terrible state, all almost impassable in severe weather, even preventing children getting to school and adults going to church. The 'Gentry' on horseback or in their mud-splattered carriages, often were delayed on their way to Fleet Railway Station and sometimes trains were lost. The owners of large houses used all their persuasion with their friends on the County Council at Winchester, who agreed to create the self-governing Urban District of Fleet. Previously, this area had parish councils with practically no powers.

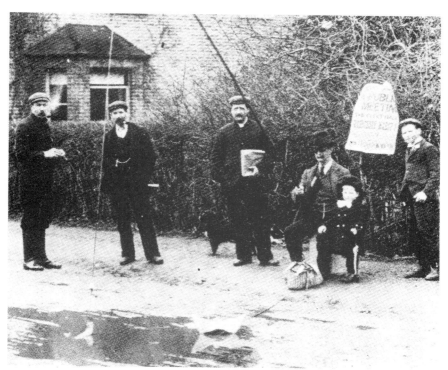

Sam Wackett registered his complaint about the conditions of Fleet Road by fishing and sailing paper boats in a large puddle near the Oatsheaf.

Elections Several public meetings were held and many posters displayed in shops and cottage windows. Permission was granted and the first election was held for councillors to endeavour to improve the locality. At that time, there were poor roads, no street lights, no water mains – only wells, no gas, no electricity. The election was extremely popular with everyone talking and suggesting ideas of work necessary for the new Council to undertake. The list of the new councillors is well known and quoted in local histories.

The first meeting was held at The Views. Col. Horniblow, elected chairman, Jeffrey Edwards, a barrister, explained the legal powers now and for the first time available to the people of Fleet. The father of the writer, Mr. E. W. Edwards, being a schoolmaster who could write the new Pitman's shorthand, was requested to write the minutes. At the second meeting, it was agreed to rent, with a view to purchase, the small house standing at the corner of Albert Street and Upper Street (north-east corner) for a council office. A permanent clerk was advertised for and Mr. Wright, who had been clerk to the Winchfield Workhouse and had taken early retirement, obtained the position. He lived in Pondtail. However my father continued without remuneration to write council minutes for about 10 years.

Rates Without money, the Council could not undertake to fulfil its promises. A grant from the County, together with advice enabled the Council to fix its first rate. A rate collector was advertised for. A middle-aged gentleman named Ivor Smith had just recently married a rich woman and built a pleasant house situated on a corner site to Kings Road and Kenilworth Road. The house was and still is called Ellerslie. Mr. Ivor Smith, finding little to do, applied for the situation as rate collector and was duly appointed. The rate application forms were printed locally. Mr. Ivor Smith, a sturdy, well-built man *walked* and delivered a rate demand to every house, cottage, farm and pub. He arranged with every ratepayer to visit in a few days time and collect the money demanded. At about this time, Mr. Morgan, editor and owner of the locally printed *Fleet Times*, agreed to print without charge a notice stating that the rate was due and Mr. Ivor Smith would be calling for the payment, as stated on the rate form recently posted to householders, postage ½d.

The rate collector became a well-known figure and as the area was quiet, with few visitors, the rate collector was nearly always asked to enter and sit down whilst the money was counted out and handed over. The writer's father owned a pair of cottages in Clarence Road occupied by two ex-soldiers, Mr. Trimmer and Mr. Gardener and their families. The rent of each cottage was 7 shillings per week; half yearly, the rates were 23 shillings.

Roads The next item for the Council to consider was repair of roads. Owing to lack of money, contracts for road-making were not considered. However, it was agreed to hire a horse and cart from Mr. Hankins, who earned a livelihood by charging for the hire of horses and carts or for undertaking to move sand, gravel, bricks and manure. The cost of a carter with horse and cart was remarkably cheap – less than 10 shillings per day. The Council then employed several roadmen to repair and sweep the roads, which consisted of loose gravel.

It was soon decided that if progress with development was to be accelerated, a building surveyor should be employed. An advertisement in the daily press brought Mr. Chivers for an interview. He came from Eastleigh and he was a chartered surveyor. He was appointed because he had assisted his father, who was surveyor to Eastleigh, to lay public surface-water and sewerage drains throughout that district. It was exactly such projects that were expected to occur in Fleet. A scheme for dealing with surface water (road drains) was soon started in Fleet Road. The manual labour staff, who were very badly paid at about £1 three shillings each per week, was increased to 12 or 14 men.

In seven years a good many roads were constructed and finished with a steam-rollered surface. From about 1906, Fleet Council 'made up' Fleet Road, Aldershot Road and Reading Road by digging out 9 inches of soil and in-filling with gravel dug in Pondtail where huge quantities were found just below the shallow surface soil. Gravel digging and screening to different sizes of aggregate gave a livelihood to many hard-working men who were also very badly paid about £1 three shillings a week.

The roads were made by steam-rollers consolidating the gravel with a spray of water running down over the front roller and were all cambered and rolled into shape. The steam-rollers were hired by the Council from Wallis & Steevens of Basingstoke and stayed in Fleet for several years the drivers using 'Living Vans' pulled by the engines. Fleet Road was the very first road to be curbed with 12 inch by 6 inch by 4 foot Belgian granite kerb stones. By 1910, Fleet Road had nicely gravelled and rolled footpaths.

The early inhabitants, helped by the Council, planted trees either side of the roads at 15 foot intervals. Pinewood Hill, Dunmow Hill, Avondale Road, Branksomwood Road and Victoria Road all had trees on either side until the coming of concrete kerb stones. A few – very few – trees remain in Victoria Road. The trees were in continuous use for 'hitching' the reins of tradesmen's horses. Through roads had footpaths with their edges to the roads strengthened by a 9 inch wide grass turf edging.

The gravel roads became pounded on the surface by heavy horse traffic and grit and dust became a nuisance. The Council purchased a horse to draw a water cart with a large tank and a spray of water at the rear. Later the horse was used to draw a large tar pot. This vehicle had a tank to take

a barrel of 40 gallons of road tar, or gas tar with a little pitch. A fire beneath the tank heated the tar and a man pumped the contents, via a hose, to another man who controlled the spray of tar on to the road. Sand was hand-scattered over the tarred road and a steam-roller consolidated the road surface.

Although the main part of Fleet was high and dry, there were several instances of waterlogged places which, together with green shifting sand, caused much trouble to stabilise it. In such places, the area was excavated to a yard in depth. Fine twiggy birch bavins, or bundles two yards long, were carefully laid upon the moving sand, then a layer of heather and the hole filled with ballast or gravel. Somehow the whole area consolidated and became as stable as other parts of the road. Some of these boggy places have remained in a roadworthy condition for many years. The lowest part of Church Road, several places in Kings Road and low spots in Velmead Road were treated in this manner.

There were only about 1,000 inhabitants when the Council began road-making in 1905. This only increased to about 2,000 by 1914. Money was scarce, the Council was kept within a strict budget by its members. The surveyor's first priority was the through roads and then, one by one, never more than two roads a year, the other roads were properly surfaced. Even in 1920, the lower halves of Kenilworth and Westover Road were still in a rough state.

Although Victoria Road was in existence before the local council was formed, the council decided that the new roads designed by Mr. Brake should be also royally named: Kings Road, Albert Street, Clarence Road, Connaught Road, Wellington Avenue, Albany Road. As development progressed, well-known persons names were used: Fitzroy Road, Gough Road, Calthorpe Road and then Wickham Road after the first Vicar of Crookham Parish Church. More recently retired councillors and other persons names were used: Jean Orr Court, Champion Way, Campbell Close, Holland Gardens, named after William (Bill) Holland who in the 'good old days' was the local slaughterman, who would come and kill a pig for 1 shilling and assist in dismembering the carcass into the correct joints. He lived a quiet life on his smallholding which was a pleasant farm-like area, well within the then Urban District of Fleet.

Water mains The Council decided that the most urgent requirement of the vicinity was an adequate supply of water. A most important occurrence in the latter half of the 1800s was the formation of the Frimley and Farnborough Water Company, under the supervision of their engineer, Mr. Payne. The earliest project affecting all the inhabitants was the contract with this Water Company to lay a water main from Farnborough, via Cove Road, and then to lay and make main water

available to the whole of Fleet. Navies with picks and shovels laid the incoming main in record time. The company had to expand its supplies by installing a pumping station at Itcheil, Crondall and another at Greywell, where an immense underground supply was pumped to many areas. This water, which supplied Fleet, was extracted in a wonderfully pure state. The supply of water soon completed throughout the district, the Fleet Council members began to canvass and persuade for the approval of a sewage scheme.

Sewers To the surprise of the general public, the 'well to do' members of the Council were against the scheme. The 'shopkeeper' members, not wishing to loose their best customers, also decided to vote against the scheme. It was said that Fleet was a pleasant and quiet place to retire into and this would be spoilt by acceleration of undue progress and development. From 1908 until 1910, the main sewerage scheme was often put forward and defeated. However, constant agitation caused the Council to agree to the surveyor drawing up a scheme for future use. This was completed, but only in 1912 was it agreed to obtain estimates from sewage contractors. Thomas Hardy and Company submitted the lowest estimate and work gradually got under-way in 1913, but upon the outbreak of war in 1914 the contract had to be abandoned. In 1919, it was agreed to resume work. Great was the incrimination and abuse of those councillors who had held up the idea for several years. In those days, there was no talk of inflation, but Thomas Hardy's estimate had almost doubled since the war.

The surveyor's design was to have two main artery sewers crossing Fleet from Reading Road towards the railway station. These sewers were laid at about 8 to 10 feet from the stream banks to follow the natural flow of the streams. These streams entered Fleet Pond, but the Pond overflow used by Fleet Mill flowed on via the Mill Stream to Broomhurst, where sewer beds were proposed. The central artery sewer drain was constructed from Church Crookham under the canal and alongside the stream via Burnside to Avondale Road. It then went across country in a straight line, crossing Chestnut Grove, Wellington Avenue then in front of the Station Hotel, thence across the golf course to the Outfall Works. This section of the sewer was completed before 1914.

The line of these sewers was along the wettest and always waterlogged ground. Practically without any modern mechanical equipment, the trenches were excavated in waterlogged ground by means of picks and shovels. Several 4 inch-bore mechanical pumps were in continual use powered by very slow running horizontal paraffin engines. The slow thud, thud of these engines could be heard at long distances. The sides of the trenches were lined by close-boarded 9 inch by 2 inch deals framed with 4

inch by 3 inch longitudinal and cross bearers. To prevent the bubbling and oozing green sand sinking whatever was laid upon it, cut heather was thickly scattered over the bottom of the trench, then upon timber bearers, corrugated iron covered the width of the trench. Nine inches of concrete was then laid for a bed for the 12 feet cast iron sewer pipes. Each pipe collar was supported on a 4 inch by 4 inch elm pile about 10 feet to 12 feet in length. These piles were driven by a hand-driven pile driver consisting of three long sheer legs and the pile driver, a great balk of steel-shod hardwood, was pulled high by men with ropes and then suddenly released. The consequent thud could be heard at some distance.

In Avondale Road, a great cast iron globe was built into the road. This globe, about 12 feet across, weighed a considerable amount and its completion to working order meant many weeks' work of a dangerous nature. In Kenilworth Road, a pumping station was built with two large horizontal engines to provide compressed air. This power was piped to the chamber in Avondale Road to hoist and pump the sewerage to the sewage station. The whole affair was a great success, especially as the completion was carried out by wholly manual labour, save for the use of elementary pumping gear. Apart from one or two main man-hole chambers sinking, perhaps caused by modern heavy traffic, the whole scheme was a great feat of engineering. Neighbouring councils were not too successful.

During the last 20 years, the laying of drains in waterlogged land has been simplified by modern 'de-watering' apparatus which can suck out all the water from a track of land where drain laying is to take place. Extensions to the Fleet sewerage system have been carried out with this 'de-watering' also with the use of excavators, dumpers and even boring machines which can successfully bore a hole under the railway and then draw through the necessary pipes.

Gas The Aldershot Gas Light Coal and Coke Company had laid a gas main from Aldershot to Pondtail canal bridge where a storage gasometer was constructed. From this gasometer, mains were laid throughout Fleet. In 1900 the Gas Company began to install gas supplies to the majority of houses for a small connection fee of £3 and supplied a very efficient cast iron (black) gas cooker with oven and three boiling rings. This was supplied and fixed without any extra charge. Local gas was so cheap that in Fleet hundreds of slot gas meters were installed free and the gas supply was measured and prepaid for by a one-penny slot in the meter. One shilling's worth of gas prepaid by a 1 shilling meter, would enable a small dwelling to have sufficient gas for lighting and cooking for not less than three days. The first gas lights originally fixed in cottages were naked gas jets. Soon the Gas Company opened a shop near the railway station for the sale of gas apparatus – better type gas cookers, gas fittings with upright gas

mantles and glass globes and much later, inverted gas mantles and globes. For close work, such as writing and needlework, the gas light in the centre of the ceiling was about 2 feet lower, fixed between an ornamental brass oval loop. Grey enamelled cookers did not arrive until nearly 1920.

The local people were quickly weaned away from the use of oil for lighting. Also, solid fuel kitchen ranges used for cooking and heating were gradually changing from the range to a fireplace with an iron fire grate, tiled sides and a mantelpiece. This was indeed progress, so why not street lighting? The growing district, now about 2,000 inhabitants, began in 1910 to almost accuse the Urban Council of not making enough progress. This attitude was brought about because the main road at Hartley Wintney was brightly lit by street lamps, the gas being locally produced. The street lamps were well made, standing 12 feet high. The whole scheme was carried out by private enterprise with the gas produced by works in Hares Lane. The last remaining gas lamp standard is still standing at the junction of Fleet Road, Hartley Wintney with the A30.

However, the Government had made orders for local governments enforcing that district lighting and other facilities, such as water drainage, were to cover all the district concerned.

By 1912, after much serious consideration, Fleet got its gas lighting to all roads. Two lamplighters were employed, each with a 10 foot pole. The top of the pole had a long arm protruding which, when pushed into the bottom of the lamp turned on the gas. The pole had a tiny lighted wick which lit the gas. A trial lighting was held in Fleet Road and Kings Road and from this, the hours of employment of the two men were settled, also the time when they were to commence their rounds. There was quiet jubilation over the street lights. The evening papers were often read near the street lights, especially adjacent to the newsagents. The churches appeared rather dim after the street lights. The Parish Church continued for many years using their beautiful wrought brass oil lamps, but the railway station immediately became brightly lit in their offices and other departments and also with several gas street lamps situated near the far ends of the platforms. For several years, the street lights were put out at midnight and this was so until the Government prohibited street lighting during the winter of 1914. The lamps remained out – unlit until 1918.

First council houses After the 1914-18 War, Fleet Urban District Council were preparing to build their first council houses. These three-bedroomed houses with bathrooms, but no hot water, and built on land purchased by the Council were tendered for at a price somewhat below £500 each, i.e. £480. The Government, for several reasons, offered a subsidy of £50, later rising to £90, on each house privately built to the same specification as the council houses. These single-fronted houses can be seen in different roads

in Fleet. They were quite well built and their cost, together with a freehold site, varied from £590 to £620. The housing subsidy was stopped by the Government late in 1928. The 'Depression' had begun and lasted until 1932. Small builders, to keep going, speculated by buying land and building these houses, all at the same price, their profit was never more than £50 or £60 per house with the small builder working hard with his men.

Then and now I would like to stress the following events concerning Fleet Urban District Council as one of the most important parts of this book.

Mr. Edwards presented his Fleet Urban District Council reports to Mr. Josiah Morgan for the write-up as 'Council News' in the *Fleet Reporter*. For this work, he was paid by Mr. Morgan 'by the printed line' one farthing a line. Such was the dearth of news, as daily papers were not yet read by many persons, that just at 6.00 pm on the last Friday in the month, about six or eight interested men waited for delivery of the *Fleet Reporter* to Mr Parrott the newsagent. They bought the *Fleet Reporter* and in good weather read the council report just outside the shop door. The shop ran back quite a way from the door and these regular customers were allowed to read and discuss the council news within during bad weather.

Now, Colonel Horniblow, Chairman of the Council, who resided at The Views, would be seen to be slowly and stately walking along his drive towards the paper shop to purchase his copy. Clad in a dark cut-away coat, Winston Churchill type, square bowler hat and with his walking stick, he greeted the male onlookers and then purchased his copy of the *Fleet Reporter*. Immediately he was surrounded by those who also had just purchased and read the council news. Lively discussions, sometimes minor arguments occurred. Certain items were 'thrashed out' and thoroughly cleared of any doubts as to why the council had decided to proceed with this or that. Voices were never raised, never threatening behaviour. Soon it became a regular custom. Col. Horniblow's presence was followed by other councillors. Many could be named, George Elms, George Stratton, Inspector Groves, Mr. Cubby, Mr. Blacknell and Mr. Hamilton-Bell.

It would be more than a miracle if such discussions could be revived. There is ample room in the spacious rear council offices for an informal monthly meeting to be held so that the public, the council staff and the council members could review what had taken place during each month. May I just add, Mr. George Elms and Mr. George Stratton were reasonable and erudite working men, both Christian Socialists. All the time they sat on the council they worked as watchdogs for the curtailment of unnecessary spending, thus keeping the rates within the means of the ordinary inhabitants. It is regretted that modern socialism is now exactly the opposite, 'Get everything possible from the ratepayers'.

The Fleet Urban District Council, during the whole of its existence, was an example of steady progress of development and improvement without excessive expenditure burdening the ratepayers. Mr. Hamilton-Bell, for many years chairman, was principal of a large London firm of Insurance Actuaries. Council staff produced annual estimates of expenditure before the fixing of the coming year's rates. Mr. Hamilton-Bell had these estimates analysed in his London office, consideration was given to essentials and to improvements to the locality. His opinion was put to the whole council, who, with only very minor adjustments, agreed his figures for the coming year. A vote of thanks was also unanimously passed.

Fleet was always an outstanding locality of tidiness, small cottages all had their gardens cultivated. The local council set a high standard and from 1910 until 1938 all roads and paths were swept, and maintained quite free of any litter. Council 'sweepers' were employed each Saturday morning in sweeping all footpaths to places of worship. This included the footpath

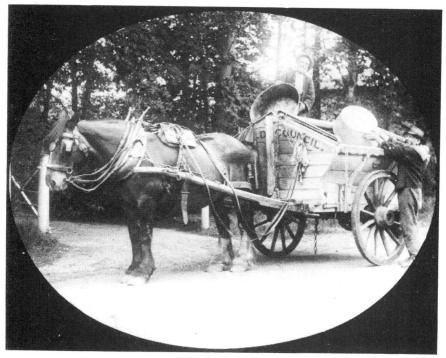

1920: Fleet Urban District refuse cart. In use until modernised refuse vehicles were purchased.

from The Views to the Parish Church. Colonel Horniblow had given this pathway as access to the church.

For the 10 years of the period 1930-1940 Fleet could be regarded as a well-governed locality with expected steady rates. It was considered to be an extremely pleasant area with desirable properties and a generally good environment. To emphasise the foregoing description it can be officially stated that the district of Fleet – per head of population, gave more than elsewhere for Remembrance Poppies. It also had more dog licences per head than other districts. This does not bear comparison with the 1980s, when during this time the Hart Council borrowed one million pounds from the London yearlings money market, a year or so later, another half a million was borrowed. It was a most curious fact that at that time I mentioned this borrowing to three different councillors and received the same answer: "I am not on the Finance Committee and I know nothing whatsoever about it."

Now, in 1986, the council is housed in an immense palace. Practically nothing is publicly divulged about current expenses. Surely ratepayers have every right to ponder whether £25,000 repairs to the Assembly Hall roof are just a very minor affair. Possibly, the financial puzzle of the costs of council estate properties to the ratepayers are now of no consequence to these ratepayers. As the occupier of a 150 year-old cottage in the centre of Fleet with just three bedrooms, I now find that one week's rates paid in 1985 are exactly one year's rates paid in 1940. My income and that of the general public, although of average growth, can never match the foregoing figures.

Future growth?

Enterprising businessmen who have founded small factories and other places of work, prefer to employ local people. Without official figures it is possible to say that, in 30 years, the number of school-age children will outnumber the original population by four or five times. The amazing growth, now vastly increasing at an exorbitant rate, may mean the loss of Fleet Pond which could easily be drained to its solid and hard bottom and sold for development, bringing the council £10,000,000?

Chapter Three
Shops and Businesses

Reading Road crossroads

The Market Place now had large houses which, at first, stopped development on either side, so houses with shops were built at the Reading Road and Fleet Road crossroads.

Mr Cane At the corner of Fleet Road and Reading Road stood a small lock-up shop, timber built, standing in an orchard of apple and pear trees and also a quince tree. About 1890, Mr. Ernest Cane, a farmer's son from Basingstoke, bought the shop and site. As trade had recently improved, including Post Office business, Mr. Cane purchased an old railway carriage and used this for retail and storage purposes, while a corner shop and later a house were built. This railway carriage must have been on the site for at least a hundred years and remained as storage until quite recently. The whole of the corner, including the shop and house and the Baptist Church were demolished to make way for the existing range of shops.

This grocery business grew until it was noted throughout the district for its excellent goods and service. Contrast the service then given, with that of a modern large multiple store. Mr. Cane employed three efficient men who walked or bicycled about the district for 10 hours a day, calling on householders for grocery orders. Delivery always took place next day by three pony-drawn delivery vans and three or four errand boys. At least six men and women served shop customers or packed groceries for delivery in wooden boxes.

Mr. Ernest Cane, grocer, was always present in his shop, coming forward at once to greet and advise customers. This, perhaps old-fashioned way of shop owners, has almost completely disappeared. What is more important is the complete inaccessibility of bank managers. As a retired builder with now highly expensive properties changing hands, I have not been able to contact my bank manager for the past 20 years. Mistakes – large and small – however much they involve the bank, never produce the presence of the manager!

Mr Taylor A clock and watch repairer, he built a small shop and house at the Reading Road, Fleet Road corner. The corner shop fronts were quite small with windows about 5 feet wide by 4 feet high. A limited stock of jewellery was on show in one window and within the other, Mr. Taylor sat

at work much to the interest of everyone including small boys. To counteract those who stopped and stared, Mr. Taylor placed a large clock in this window. For many years it interested most passers-by, because the pendulum consisted of a clown working up and down on a trapeze. The works were gaily painted and were not removed until Mr. Taylor died and his son, Albert, carried on the business. These clocks were quite rare and even in that trade very few have ever been seen. Mr. Taylor's 6 foot green privet hedge stretched from his corner shop along Reading Road to Albert Street.

Tower Building Mr. J. G. Wilcox came to Fleet and built a shop on the corner of Reading Road and Fleet Road opposite the Oatsheaf. Living accommodation was provided at the rear and over the shop. The roof was finished with a circular leaded dome with a central staff thus enabling the place to be named Tower Building. Mr. Wilcox traded there as a Gents' Outfitter for many years, but eventually moved to new premises close by Parrotts newsagents in Fleet Road. Tower Building seems to be a little too much of a corner shop, changing hands many times. For a good many years it was a booking office for Aldershot Traction and Bus Company. It continues to trade as a Fried Fish Shop.

Eighty years ago the crossroads and the vicinity of the Oatsheaf Hotel, was thought to be a good area for trading. However once the Post Office was built in Fleet Road with its use vastly increasing, the shops near to it were thought to occupy envious positions. In all towns and shopping areas this has resulted in fabulously increased prices of sites or rents.

Fleet Road

Mr Spooner Mr. Sam Spooner, having observed Mr. Fred Willmot's shop and bakery by Victoria Road, also Mr. Rutter's butcher's shop and residence, decided to be part of the prominent type of building now appearing along Fleet Road. Nearly a dozen large houses had been built between Fleet Station and Reading Road. Mr. Spooner purchased a plot of land in Fleet Road, employed an architect to design and build a shop and residence of an outstanding appearance. The front of the building had several heavy Victorian items of architecture. The design could be described as quite different from the nearby shops and houses.

When completed, Mr. Spooner stocked the shop with local and imported high class greengrocery. Inside each plate glass window were fitted two large and powerful gas fixtures, giving four lights in all. The gas mains were now being laid throughout Fleet, but there was then no street lighting. By the standards of that time, the four illuminated gas mantles and globes, on goose-neck fittings, almost dazzled the area around by the bright clear white light given. On dark winter evenings, these blazing lights

were very welcome after progress along pitch dark streets with nothing to show the way. A rather pleasant temporary landmark for those times.

Within a few years Mr. Spooner became ill and after lingering as a very sick man, wasted away and died. Mrs. Spooner with two children, a girl and a boy, lived quietly in the house behind the shop which was eventually closed down. The property remained vacant and for sale for a very long time. Eventually, the property was sold to the Sharps Creamy Toffee Company, to be used as a distribution store for their products. The retail shop remained closed with blinds drawn. Sometime during the 1930s, the premises were bought by Mr. Longley who had been in the drapery trade for several years, trading from a small shop adjacent to the corner shop to Reading Road and Fleet Road. It continues as the thriving business now known as Longleys.

Parnells In 1902 Mr. W. Parnell came to Fleet. He built the premises now occupied by C. D. Hankin. Mr. Parnell, an energetic East Londoner with a cockney accent, scoured the vicinity for house building materials and very cleverly and successfully incorporated several different types of brick and pieces of masonry. By direct labour, he built three small shops with living accommodation for two families at the rear and above. His work-force were to be his co-mates from his early East End life. Cheap workmen's tickets before 8.00 am and after 6.00 pm cost less than 2 shillings return from Waterloo to Fleet. Some employees camped out for the working week, others arrived daily at Fleet Station at 7.00 am and were brought along Fleet Road by Mr. Parnell's light horse and van. Twelve hours a day they worked and then the men were conveyed back to the station for the 7.00 pm train.

Mrs. Parnell ran one shop for the sale of sweets and cheap toys, while Mr. Parnell ran the centre shop for the sale of footwear. He was extremely obliging. He paid a weekly visit to London and arrived back with a big bag containing special orders taken in his shop. His footwear shop was entered by a step down into a dim-lit shop with one stool for the use of a customer. Other customers stood while waiting to be served. For final inspection before deciding to buy, goods were carried to the shop window for exposure to the better light. A special Parnell feature was real leather boot laces, well over 1 inch square, suitable for heavy boots such as worn by farm workers and other rough workers. His third shop was turned into a footwear repair shop, commonly called the 'snobshop'. Here, with the shop door always open, sat a shoe repairer, who would accept articles for repair and always ready for collection in less than 48 hours.

Mr. Parnell thrived and so built another two-storey shop beside his premises. This shop stocked a great assortment of crockery, including wash-stand equipment and kitchen ware. One part of this shop sold

household oil lamps, capable of sufficient light to read by. This led to the purchase of a horse and van, equipped with a 200 gallon oil tank with a tap for the sale of lamp oil with deliveries throughout the district.

Cycle shop Mr. Osmond of independent means, lived in a four-bedroomed house with a good garden adjoining. However, realising that the population was increasing and Fleet Road was to be a shopping area, he built quite a large shop in front of his house. This shop with a central doorway and two large plate glass windows, was stocked with bicycles for sale: Raleigh, BSA and New Hudson. They were rapidly expanding manufacturers, with bicycles which were much improved from the old heavy iron steeds. With pneumatic tyres and a frame of today's shape, they swept the market.

However, the roads were all sharp, loose grit, and punctures and worn tyres were very frequent. Tyres, even after repairs only lasted three months. Mr. Osmond's business expanded quickly, solely because he employed a full-time man for cycle repairs who mended punctures while one waited. Gent's bicycles were somewhat similar to today's, but the ladies' had very high handlebars, as stateliness and a straight upright back were most fashionable. Envious people called these ladies' bicycles 'sit up and beg' models. Long skirts were protected from the steel spokes by twine threaded close together each side, running from the wheel hub to the rim of the mudguards.

Growth Fleet grew very quickly between 1890 and 1910. After development as a small village, business people with ownership of several shops in the near district, came to Fleet as it now had a local council and a good chance of development. The shops were quite new to Fleet and were most interesting.

Liptons Where the Wine Store (Roberts) is now, was a small shop which had never been very prosperous. However great progress was made by Thomas Lipton, the shop front and interior were remodelled. A mahogany shop front and tessellated tile floor led to the counter, which stretched right across the shop. The counter top was scrubbed cool marble upon which stood three great square slabs of butter, fresh and slightly salted. Between the slabs of butter, stood two pairs of wonderful 2 foot high polished brass scales, each with its set of weights from ½ oz. to 1 lb. The white-coated shop assistant with the aid of two ribbed butter platters, scooped off the butter from the slab and placed it upon greased paper on the scales. Custom and skill meant that this first scoop was always correct within ½oz. After weighing the 1 lb. of butter, it was shaped ready for wrapping, but before this was done a full sized impression of a thistle was

pressed upon it. A second counter sold packeted tea. Many blends were sold. The stocks were stacked high and a pleasant aroma of tea pervaded the shop. After just a few years, the shop was run by the Home and Colonial, who maintained the business and ran it in its old style.

International Stores – an imposing looking store with a large stockroom and warehouse at the rear, built in 1910. This building stands on the left-hand side of the entrance to the new council offices. It was the first shop with two entrance doors. There was a good turnover of groceries, including butter and tea, which probably affected the Home and Colonial's butter and tea trade carried on nearly opposite in a small shop.

Frisbys Opposite to the Home and Colonial, Mr. Frisby of Aldershot built a fairly large double-fronted shop with ample accommodation for the sale of boots and shoes. The shop windows held a good display of footwear. Living accommodation was included in the building and a male assistant and a female assistant (for the ladies) were there to serve customers. A shoe repairer was accommodated in a brick built workshop at the rear. Several chairs were available for prospective customers to try fittings from large stocks.

Nelson and Goodrick In Aldershot there can still be seen the two bow-fronted shops at the entrance of the old arcade. Also in Lynchford Road, Farnborough there is a double-fronted shop and in Farnham there is a shop in a prominent position, now Elphicks. Before 1900 all these shops were owned by Nelson and Goodrick, who were successful business partners, selling general drapery and furnishings. In the course of time, the original partners died and the whole of the businesses came into the control of a young Mr. Nelson. He was newly married and bought the four-bedroomed house now at the rear of the pet shop and built a fairly large shop adjoining Mr. Parnell's. As well as rearing a family of three boys and a daughter, Mrs. Nelson supervised the day-to-day running of the shop, which soon employed three to four assistants and, despite opposition from Mr. Ernest Oakley, a thriving business flourished from 1903 to 1939.

Mr. Nelson became a sick man and sold the Farnham and Aldershot businesses to near relatives, who both proceeded to sell-up and retire. The Farnborough Lynchford Road Shop was sold to a nephew, Bert Dacombe, who traded there for many years. He also became a prominent local councillor. Despite a modern shop front installed in the Fleet shop in 1922, the third generation allowed the business to dwindle and it closed in 1938. Comment: "A large thriving business with three branches now completely forgotten and unknown in Fleet."

Lasletts Following the establishment of Nelsons and Goodricks drapery business, Mr. Laslett, who was successfully running a Men's Outfitters, combined with the sale of household linen at Aldershot, came to Fleet and opened a single-fronted shop (near Bakers). This quickly became popular, so Mr. Laslett purchased a large house and built a huge frontal extension as a shop with several plate glass windows. This is now the site of Norway Parade. After about 20 years of successful trading Mr. Laslett sold his Fleet business, thus enabling him to open new shops in such places as Dorking and similar well established localities. The shop at Fleet continued for many years as a Drapery, specialising in ladies' apparel. The firm of Lasletts is still in business in Aldershot.

Newsagent Exactly opposite the gate and tree-lined drive to The Views, Mr. Parrott built a shop with living accommodation. His business as a newsagent stocking magazines and weekly periodicals soon flourished. Boys delivered newspapers every morning (not Sundays) between 8.00 am and 9.00 am. Mr. Parrott instituted a very early delivery at 7.00 am of The Times, especially for businessmen and others who might be departing from Fleet by train for Waterloo, and on to business or the Stock Exchange. This early delivery was maintained until about 1970.

Mr Richardson In 1878 a man and his wife built a small shop close to the newsagents and stocked kitchenware, crockery and odds and ends of ironmongery. The proprietor, Mr. Richardson, died a few years after the shop was opened so his wife rather off-handedly and abruptly served all the customers who became few and far between. Mrs. Richardson lived alone and ran her business until about 1925, when the shop closed as she was unable to continue because she had reached the age of 90 – she died two years later aged 92.

Nash and Vann On the corner of Branksomwood Road we have the site of what was the office and living accommodation of a solicitor, Mr. Ernest Nash. This very pleasant and affable man was in business before the turn of the century. He assisted the local council in legal matters and helped with the purchase of land and the building of the Fleet Social and Bowling Club. In these matters no mention was ever made about 'costs'. Until his retirement he regularly enjoyed an evening game of bowls at the club. He moved away from Fleet upon retirement and with him ended very many opportunities of obtaining friendly legal advice *free*.

Lloyds Bank As local residents of standing used banks for business and domestic payments, there were requests made for banking facilities at Fleet. Eventually in 1898 the Capital and Counties Bank built a stone-

faced, rather imposing, building in the centre of Fleet Road. Quite soon the name of the bank was changed to Lloyds Bank. The staff consisted of a manager and one clerk-cum-cashier. The manager, Mr. Gardener, very correctly dressed in a dark suit with a white shirt with stiff butterfly collar, waistcoat with gold watch-chain and, most prominent, six inches of stiff ironed white cuffs showing at each wrist. The solitary clerk was similarly dressed.

As a boy of 11, I entered the bank to make a payment for my parents. A silence, more quiet than an empty church, prevailed. The clerk eyed me and continued with his pen and ink. After a lengthy wait, the entrance door opened and an extremely imposing well-built gentleman entered with a black silk top hat on his head. As I felt somewhat overawed by the silent bank, I had removed my grammar school hat. The gentleman put his hand on my shoulder and said: "Why did you take your cap off?" I stared, and he said: "Put it on, remember to always make the bank your servant or you'll never get on." The Bank Manager and the Clerk appeared and greeted Mr. H. J. Brake, who owned half of Fleet, with a courtesy suitable for a royal person. I never forgot this incident for I regularly visited the bank for my parents and usually it was empty of customers and more silent than a churchyard.

Westminster Bank The house standing between Nash and Vanns and the Lloyds bank, was converted by a Mr. Dyson into two shops by building frontal trading premises. Beyond Lloyds Bank were two or three private houses which reached to Mr. Rutter's butcher's shop at the corner of Victoria Road. Originally these houses were screened from the highway by fences and cypress trees. The house beside Lloyds Bank was built and occupied by a retired clergyman. About 1890 it had shop premises built upon the forecourt and a Mr. Burnett opened a jewellers shop and clock and watch repairer business. In 1921 Mr. A. W. Archer purchased and continued the business until 1961 when the premises became the Westminster Bank. Beside the bank was the house and office of Mr. Richard Pool, Removal Contractors.

Chemist Close-by stood another private residence, this also was converted into shop premises by Mr. MacKnight. A rather striking shop front displayed from floor to ceiling, all the medicaments and medical appurtenances of a chemist. Upon a centrally positioned glass shelf stood two extremely large glass flasks, one filled with red coloured contents and the other with green. Just to the rear of this display, gas lights improved this almost sparkling arrangement. It was impossible to see into the shop via the shop door. Inside, loose medicaments and powders were stocked in an arrangement of 6 inch by 4 inch drawers similar to a miniature dresser.

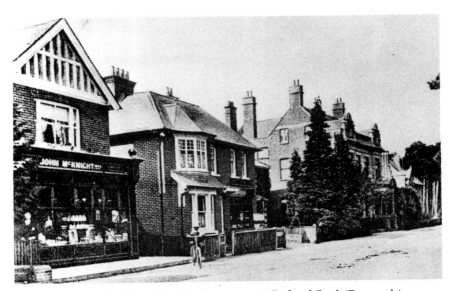

The first Chemist's Shop (MacKnights, centre), Richard Pool (Removals) Office. Space between Richard Pool and Lloyds Bank, house and shop, built for Mr. Burnett, Jeweller.

Mr. MacKnight, a tall, thin, hollow-cheeked man, seldom entered into conversation with customers. His wife and a domestic, named Emily, were also extremely aloof and did not mix with the public. If a doctor's late night prescription was required, one knocked on the door in trepidation and there you stood and waited even if gales and snow were occurring.

At that time the nearest Veterinary Surgeon was at Farnham, but John Kimber and Charlie Vickery could be relied upon to suggest treatment for ailing horses and cattle. Mr. MacKnight, at first refused to dispense medicaments for animals, but the wealthy people with horses and carriages were such valued customers that he could not refuse. During this period books on horses were quite commonly in use, detailing ailments and prescriptions and many were to be found in Aldershot, home of the Cavalry. Horse owners read such books and proceeded to administer suggested treatments. I remember, as a boy, taking an empty quart bottle to Mr. MacKnight for a quart of *Juniper* drink for a horse with a chill. Mr. MacKnight had to search in several books for the prescription and I am sure he intentionally kept me waiting in silence for half-an-hour.

Mr Pace About 1900 Mr. Pace came and built a shop and living accommodation to establish a drapery and corsetry business. This shop,

very close to the present Woolworths, was then thought to be extremely modern as it was built with floor-to-ceiling plate glass windows. The three plate glass windows were each cast in one piece, but in place of right angles, the corners were curved running around at 90 degrees. The shop thrived for many years and its shop front survived until 1984. After about 20 years in his original shop, Mr. Pace, a staunch Methodist, moved to new premises almost opposite the Post Office. He and his two daughters always ran the business and he himself considered that he was an expert on 'corsetry' and he was always quick in 'coming forward' to advise a prospective lady customer!

Post Office Mr Crick's newsagent shop began to handle Post Office business. From this time postage matters speeded up and soon there was a temporary Post Office in Fleet Road whilst the new Post Office was being built. Pillar boxes were installed, sub-Post Offices licensed and walking postmen in uniform were employed.

A great step forward was the opening of the General Post Office in Fleet Road in 1906. A photograph of this building, taken then, shows that Fleet Road was just a gravelled surface with the edges of the rough footpaths retained by strips or clumps of grass. It is recommended that readers should stand on the opposite side of the road and observe the only classical architecture in Fleet that is above the ground floor of the General Post Office – now a Woolwich office. We have turned the full circle after one hundred years and now only have a post office counter in a newsagent, despite the population increasing from a thousand in 1904 to almost 30,000 currently! Sadly this is called 'progress'. What would Mr Crick make of it all?

The first person in charge of the General Post Office was a Mrs. Harris, a widow of a person of importance. The position together with accommodation, appeared to be a 'grace and favour' appointment. Mr. Crick was appointed to serve behind the counter, to oversee the three postmen and a telegraph boy. He also received and sent messages by the telegraph key all in Morse code. Letters and parcels, were sent and received from Fleet Station. The Senior District Office was at Winchfield Railway Station, but later a horse-drawn mail van ran between Fleet and Aldershot.

Although messages were hitherto all sent by telegraph key in Morse code, other nearby places had telephones with verbal messages transmitted by wires and poles. In 1902 the Post Office decided to erect the first telephone poles with wires available to residences. A cottage in Albert Street situated near to Upper Street had one living room converted to accommodate a small switchboard. Within a very short time (just months), 70 private telephones were connected. The switchboard could

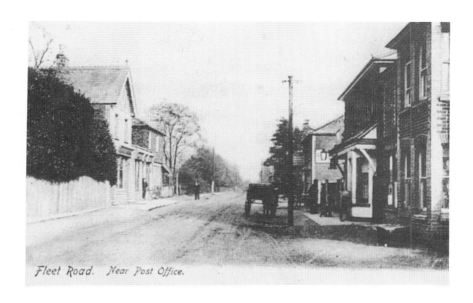

Fleet Road. Near Post Office.

(Top) Fleet Road approaching Church Road, hedge on left is present International Stores site. Earliest Post Office on right. 1903. (Bottom) Old Post Office 1905. Present Post Office is now just past these buildings.

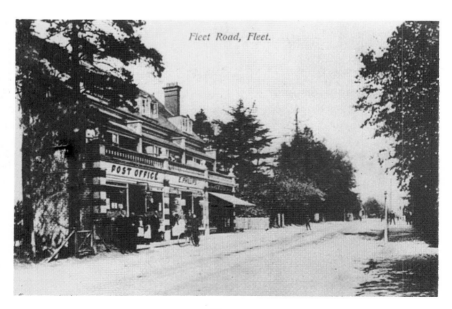

Fleet Road, Fleet.

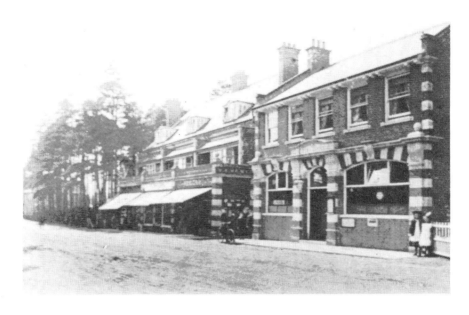

(Top) The General Post Office, built in 1906. Note: Fleet Road was still unmade. (Bottom) Fleet Post Office, 1920. Note the first kerbstones between the path and road.

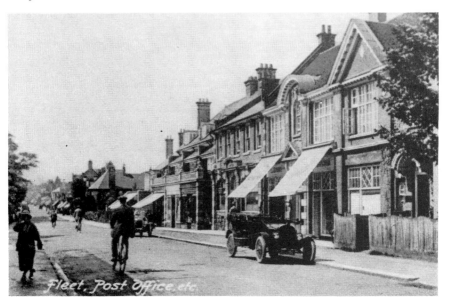

connect one local telephone to another. Three lines were available to Aldershot, one to Hartley Wintney and three to Basingstoke. Phone calls were expected to be made before 11.00 pm. At that time, the operator, Mrs. Willmott, went to bed. Rare emergency callers had to wait for her to come down from her bedroom to operate the switchboard.

The building firm of Pools, Fleet and Hartley Wintney, proceeded to build the row of shops adjacent to the General Post Office and included the residence occupied by Mr. Herbert Pool.

George Wright Mr. Voller's shop at Church Road corner was the first shop in Fleet, but George Wright of Fleet Mill being the only purveyor of corn, flour and all horse and cattle fodder, built a shop and yard at the corner of Fleet Road and Church Road, opposite Vollers. Fodder was delivered throughout the district and business was so successful that another shop and yard was established further along Fleet Road. This property is now Bradshaw the chemists.

Kings Road

Grocers Opposite Vincent's the butcher, Mr. L. C. Cox, a grocer, built the property now standing at the east corner of Clarence Road and Kings Road. Mr. Cox, a devout churchman, endeavoured to serve the larger houses where the provisions were required by the gentry and servants. Mr. Cox filled his shop and three windows with a worthwhile show of groceries, including a coffee roasting apparatus and a choice of butter and a great choice of cheeses. Close to the till a tall rack displayed boxes of good class chocolates. Mrs. Cox was a thin sharp-featured, and sharp-spoken woman who often helped behind the counter.

Now, a certain Lady from Elvetham Road with a pouter-pigeon figure, beautifully dressed, with a large feathered hat and silver mounted umbrella, regularly arrived at the shop on Monday mornings to order the week's groceries. Mr. Cox, very politely hurried about showing the lady teas to sniff, polished rice to handle and finally cheese to taste. While Mr. Cox wrote up the order the lady deftly extracted a chocolate from the right-hand top corner of the sweet display. Mrs. Cox glared at her but the lady observed: "One cannot leave with breath smelling of cheese."

Unable to stand the weekly loss of a chocolate, Mrs. Cox smeared the bottom of a chocolate with mustard. The ruse worked. However, standing quietly in the corner of the shop was the errand boy who was employed to deliver the groceries in a heavy hand truck. The boy was a chorister from the church nearly opposite the shop. The next Sunday this errand and choir boy had a great time entertaining his fellow choristers, especially as the victim was a regular and prominent member of the church congregation.

Broadway Shops These shops were built in 1906 quite soon after a Building Surveyor had been appointed. A prolonged argument arose because the front walls of the shops were exactly at the side boundary of Kings Road. Question: Did the projections of cills and overhang of eaves trespass onto Kings Road? Mr. Redpath, who had spent a lifetime running a public house in Aldershot, built two shops employing C. Cranstone and W. Dimes, bricklayers and budding builders, to carry out their construction. The Broadway, being close to Kimbers Off Licence, became a liability as all three liked beer. Mr. Redpath was persuaded to build two more shops, making four in all. This bankrupted poor Mr. Redpath and the shops were taken over by his late employers, who were brewers with their offices known as Kenwood House, Hartley Wintney. Mr. Redpath was given a free lifelong tenancy of one shop.

WILLIAM HARDING,

ROSE BANK,

VICTORIA ROAD, FLEET.

LANDSCAPE GARDENER,

FLORIST, ETC.

Plants, Seeds, Bulbs, Etc.

WILLIAM PHILLIPS,

FLORIST,

ALDERSHOT ROAD, CROOKHAM.

WINDOW AND BEDDING PLANTS.

*Bouquets, Ferns, &c., always on Sale
Wreaths and Crosses made to order.*

WILLIAM HOAR,

NURSERYMAN AND GARDENER,

MIDDLE STREET, FLEET.

GARDENS LAID OUT AND KEPT IN ORDER
BY CONTRACT OR OTHERWISE.

All kinds of Nursery and Greenhouse Plants
kept in stock at very moderate prices.

Chapter Four
Butchers

During the years 1850-1900 the working class could not afford expensive meat such as beef. If a householder reared a pig for home use he sent for Bill Holland, who owned all of Holland Gardens and lived off his land and his chickens and pigs. Mr. Holland was a quick and merciful slaughterman, and for many years only charged one shilling to come and slaughter a pig. Small boys somehow learned of Mr. Holland's call and loved to watch the proceedings with blood pouring into a bucket. Great glee and excitement occurred if the owner of the pig gave a neighbour's boy a piece of liver to take home for a mid-day meal.

Mr Monk As the Odiham butcher (established for nearly 300 years) he sent a man with a horse and van each week to Fleet to deliver and take orders from the larger houses. Winter and summer the delivery started from Odiham very early in the morning so that a large joint could be cooked by mid-day. After taking orders the horse and van stood near the Oatsheaf, usually at noon. People became aware of this and would go and buy what meat remained in the van, but the Oatsheaf Hotel did not encourage any market on the forecourt. Thus Mr. Monk purchased a plot of land at the corner of Church Road and Albert Street (now Lismoyne Offices). A small timber bungalow with a tiled roof was built consisting of two tiny rooms, a fireplace, and a shop front with sliding sashes, all sheltered from the sun by a verandah. The site was enclosed by a neat, clipped hawthorn hedge (the only hawthorn hedge ever in Fleet). The shop was opened for two days a week, butcher and meat arriving quite early in the day from Odiham. After several years the shop was closed because of lack of trade.

Mr Rutter He was an affluent butcher from Hartley Wintney, who came to Fleet and bought a very old cottage well back from Fleet Road and next door to Voller's shop (the last tenant was Bretts greengrocers). He built a timber shop in front of the cottage installing sash windows and a marble display slab. The shop trade increased and Mr. Rutter envisaged a prosperous meat trade in Fleet. He purchased the plot of land at the corner of Fleet Road and Victoria Road. A large butcher's shop was built together with good living accommodation and a stable and shelter for his delivery horse and van. All were enclosed within a brick wall to Victoria Road with high gates. He also planted the three horse chestnut trees still

standing and grown nearly 60 feet high. This was considered a desirable spot, bettering the Market Place with a hope for increase in trade.

Parsons A large family of Parsons originating from Bentley and Lodge Farm, Odiham, decided to open shops and sell their own reared sheep and beef cattle. This quickly became successful. Suitable shops, usually open to the footpath, without glass and only shuttered at closing time, were nevertheless smart with glazed walls and modern fixtures for display. This family opened shops in Odiham, Hartley Wintney, Crondall and Fleet. The Fleet shop and house occupied a position which is now the left-hand 40 foot wide portion of Waitrose. The business premises of A. W. Parsons included the site right through from Fleet Road to Albert Street. Built within this area were stables for a delivery pony, and a waiting shelter for cattle to be slaughtered. The large slaughterhouse included a killing area and sufficient space for cutting up and hanging quarters of beef. It became very busy with bullocks, sheep and pigs slaughtered every week.

Before the turn of the century, Parsons' brought cattle for slaughter from Odiham in a crude type of horse-drawn cattle truck. Passers-by stood in Fleet Road to watch these unfortunate animals being unloaded and led to the slaughterhouse. Now and again, but quite rarely, a bullock managed to break loose and run through the streets. Sensible people took cover, but boys thought it very exciting to watch from behind a fence. Older boys took part in the chases, especially if the bull had on a halter and a piece of trailing rope. A horrible noise from the slaughterhouse could be heard in Fleet Road and for quite a distance. Pigs squealed while being man-handled onto a stool and held down for their throats to be cut. Bullocks were fitted with a strong halter with a rope attached which was put through an iron ring in the floor. Men pulled the rope until the bull's head and body were fetched to the floor. The head being now quite well fastened and still, the slaughterman struck the beast between the eyes with a pole axe. The blow being skilfully aimed, the brain was penetrated sufficiently for a fairly quick death.

The Hardens Following the establishing of Mr. Parsons' butchery business, two brothers, Percy and Tom Harden, decided to go into partnership and sell meat between the Market Place and the Oatsheaf crossroads. A shop with living accommodation, also a yard and slaughterhouse were built. Its position was at the left-hand end of Overs furniture store. The right of way to the yard is still in existence.

Years ago, butcher's premises were either built in the shade of tall buildings, such as *The Shambles* at York, or, if possible, plane trees were grown to shade the meat in the open shops. A very old butcher's shop at Selborne is well preserved in this way and only a few years ago Parsons'

shop at Crondall was shaded by trees. The Harden brothers decided to build a two-post verandah in front of their shop. This stood on the main road footpath and, as at that time, there was no Local Authority, it was erected with a flat roof and iron railings so that it could be used as a balcony from the front bedroom. This shelter, built on to the footpath, was the second such erection. These were taken away in 1920. From about 1890 until 1939 the slaughter of animals for beef, mutton and lamb, occurred without fail each week. The noise of animals confined before killing could be heard a quarter-of-a-mile away, simply because there was usually a peaceful silence, broken only now and again by the clippity-clop of a horse passing by. (Note: no motor vehicles until 1912).

Tom Harden decided to break up the 20-year partnership and he proceeded to put a butcher's shop-front into the premises quite close to Tower Buildings in Reading Road. A butcher's business is still there. As previously recorded, animals occasionally escaped from the butcher's yards causing excitement and talk. People would say: "Mr. Harden, I am glad you recaptured the bull – sorry the pig is still lost."

Mr Vincent Precisely at the time these butchers were trying to establish themselves, Mr. Harold Vincent, a butcher originating from Chertsey, built a butcher's shop with living accommodation and stables at the corner of Kings Road and Clarence Road. For many years he worked hard opening his shop for long hours, also producing poultry and eggs on an acre of land in Pondtail Road.

Early in 1900 the British and Argentine Meat Company began to import frozen carcasses of beef. Refrigeration was yet to come, therefore the meat was frozen and packed in the shops in great slabs of ice. Instead of refrigeration, as we know it today, the meat was kept completely frozen in ice in what was known as 'cold storage'. It took three days before the meat was thawed enough even to be chopped and made to size for handling. This frozen beef was far and away cheaper than fresh English meat. So the butchers built cold storages, really to slowly thaw the meat, so that it could be hung and displayed. This cheaper meat enabled working families to have more than one joint each week. The 'better class' people were prejudiced against the importation as they or their friends were interested in farming beef cattle.

As Mr. Vincent's trade included many large houses in Fleet, he made it known that 'no frozen meat sold here'. Working people thereupon bought their meat from butchers who dealt in frozen beef. The trade with the larger houses could not keep Mr. Vincent going, so he built a cold-storage room on to his shop and, at first with much distaste, thawed and sold Argentine beef without which his business could not prosper.

COAL! COAL! COAL

W. BATEMAN,

COAL & COKE MERCHANT

UPPER STREET & FLEET STATION.

All kinds of Coal supplied on
Reasonable Terms.

BRIQUETTS FOR NURSERIES 8d.
PER DOZEN BLOCKS.

SPECIAL PRICES PER TRUCK LOAD ON
APPLICATION.

Hire Carting orders respectfully solicited.

By Appointment to the Royal Family.

S. E. DARNELL,

FAMILY BUTCHER,

FLEET & HARTLEY WINTNEY,

Winchfield, Hants.

Pickled Tongues, Corned Beef, Poultry, Game, &c.

Chapter Five
Tradesmen

Coal Merchants

Before 1890 even such small places as Fleet became dependent upon coal. Large residences had great kitchen ranges nearly 6 feet wide and 6 feet high. These ranges were quite capable of efficiently cooking everything required by a household of about 12 persons. A large household, such as The Beacon would need two trucks of coal, say 20 tons per year. Although coal-fired boilers by Ideal were installed in a few large houses, the systems were sluggish and were augmented by several coal fires. Central heating pumps were not yet invented. Before 1900 every house, however small, had its coal-consuming kitchen range. Stevens and Johnsons of Aldershot maintained a very large stock of ranges. Before 1900 (gas cookers just beginning to be made) weekly supplies of coal at Fleet Station amounted to at least five or six railway truck-loads of coal, each truck containing 12 to 14 tons.

George Wright had brought several barge loads of coal from Basingstoke via the canal, unloading at Winchfield or Wharf Bridge, Aldershot. Thence the coal was conveyed by horses and wagons to the larger and more important houses in the district. Milling by water power became out of date especially as Aldershot now had several steam mills. With the diminishing trade for corn, flour and fodder and with the building of a railway siding at Fleet Station in 1868, George Wright succeeded in building up a thriving business as a coal merchant with deliveries anywhere in the district. He had two coal yards, each with three horse-drawn coal drays delivering coal and took in Mr. Herbert Williams as partner.

Mr. Whitfields, rather aggressively, opened a corn shop and coal yard next door to Wright's second shop (now Bradshaws Chemist). There was no Urban Council, so he built an open verandah upon the road footpath with two supporting posts. As an advert he placed a large piece of coal under this shelter. It was about 4 feet square and 5 feet high. This 'knob' remained intact until the 1914 War blackout when it somehow(!) became smaller and smaller, until it was totally removed.

Coal and coke were weighed into heavy hemp sacks. Each sack had two small rope handles and the sack was completely soaked in tar and pitch as the heavy texture of its construction could cause an absorption of much rain and icing. Each of the contents had to weigh one hundredweight

(112 lb) and it was the custom to add 3 lb of extra coal in the summer and 5 lb of coal during inclement weather. Coal prices were reasonable and working people managed to buy and have delivered a hundredweight of house coal costing just a few pence more than 1 shilling. In modern currency this was £1.20 per ton compared with the 1986 price of household coal exceeded £100 per ton and the price has risen still further.

In the *Fleet Reporter*, the first weekly newspaper and dated 1893, the following advertisements were inserted by Fleet coal merchants:

> George Wright 2 depots.
> Mr. Whitfields, Fleet Road Lodge and Keep, Fleet Station.
> W. Batemen, Fleet and Aldershot.
> W. Smith, Spruce Villa, Fleet Road.
> J. R. Sisterson, 112 Fleet Road.
> Dennis, Aldershot Road, Fleet.
> Mr. Coveny at the Broadway.

There were also deliveries made at Crookham by Limings and Potter Bros. Several of these small firms did not last very long as working class people minimised their summer purchases. The last newcomer to the local coal suppliers was Toomer and Co. In 1980 only Potters sell coal in Fleet and Church Crookham.

Milkmen

Rose Farm Farmer Mark Kimber, the owner of Rose Farm, began deliveries of milk in 1862. The entrance to Rose Farm was beside the Prince of Wales public house, and it had fields bordering the canal almost from Reading Road Canal Bridge nearly to Velmead Road. The Rose Farm labourers' cottages were on the far side of Reading Road exactly opposite the farm entrance. Mark Kimber was the first man ever to deliver milk with a pony and milk float. Daily he purveyed skim milk, milk, cream and butter throughout Fleet and Church Crookham. At one of the farm cottages in Reading Road, the wife of one of his labourers sold milk etc, to callers. It is of special note that the principal local dairy in Fleet is still named Rose Farm Dairy and this name is upon each milk bottle; the name persists after 124 years.

Bert Meech and Broomhurst Farm Just before the end of the 1800s, a speculating builder from London built a row of small villas just between Fleet Railway Station and (now) Old Cove Road corner. Bert Meech, born in Rochester Grove, contracted with the builder to have the corner villa altered to have a small shop window and a small stable and shed installed so that he could buy milk from Mr. Adams at Broomhurst Farm and purvey it to that adjacent part of Fleet. For several years he was quite successful in a very small way, so much so that he built a shop at the

corner of Rochester Grove and Aldershot Road. This shop and dwelling sufficed for a few years, but as age took its toll of Bert Meech, the business premises were put up for sale.

It must be understood that those who purveyed milk rose at about 3.00 am summer and winter and drove their horse and cart to the farms to collect milk in 4 foot 6 inch high metal milk churns. Before setting off to the farm to collect the milk, the horse had to be fed and watered; also groomed and harnessed. After delivery the horse had to be attended to and all milk containers, half-pint and one pint measures and the churns, had to be scalded with boiling water. At least two other men attempted to deliver milk; both of them only lasted a year or two!

Tom Cubby Mr. Meech sold his business, house and shop, to Mr. Charlton who lived nearby in Rochester Grove. Within a few years Mr. Charlton sold the business and premises to a stranger, Mr. Tom Cubby. This man was a keen businessman looking for opportunities to improve his position. Just prior to the 1914 War, Mr. Adams, owner of Broomhurst Farm who had supplied much of the milk to the locality, sold several acres of farmland for Fleet Urban District Council to construct a Sewerage Outfall Works with filtered water flowing into the Mill Stream. A shop fronted-dairy with living accommodation and a yard was built in Fleet Road (next to Boots and Saddles). Gradually the Adams' interest petered out. Mr. Adams died; later his eldest son was killed by a stray bull and farming at Broomhurst became almost at a minimum. The Adams' interest was sold to Mr. Tom Cubby of Rochester Grove who moved into the new Fleet Road premises. Not only did Mr. Cubby improve the dairy business, he also became a councillor and later Chairman of the Fleet Urban District Council. He was the last chairman who had the minutes of all committees read in full to the whole council before allowing council approvals.

Ted Watts and Rose Farm Dairy Mr. Ted Watts of Bramshot Farm gradually supplied most of the milk and, eventually, he bought a share and partnership with Mr. Cubby. The Fleet Road Dairy and the supplying of milk grew, until in 1914 there were five milk floats drawn by New Forest ponies, all delivering milk early each morning. The business, by careful management, greatly increased and after Tom Cubby retired the family of Watts purchased the whole of the business. Years ago the milk arriving at the Rose Farm Dairy was all hand pumped through a heating and cooling apparatus, the forerunner of pasteurisation. The business of Watts Rose Farm Dairy grew partly because the Government's Milk Marketing Board began to collect all milk in sterilised motor tankers and milk bottles came into common use. Soon the electric milk delivery vans superseded all other

means of delivery. Pasteurisation was required by Government legislation. The dairy now has a very modern pasteurisation method of dealing with all milk arriving by tankers. The milk is pumped straight from the tankers up to the top of the pasteurising plant and then into steam-cleaned bottles ready for delivery. Each morning, 30 electric delivery vans set out early to deliver milk in Fleet, Odiham, Greywell, Tunworth, North and South Warnborough, Cove and part of Farnborough. The pasteurisation plant can deal with 3,000 gallons daily and deliveries amount to between 2,300 and 3,000 gallons. This is a successful result of an entirely local enterprise.

Dairy Farms In the 1930s the larger farmers such as the Calthorpe Estate, the Guinness Farm and several gentlemen farmers, all now had cow sheds and facilities for breeding herds of pedigree Jersey cows. The quality of the locally produced milk was probably equal to the highest standards. Although the milk was collected from the farms by motor lorries, milk churns were still used and customers had to 'put out' their milk jugs for early deliveries, making sure that cats were unable to steal from the jugs. In 1980 the farming portion of the district included numerous farms with dairy herds of cows. In the area bounded by Home Farm, Hartford Bridge, Hazeley Bottom, Winchfield and Crookham Street, could be seen at least 1,000 Jersey cows, producing Channel Island milk. All these herds were beautiful and generally prize or pedigree beasts. Daily deliveries of milk in Fleet averaged 3,000 gallons with the Milk Marketing Board using the surplus for cream, butter and other dairy products.

By 1986 not a single milking cow could be seen throughout the aforesaid area. Grade A cow sheds, milking parlours with expensive up-to-date electric milking apparatus and stainless steel milk tanks were not in use. The future use of these deserted fields is very uncertain and eventually it may mean a changed appearance to the countryside.

For many hundreds of years, milk has been drunk daily by nearly all of the population. Recent perpetual propaganda by the Ministry of Health and the medical profession had, locally and nationally, resulted in this district altering their milk consumption from 72 per cent Channel Islands milk to under 30 per cent. A local enquiry found that the local doctors, active and retired, still consumed Channel Islands milk together with cream during the strawberry and sweet fruit season. Therefore – only do as your doctor tells you?! Why does the Ministry of Health advise the population that a man's heart is not yet acclimatised to flying, parachute jumping and continuous motoring mile upon mile between 60 and 100 miles per hour??

Nurserymen, Greengrocers and Orchards

Before 1900 Fleet and Church Crookham had numerous large residences, many with stables and conservatories, usually all built within an area of several acres. After the houses were built, it was usual for these wealthy people to provide themselves with a splendid drive from the road extending to the front entrance door and then on to the stables and ending near the garden. Ornamental shrubs were planted to line each side of the driveway, the favourite choice usually being rhododendrons.

Nurserymen Before gardeners could be employed, nurserymen were contracted to make the drive, clear scrub, heather and trees, plant shrubs, double trench the soil to form lawns, flower beds, fruit trees and the kitchen garden. From about 1880 many nurserymen established themselves in Fleet and were kept busy undertaking this work. All employees were agricultural labourers earning about 32 shillings per 60-hour week. Many nurserymen had never attended school because there was no school. Tom Ayres had a nursery in Fleet Road. E. D. Shuttleworth ran a successful nursery extending from Fleet Road into Albert Street, and this business recently closed down after the last proprietor, Mr. Saunders retired. William Hoare, Nurseryman, Middle Street, Fleet, laid out many gardens and part of his large orchard was only recently built upon. Other garden contractors were: Henry Shilling, William Harding and William Phillips of Church Crookham.

At Pondtail two quite large Nurseries were well established. Mr. Jones employed several men and boys and he was the first person to supply successfully wholesale greengrocery to the local shopkeepers. In the same vicinity at Pondtail, Mr. A. Heaysman built up a large nursery mainly for vegetables, apples, pears and plums. These nurserymen probably chose to establish the cultivation of the arid sandy soil of Pondtail because, over Eelmoor Canal Bridge on a nearby corner of Laffans Plain, there was a long and large embankment of horse manure. In Aldershot the Army consisted of Cavalry, Royal Army Service Corps and Royal Artillery, all with horses. Each day two horse-drawn vans brought all the fresh horse manure and tipped it onto the embankment. Provided there was no untidiness, the manure was free to be taken away by the public. The only hazard was that the warm manure became the home and breeding place for grass snakes, adders and the Hampshire smooth brown snake. Without the aid of this free source of manure, Mr. Jones and Mr. Heaysman would have found the Pondtail heather clad soil almost useless for cultivation.

Greengrocers Mr. Heaysman established a large orchard and he regularly sent a pony-drawn greengrocer's van with a man to tour the roads in Fleet and sell fresh vegetables from door-to-door. Mr. Jones and Mr. Heaysman

built themselves pleasant houses and employed servants to help as domestic aids. The area, cultivated as a nursery and the name of the house lived in by Mr. Heaysman was called Westbury. Now the vicinity is known as Westbury Gardens. During this period, as many as 30 men were employed by local nurserymen who found that they could employ a hard-working man for a very long day and week for 7d per hour. No pay for loss of working time because of inclement weather! Men without any skill, employed just to dig or trench virgin ground could be paid much less, about £2 a week.

In the last period before the coming of the motor car and because the majority of people were extremely poorly paid, nearly every householder cultivated every portion of his garden. Until well after the Depression of 1929-33, wages were extremely poor and with this low pay the diet was also poor by today's standards. Apples, stewed, apple pies and sometimes apple boiled pudding were very regularly on the menu, perhaps varied by a skim milk rice pudding. Dried apple rings were for sale in all grocer's shops.

Orchards Hampshire always provided many seamen for the Navy and Merchant Service. The Navy regularly released as many men as possible at Easter, so that these men could plant potatoes and other crops to help maintain their families during the winter.

Merchant seamen officers received a small percentage of the profits and even if single, occasionally a portion was used to buy a building site with a view to eventually getting married. These plots were not cultivated, but were planted as orchards. This is a list of some of the orchards planted in Fleet before 1900: Burnside close by, but in Kings Road; Mr. Higgins orchard, Chestnut Grove beside Birchen; Avondale Road just past Brookley Gardens; Holland Gardens; Medonte, Aldershot Road; Kings Road, two orchards on sites to the rear of frontage plots, now a cul-de-sac on south east side of Albany Road; two in Victoria Road. The majority of these building sites, with orchards, were not built upon for many years. The orchards, or what remains of them, now contains one or two 90 year-old apple trees whose diameters may reach 14 to 15 inches.

Chapter Six
Richard and Herbert Pool

Richard Pool

About 1880, Richard Pool's Removals stables and yard were at the corner of Upper Street and Albert Street. The firm had an office in Fleet Road and was a thriving business. Unfortunately a fire occurred at the stables and the horses including several beautiful dray horses perished in the fire. The remains of the horses were buried in local disused gravel pits. At that period of time, the total of horses in the locality almost equalled the male inhabitants.

Richard Pool, very upset at the disastrous fire and the loss of his horses, abandoned his two horse-drawn pantechnicons and shortly afterwards purchased three steam Foden engines to draw the pantechnicons as trailers. These travelled throughout the South of England, not only drawing a heavy load of furniture, but also half-a-ton of coal for engine consumption. The drivers and removal men often slept away from home and usually made beds in the furniture vans. The land at the corner of Upper Street and Fleet Road was undeveloped and small boys stood at

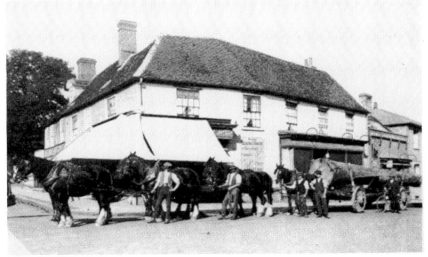

A great oak tree was felled in Eastern Dunmow, Essex. It was hauled by seven horses and the journey was completed to Pools, Fleet, in one day.

weekends to watch these steam monsters standing with their fires still alight, but banked down ready for moving-off early on Monday morning.

Richard Pool built a large building almost attached to Alfred Pearson's new offices at the junction of Fleet Road and Kings Road. This large square building was intended as a furniture depository. Eventually Mr. Alfred Pearson hired this hall from Richard Pool to hold furniture auctions. The vicinity being at that time quite small, these auctions were only held when circumstances required a sale. From once a year to three times a year, the sales became sufficiently regular for Mr. Pearson to consider building an auction room. Mr. Pool's removal business was also steadily increasing and by about 1910 the Pinewood Hall, as it was called, was definitely in use as a furniture depository (now Cantays). Mr. Pearson increased his agents' business and employed a young full-time clerk. The man remained with Mr. Pearson as a general clerk, letter writer and auctioneer's clerk until he retired at 70 years of age. He told me that from 1910 until 1935 his gross wage never exceeded £3 per week.

Herbert Pool

Mr. Richard Pool's brother Herbert, carried on a Fleet branch of his father's building firm. The builder's yard, joinery works and stables were situated at the rear of Fleet Post Office. Between 1890 and 1910, many large houses were built: Thurlston House, plus servants quarters and stables, Broom House and stables, Wood Norton, Lismoyne (Col. Anstey). Several such houses were built in the surrounding district.

Elvetham Hall The building firm of Pools spent several years restoring and adding to Elvetham Hall. This immense operation required a large labour force. Building craftsmen were advertised for in the West Country. Many men responded to the advert. At that time the building trade was extremely slack. Craftsmen were generally poorly paid. Joiners, carpenters and other skilled trades earned much less than one shilling per hour. Labourers less than £1 six shillings per week. Several West Country families moved to Hartley Wintney and nearby, including the Chapmans, known as champion Cornish wrestlers together with the Lewingtons. Several single men came and lodged in Fleet and after 1896 when the restoration was completed, found work locally, either with Pools or other local building firms in Fleet. They decided to stay and live in Fleet and married and raised families. They were highly intelligent craftsmen and quite a few of their children passed scholarships to grammar schools and on to further education. One became a chief aircraft inspector, another girl managed a large employment exchange in Reading. So the families of Lewington, Oram, Pidwell, Woodman, James and Ponds were now established in Fleet. Jack Woodman's son eventually became Chairman of

Fleet Urban District Council and sat on the Aldershot Magistrates Bench as a JP.

It was said by several of the men who assisted with the improvements at Elvetham, that Mr. Pool obtained a large number of different forms of conveyances and quite a few stonemasons. At that time the Old Newgate Jail in London was being demolished and the story goes that Mr. Pool purchased quite a lot of the stone and other building components. Many local stone lintels and gargoyles were pointed out as parts of the old jail.

War Department timber Close to the Railway Station was an overspill from Fleet Pond, a goodly stretch of water especially suitable for skating and curling in the winter. Beyond this, boggy land stretched nearly to Avondale Road. Soon after the outbreak of the 1914 War, Mr. Pool obtained a lease of this land from the War Department as there was a small high-and-dry strip adjacent to Fleet Station goods yard. Mr. Pool quickly obtained a very large contract for supplying timber for the war and the leased area of land facilitated loading timber onto the railway. The business grew extremely rapidly and soon three steam engines were working overtime producing sawn timber. A tremendous amount was used for making 'Duck Boards' for the water logged trenches in France, especially in the area of the Somme. Requirements were so great that vast areas of fir trees were felled and sawn. A large part of Hartford Bridge Flats, then covered by mature trees, was completely cleared.

The supply became so important that Australian lumberjacks came to this country and, assisted by their own horses, felled and cleared fir trees from many localities. A large fir plantation in the Stockton Drive Estate was cleared by these men and their horses. The lumberjacks stood more than a 100 feet away and signalled their horses by whistling, thus guided, trees attached to strong chains were brought to the roadside in a manner beautiful to watch.

The small high-and-dry piece of land near the station yard was fully occupied and soon a mountain of sawdust accumulated. This was pushed and levelled into the water and, with the water soaking, soon became a kind of peat. With some soil and ashes from the steam engines and from the railway, this all became consolidated enough to be used as dry land. By the end of the war, half of the site became dry land. Mr. Pool was now able to purchase the land from the War Department.

To provide work for returning demobbed soldiers, the Government instituted many road-making schemes and in just a few more years, 50,000 cubic yards of soil completely infilled all the low parts of land. By providing adequate and suitable foundations, the existing factory site became filled-in and formed into the present trading estate with some 20 factories thereon.

Post 1914-18 building After the 1914-18 War, building houses became the dominant feature providing work for about 100 men. Returning from the war, the building tradesmen were expected by their employers, to work at pre-war rates of pay, carpenters and bricklayers averaging £2 seven shillings per week of 50 to 60 hours work and labourers about 9d per hour. Herbert Pool's firm and H. J. Poulter's firm obtained several contracts to build houses as men returned to civil work, but one Monday morning all these employees stood together solidly on strike. By 11.00 am Pools settled for a tradesman's pay of 1 shilling 4d per hour and labourers 10d per hour. H. J. Poulter's men also agreed to return to work for a similar rate of pay. Thus, in the spring of 1920, the first and only strike every known in Fleet was over in approximately five hours.

The Blue Triangle The boundary of the Calthorpe Estate in 1920 ran from the rear boundaries of properties, on the lower north side of Church Road, identically to the rear boundaries of Sunnyside, Victoria Hill Road then north of Buenna Vista to Reading Road North, along Reading Road, to and including the cricket field and on to Leawood and Whites Farm. This boundary was sacrosanct to the estate neither to be sold nor developed. However Herbert Pool, whose family had recently refurbished Elvetham Hall, successfully negotiated for the release of this land for good class development from Sunnyside along Elvetham Road and along Hitches Lane to include Fitzroy Road. Included was frontages from Elvetham Bridge all along each side of Reading Road North to the Oatsheaf. The firm of Pools expanded and were solely responsible for development and building Waverley Avenue, Pines Road, Calthorpe Road, Gough Road, Hagley Road, Broomrigg Road and Herbert Road.

This beautiful area covered with mature trees such as pine or fir was to become, many years later, 'The Blue Triangle'. The well-built and well-designed houses were commodious with four or five bedrooms situated on not less than one acre of land. These pleasant residences were a new type of house capable of being run without domestic staff. Each individual house was so well screened by trees and shrubs that privacy was and is a great asset. This development continued almost until the mid-1930s. Except for one or two larger and special houses, all this development was quickly sold and occupied at a cost averaging £5,000 each. In a few years time each house, well maintained on its acre of land, will be valued at £250,000. The same firm, now Pool and Son, were later solely responsible for the construction of Fitzroy Road and the residences on either side. An outstandingly pleasant area.

Chapter Seven
Houses and Servants

1860 to 1910 – The Good Old Days?

In Fleet the working class families were truly working families. Fleet and Crookham churches were built by local building operatives. Craftsmen received 7d per hour and labourers received 1d less per hour. The wages earned for a 60-hour week were insufficient to support a medium-sized family and pay the rent. After 60 hours hard work, gardens were cultivated for vegetables. Chickens were kept and, if the garden was large enough, a pig. This provided all the food for the family.

Washing Limings the Crookham builders, built many large houses in the district. These houses, several in Fleet Road, were big enough to necessitate two or three indoor servants with wages ranging from £10 to £40 per annum. Because of steam pervading the large house, baskets of washing were taken home by the cottagers, laundered and returned for about 3 shillings per large household's requirements. A fairly large house required a week's washing for many bedsheets; also the gentry's and the servants' underclothes, the servants' uniforms and aprons. All this had to be washed, dried and ironed. Ironing was highly skilled work, including gents' stiff starched collars, ladies' blouses and summer frocks, full of tiny pleats, not forgetting very smart silk aprons for the parlourmaid to wear to serve meals and teas.

Several working families possessed a hand trolley – a wheelbarrow without sides for transporting laundry from the big houses to their cottage homes. Others less fortunate used an old pram for this purpose. Laundry baskets were several sizes up to 1 yard across and were circular with two handles opposite each other. Basket making was quite an industry. The sheets and similar linen were boiled in a brick-built copper with a 5 or 10 gallon galvanised bowl. At that time only yellow bars of Sunlight soap were available. These bars, approximately 3 inches by 2 inches and 12 inches long, were dried hard in the sun and then with a sharp knife were flaked into the copper; if soiled linen was present a little soda was added. Those with an extra large copper had a wooden 'dolly' for plunging into the copper and stirring the contents. The copper was heated by a small firebox beneath. Fuel was always a worrying problem.

For a quarter of a mile each side of Burnside Stream was an abundance of fir trees. Again, old perambulators were used with all the female

members of the family gleaning dead wood, small children were often required to fill a sack with fir cones. Failure of fuel meant that worn-out boots and shoes, tight small balls of newspapers and anything suitable for burning was popped into the firebox. The small cottages had a tiny scullery with the copper in a corner, some lucky people had a 6 foot high mangle with two 6 inch wide wooden rollers for squeezing out surplus water. On wash day the scullery could be hot and steaming damp.

Drying laundry in the winter was a great problem, the cottagers' living room, usually 10 feet by 11 feet, contained a kitchen range. This was stocked up with coke to produce heat for the cast-iron irons to be heated. Added to this, if the weather was wet, several drying lines of washing were stretched across the room. In this hot and steamy atmosphere, the ironing was carried out. Men and children sat around the room as the best room was not to be used.

Large houses The north side of Fleet Road, going towards the Oatsheaf Inn, contained some of the oldest large houses. Starting with Cranbrook House, Amulree, Fleet Lodge, Tullamore, Lostwithal, Hallands, Heath House, Conningham and Woodcote. These houses had four or five bedrooms, servants sleeping quarters, stables and outbuildings. Some of the gardens were very large – Fleet Lodge and Tullamore had extensive grounds extending to the boundary of Stockton House. Each house maintained a staff of at least four indoor servants and a gardener. Several had a horse and carriage with a groom.

The houses were built by Limings and Poulters of Crookham (H. J. Poulter, Estate Agents is a descendent). Limings were an extremely old building firm who were in existence long before they helped to build Crookham Parish Church. If old Mr. Liming thought that a building operation gave him satisfaction, he left his mark by planting a monkey puzzle tree. Several of these are still to be found in Fleet. There was one at The Views (previous council offices), three or four in Fleet Road and others can be found throughout the district. About a 100 years ago Limings rebuilt the greater part of Odiham Grammar School which was previously a thatched roofed school. The monkey puzzle tree at the school grew to be 80 feet high.

Servants The staff to run these large houses were poorly paid, a housekeeper or a first class experienced cook were paid quarterly and received about £7. Other servants, parlour maid, house maid, kitchen maid, received very little, but they were all supplied with dresses, suitable aprons and stockings and shoes. Young girls were given a situation upon leaving school at 12 to 14. After kitting out with clothes (almost uniforms), they were instructed in their duties, with emphasis on the

regulation that they were confined to the property and never to go outside the gates, also not to speak to the outside staff, such as the gardener and gardener's boy. If the young servants were from a local family, they were allowed to go home once a month on a Sunday for about four hours. If from outside the district, they were allowed a home visit once a quarter. No means of transport was available. Special permission, not too often, could be obtained to walk to the nearest post box to post a letter. These domestics were very well fed with plenty of fresh garden vegetables and the remains of the household joint to enable heavy duties to be carried out.

The exterior painting contract or internal redecorating brought men into contact with the servant girls, who were strictly forbidden to speak to any workmen. A surprising number of domestic girls married delivery men, the grocer's and the baker's roundsmen. 'Followers' were forbidden, but a good-natured cook, knowing the movements of the employees, would quietly allow a young man into the warm kitchen during winter evenings for a very, very quiet game of whist. I myself saw a parlour maid dismissed by her mistress from The Beacon for laughing and chatting with a house painter. At once, wages were paid, her bag packed and the final lecture from the mistress contained the threat that future employment was not to be sought in Fleet.

Domestic hot water boilers were not invented, so hot water was heated by the range or copper. In the kitchens was a long row of polished copper two gallon water cans. These were quite heavy when full of hot water to be hauled upstairs for baths and washstands. Central heating was not known and young servant girls carried kindling and heavy scuttles of coal upstairs to all of the best bedrooms. Fireplaces were maintained each day with ashes disposed of and grates cleaned.

Claremount and Urquart Lodge Until 1920 stood two large houses between the present position of Waitroses and Dewhursts. These properties had sites right through to Albert Street. The frontage to Fleet Road had a 6 foot high fence with a curved drive running to each front door. These two houses, Claremont and Urquart Lodge, were completely hidden from Fleet Road by tall chestnut trees and high rhododendrons. Miss Bethel, a spinster, lived at Claremont, Mrs. Miller at Urquart Lodge. Mrs. Miller was a recluse and seldom left her residence, nevertheless, she maintained her house with a staff of four servants and a gardener.

Miss Bethel, just the opposite of her neighbour, was always busy with charitable works and church effects like flower decorations and supervising such matters as the Sick and Poor Funds and Parish Relief. Some hinted to Miss Bethel that 'charity began at home', so she promptly went to Barnardo's home and brought back a 12 year-old orphan boy. He was designated as the 'boot boy'. When a man, this orphan left Miss Bethel's

and, still in Fleet, became quite affluent. He owned several properties in Albert Street, Hurst Cottage and Leigh House in Victoria Road, and the shop and bakery near Sandell Perkins, known for 50 years as Weavers Bakery. Miss Bethel died about 10 years ago, having lived well into her 90's.

Stockton House This house must be one of the very few very old houses. It probably dates from very early Victorian times, as the servants' quarters were typical Dickensian basements. As well as the residence there was a stable building entered by a large archway with a stone horse head as a centrepiece. The stables could accommodate at least six horses with fodder stores above. Also above the horse stalls were rooms for the grooms or stable boys. There was complete accommodation for the head groom – livings rooms and bedroom.

Stockton House became vacant, almost abandoned about 1912, but Mr. Weston, the head coachman, had a licence to stay in his quarters until he died. In Elvetham Road two cottages were the living quarters of the gardeners. The owners must have lived and entertained in an important way, for at the east boundary along Elvetham Road, was quite a large building equipped as a laundry. This accommodated the head gardener and his family and two laundry maids. This building remained empty with the garden grown wild until about 1930. Sir Seymour Hicks bought it and converted it into a private residence.

The last person to use Stockton House as living accommodation was Mrs. Meredith, widow of George Meredith, the classical novelist. Until 1914 Stockton Drive was the entrance to Stockton House and another large house known as Wood Norton. The drive was gated at Fleet Road and Elvetham Road. It was always beautifully maintained. This must have entailed continuous labour as at each side of the drive grew a row of large mature chestnut trees. Smouldering heaps of autumn leaves could often be discerned.

Jubilee Meadow I remember in 1915 talking to the head groom of Stockton House. He enthused about how his employer, who had provided the public with food and drinks from a marquee in the centre of a three-acre meadow facing Elvetham Road. An Army band played during the afternoon and again for dancing in the evening. The event was Queen Victoria's Jubilee. At the conclusion of the day, the owner fixed a name plate on the meadow gate naming the field Jubilee Meadow.

As the property was vacant, with no sign of life within the gates, my family paid Mr. Weston a few pounds for the crop of hay growing in the Jubilee Meadow and in another paddock near the east boundary. At 11 years of age I assisted with the hay making by leading a grown shire horse

and wagon as the hay was pitched on from haycock to haycock. The little wagoner stopped work and sat on a bank to drink from a bottle of cold tea. He yelled to me to lead the horse and wagon to the field gate. I demurred so he threatened me and I led the horse away. Afterwards he told me that he suddenly realised he was sitting on a wasps' nest. He appeared unconcerned about painful stings, but was exceedingly concerned about his horse. It seems wasps sting a horse either on its mouth or around his eyes. This can make a horse almost uncontrollable.

Rostrevor In Fleet Road immediately opposite Waitrose, are the business properties of Gateway, Share and Centre News. Gateway now occupies the site of a late Victorian residence named Rostrevor. The house was well screened from Fleet Road by a close-bounded 6 foot fence behind which grew an 8 foot high dense holly hedge. The gates and drive were usually closed. Miss Foster, the owner, having lived to a great age, was somewhat arthritic. Her visiting was via a hired horse and carriage which was usually at monthly intervals. Miss Foster maintained an indoor staff of three servants and a gardener daily. Great emphasis was placed upon cleanliness and smartness. For tea parties with visitors expected, the three servants were to change their apparel, black shoes and silk stockings, black dresses covered by beautiful silk 'afternoon aprons and caps'.

Heath Lodge Adjoining Rostrevor, and now the site of Share and Centre News, was another secluded residence known as Heath Lodge. Here lived Mr. and Mrs. Griffiths-Baker. He was a retired lecturer from a large London hospital – he lectured on dental surgery. She was a short and stout person with a cheerful disposition (quite unlike her immediate neighbour). Mrs. Baker was often to be seen busily chatting with her contemporaries as she wished to be well aware of activities which might interest her.

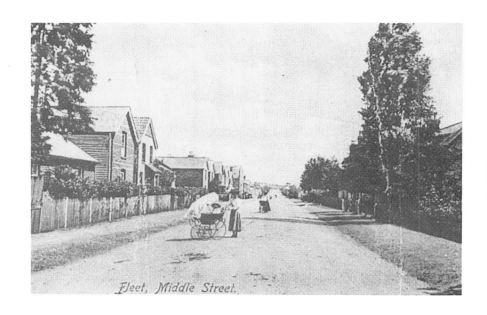

Fleet, Middle Street.

(Top) Fleet, Middle Street, now Clarence Road. Empty site on right is now the Baptist Church. Early 1900s. (Bottom) Fleet Road and, on right, Kings Road Junction. 1903.

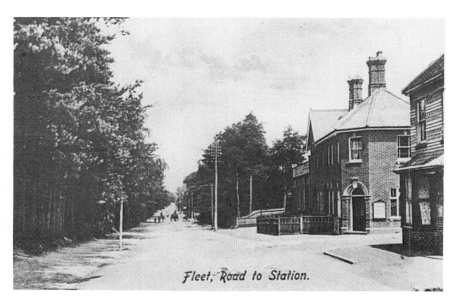

Fleet, Road to Station.

(Top) Original Pondtail Bridge, now used as a footbridge. (Bottom) Prince of Wales pub, then Hotel, Reading Road South. Castle Street on right. Pre-1920s.

Lismoyne.

Chapter Eight
Hardship, Enlightenment & Craftsmen

Hardship

The Oatsheaf public house was very often the scene of drunk and disorderly conduct. This led, if the men were married, to family hardship and those known to frequent the pub were almost unable to find employment.

Employment Various builders employed about 80 men; 100 or more found employment as daily gardeners to the larger houses, others worked as grooms, coachmen and stable hands. Carters, with regular work, went to feed their horses at about 7 am. Stables were swept clean of droppings and horse beddings. By 8 am. the carts were led to places of work, usually to the railway station to load up and deliver bricks or coal. The bricks and coal were loaded by hand, about 600 bricks for a cart load or just under a ton of coal for a horse and coal trolley. These materials were sometimes carried to the outskirts and work continued until sunset or, in summer, to 5.30 pm. After this the horses were stabled, watered and fed, the carter off home by 6 pm. Many horse-drawn carts served building sites, carrying sand, gravel and lime. A hard week's work of maybe 60 hours gave the average week's pay of less than £2. About an average of 200 men were unemployed or only partially employed. Every house that was built in Fleet, and until mechanisation made life easier, provided 'trenching' or 'breaking-up land' for garden cultivation type work for quite a few able-bodied men.

Tobacco Many exceedingly poor men with a wife and family to support became, by necessity, teetotallers and some succumbed to the use of hard twist tobacco. This tobacco, much used by sailors and soldiers, was purchased by weight in a strip about 1 inch across and ¼ inch thickness. These strips of hard compressed tobacco were said to contain a little rum. A man would buy an 8 inch long strip of this dark coloured tobacco for 2d. The tobacco was folded and kept in a small pouch, sailors using a piece of sailcloth, countrymen using a home made pouch of leather, sometimes using a moleskin.

At work a man smoked his tobacco from a broken short-stemmed white clay pipe or from a pipe made by a sailor. The hard twist tobacco was taken from its pouch and sufficient tobacco carefully pared off by a clasp

knife, then, carefully rubbed between the palms of both hands until friable and ready for smoking in the pipe. This tobacco was extremely strong and pungent and the strong smelling smoke was objected to by non-smokers. In this case, especially in certain parts of a ship or a warehouse, the consumer pared off a quarter-of-an-inch of hard twist and placed it in his mouth until it became soft by saliva. The tobacco was then steadily chewed and kept in the mouth for perhaps 30 minutes. The strong dark hard twist was said to stop thirstiness as it produced much dark stained saliva. 120 years ago china spitoons were in common manufacture and in public houses all the bars had spitoons in abundance. It was said that 300 years ago all public places even churches, were all furnished with spitoons. The spitting out of tobacco stained saliva became very accurate. If a working man thought he was being underpaid or unfairly reprimanded, he silently showed his disapproval by spitting so accurately that the saliva fell within an inch or less from the boots of his interlocutor.

Children The children of these workmen's families attending Fleet School from 1886 onwards, reflected this poor state. The girls' frocks, usually cut down from their mothers, were more often than not covered and disguised by a clean apron. The boys' trousers were often made from their fathers' and were queer shaped to mid calf or buttoned below the knee as knickerbockers. Boots and shoes were worn and mended until too small. Every three months, the school nurse came to inspect heads for nits and skin ringworm, sometimes a child was sent home because their clothes were so dilapidated that they were considered almost indecent. Measles and whooping cough were very prevalent and now and again serious fears arose because of cases of scarlet fever and diphtheria.

Domestic service There were hardships – just one authentic instance. A large house near Birch Avenue added to their servant staff by giving two 15 year-old girls a situation to train as domestic servants. The personal washing and bath water were carried upstairs from the kitchen in two gallon brass or copper water cans. The house owner, not finding his bedtime warm water on his wash-stand, enquired in the kitchen the reason why and was told that the two girls were ill in bed. The doctor lived opposite, so was fetched. He diagnosed scarlet fever. The house owner (or master), against the doctor's wish, ordered a horse-drawn cab to take the two sick girls to the workhouse at Winchfield. As it was mid-winter, the doctor demurred, but the master said: "They cannot stay, my own daughters are at risk." The cabby ascertained where the girls lived, so instead of going to the workhouse, he conveyed them to their homes.

Labour Exchange Before the 1914 War, when the local builders with just

a few employees secured a contract to build a house, this soon became known to building trade craftsmen. They were soon waiting in the roads opposite the site of the work. Quite a few men came from as far as three to four miles and thought nothing of the travelling if they could secure work. In 1920 a Labour Exchange was opened in the place of the old telephone exchange in Albert Street. The unemployed signed on each working day after 10.00 am. They entered the office one at a time. The others queued outside in all weathers, sometimes 40 men. Builders needing one or two men approached a good worker in the queue and offered work.

Depression Wages remained very low after the Depression of 1929-32 and the following account, so trivial but also so serious, was typical of the times.

Dr. Elliott, a retired consultant from a London Hospital, purchased Woodlands sited at the rear of Fleet Parish Church. The house was staffed by three female servants, a housekeeper and, outside the staff consisted of a chauffeur, gardener and a labourer or under-gardener. This last mentioned person was a pleasant and well-built man, married and living in a small cottage in Connaught Road. His family consisted of five small children. His weekly wage was £1 15 shillings and his rent was 6 shillings and 6 pence per week. It was usual for such men to have a folded sack on the handlebars of their bicycles so that, if it rained, it could be used to keep their shoulders dry. I am afraid that a few vegetables from the employer's garden often surreptitiously got into the sacks. One dark evening in November, Harry Sayers finished work at 6.00 pm at Woodlands. Before leaving he quietly removed a loose air brick from the apple store. With two pieces of wood tied together somewhat like a row boat oar, he carefully removed three or four apples from the store to his sack. Confronted very unexpectedly by Dr. Elliott, he was told: "Tomorrow is Saturday. Get your wages from the housekeeper and do not come near this place again."

This dismissal was serious as work was scarce. However Harry was a keen and good sportsman in the local football team and cricket eleven. The Curate heard of this dismissal and begged Dr. Elliott to reconsider his decision. This was done, but in future the gardener always remained openly suspicious of his under-gardener.

Enlightenment

Many owners of large houses set a good example and treated their servants with great kindness; the Lathams of Lea Wood, the Jervoises of Tullamore and Peatmoor. Coachmen and gardeners living in tithe cottages were allowed to live out their lives in their employer's property. There were several instances, for example, The Beacon and Peatmore, where old

retainers were given their cottage homes.

Good intentioned persons made work available especially to help those on hard times. The owner of Brinksway, with a large garden from Connaught Road to Albany Road, employed several men for nearly a year, creating an undulating garden with a miniature lake and water garden. Mr. R. Cross, living nearby, at The Poplars, also created work in a similar manner. Several ladies of the 'better-off' made two or three walks a week to Home Farm at Elvetham to obtain skimmed milk at 2d per gallon. In two gallon tins, this was brought to Fleet, usually resting upon a pram or pushchair. Those in need were well known. Most churches held collections for the sick and poor fund and church district visitors made distributions of food or money to buy coal in winter. At the end of the 1800s a soup kitchen was held at the Albert Street Church Institute.

Rubber Factory Unemployment and poverty still existed. About 1885, Mr. James Richie moved to Fleet and built a house in Wood Lane, then Broad Street. He was a quiet but an efficient businessman, also a qualified engineer. He was extremely surprised at the unemployment and poverty, especially as there were not opportunities available for work or employment. He purchased land on the west corner of Kent Road and Kings Road and built a rather simple type of structure, single brick walls with a corrugated slightly sloped roof. There were no houses nearby and no council authority. Planning was something for the future. An horizontal gas engine with leather belts powered several small bench machines. There was a rough concrete floor, an outside water tap and two earth closets. About 20 persons, slightly more men than women, were given employment, several walked from the outskirts of Fleet. The factory, or the rubber factory as it was commonly named, manufactured and packed Sandow Exercisers. They were nickel-plated dumb-bells, each dumb-bell was in two pieces with a strong spring between. This was to strengthen fingers and wrists. The two dumb-bells were connected by a length of solid rubber about ½ inch square and just two feet in length. Stretched apart, this was to exercise and expand the chest. The finished article was packed in a cardboard box with the name Sandow Exerciser with a picture of Atlas holding up the earth and expanding his chest with the dumb-bells.

Endeavour A man from Pondtail had one daughter and the family lived in a cottage with an income which never exceeded £2 per week, including overtime and evening work. He had the joy of seeing his daughter properly dressed and shod. At 11 years of age she won a scholarship to a local Secondary School. On leaving school, a post was obtained in the office of the largest and most important Aldershot business. Before attaining the

age of 30, this daughter of extremely poor parents, who had never enjoyed a holiday, advanced so much with her work, that she succeeded in being appointed personal secretary to the owner of this large business. Her efforts were rewarded by her purchasing a bungalow for the comfort of her parents who were now elderly and retired. Soon a car was obtained and the family enjoyed many years of unexpected comfort.

The son of the man from Clarence Road, and in similar circumstances, left school at 14 years of age, and became a heavy lorry driver. With his wages he purchased the cottage where he was born and maintained his parents in comfort, far different from the continual hardship prevalent in his youth.

Craftsmen

Many adults born just prior to the building of the National Schools during 1870 and 1890, were unable to read and write. However, it is stressed that many of these people were most intelligent and from their own experience and in observing every day occurrences, were proficient in running their daily lives.

Plasterer During the 1920s I required a new house to be plastered. Eli Randall, a master plasterer from Crookham, employing two plasterers and a labourer, came and slowly walked throughout the house and gave a price for the plaster work. His final estimate was quite accurate. He said: "My price is for plastering X square yards of ceilings, Y square yards of wall surface and Z feet of external angles (chimney breast corners)." This remarkably accurate calculation was not written down. He told me he had never been to school, but could read and write and could estimate for work and pay his hired labour. Shortly after this experience, I attended a village wedding and during the evening festivities Eli Randall sang for nearly an hour, just like a Welsh bard or Hebredian reciter. The songs were all about pastoral life and occurrences. Only one song is remembered, it was *The Queen in her Golden Coach*. This may have been the Coronation of Queen Victoria.

Masons I met and talked to a Mr. Vincent and his son who lived at Hartley Wintney, and were usually employed by Pools. These two men were often required to assist other contracts upon different sites and were willingly loaned by Pools. Their education which ended at 14 years of age, could not have included any geometry or similar knowledge. 'Yet before my very eyes', with just a rule, straight edge, a set of trammel pins and bricklayer's lines, they showed me how to set out at actual size, elliptical arches, Norman arches, Roman arches and roof ribs.

Joiner A further instance of this hereditary knowledge occurred in 1924 when Dr. Greenish had a large house built opposite the Police Station. Fred Snuggs builder, obtained the contract which stipulated that *all* the work was to be carried out by local men. The staircase had a continuous handrail 'wreathed' as it changed directions. I tried to set up a model 'wreath' by using a City and Guilds book, but was not satisfied about the result. The stipulation in the contract which stated 'only local work' prevented the work being carried out by a neighbouring Joinery Works. It is hard to believe, but old Bob Froud, a retired joiner living in St. James' Road and at 90 years of age, came to the workshop (still in existence) in Church Road and with his trammel pins, lines and rule correctly marked out the blocks of wood. After roughly shaping, he came along with a set of home-made 'moulding planes' and beautifully completed the whole handrail out of pieces of English oak.

Bumper Two Fleet men who never went to school showed great character and determination. Sacky Dicker worked from daylight to dark walking from Pondtail to Fleet at 6.30 am. His clothes consisted of heavy corded trousers, sometimes called 'moleskins'. His boots were extremely strong leather with heels and soles shod with steel 'tips'. He wore an army-type flannel shirt with a moleskin waistcoat and a sack upon his shoulders in case of rain or snow. B. Cousins who lived in Clarence Road dressed in a similar manner.

These two men were known by a very old long-forgotten name, a Bumper. They were skilled in an extremely hard occupation making, mixing and carrying 'lime mortar' for the building trade. Before others arrived for work, they were busy forming an 8 foot ring of sand about 1 foot deep. Into this space was tipped several hundredweight sacks of quick lime which was fresh-burnt chalk in knobs, very similar to household coal. The lime was 'slaked' with many buckets of water and turned to a pure white soft jelly-like substance. The lime was kept moving by a 'larry', a great hoe shaped tool, which needed strong arms, and help from one knee. Eventually the lime and sand was ready as mortar for bricks or for the plaster for walls. They then carried the mortar wherever it was needed, sometimes up three stories of scaffolding and, after 5.00 pm, sufficient mortar was prepared for the following morning.

These two quiet men hardly ever entered into conversation but were always extremely polite. After work in the long hours of daylight, they cultivated their gardens for fresh vegetables and then offered to assist neighbours with similar work: if they were prepared to pay!

Chapter Nine
Churches

Non Conformists

Dissenters Their original place of worship must have dated before 1820. It was a timber-built room, situated opposite the Oatsheaf and the site is now part of Smiths Garage. The exact site was on the south-west boundary of Smiths on the south-west side of Fleet Road. The building was used by Dissenters from Crookham and Fleet, who probably met and practised a type of religion from Cromwellian times. Tom King told me that members sat around the table to talk, worship and read the Bible. Also, at their death the open coffin and corpse were placed upon the table and a continuous watch, day and night, was kept until burial. For many years Tom King had used the place as the first wheelwright's workshop in Fleet. The building was rented from the Firs Farm which had meadows from Fleet Road to the Reading Road canal bridge.

Ebenezer Chapel This chapel in Reading Road near the Council Offices, was probably the first brick and tile chapel built in Fleet. The Bible and furnishings may have come from the meeting house near the Oatsheaf.

Burial ground In 1890 the Dissenters agreed with the Baptists to establish a burial ground upon Victoria Hill. A corrugated iron-clad building, lined with match boarding and capable of seating 30 worshippers, was built at the west end of the site. Together with the Baptists, who built their own church in Fleet Road in 1892, they commenced burials. Previously to this, funerals had to be arranged at other churchyards. At that time it was said that Yateley Church was always willing to have burials from Fleet and certain parts of Cove. It must have taken a whole day for such a funeral procession consisting of a horse-drawn conveyance and *walking mourners*.

Those responsible for the Victoria Road graveyard subscribed together and a coach-built bier was made. This was 6 feet long and 2 feet wide with a flat top for the coffin. There were four wheels and a pair of handles in front, a pair at the rear. It was all beautifully constructed and is still in perfect condition. This bier was pushed through the streets followed by the mourners, all completely dressed in black. The procession moved at a very, very slow pace. Some shops and houses drew their blinds. Everyone stood still, men removed their caps. Any wreaths were carried by the mourners,

but wreaths were not too popular, really because many people were very poor. About 1890 a glass hearse could be hired from Aldershot and 10 years later John Kimber of Fleet bought a second-hand hearse. The chapel members and the Baptists and Wesleyans thought that the use of a glass hearse was just making an exhibition of a departed person and gradually, during the next 10 years, the bier was used less and less.

Wesleyan Church This was built in the early 1900s.

Methodists James Gillam, an ardent Methodist, lived in Fleet from 1840 to 1913 in Hurst Cottage, Victoria Road. He wished to establish Methodism in Fleet and worked unceasingly to forward its cause. During the 1880s he and his helpers purchased a piece of land on the corner of Fleet Road and Branksomwood Road (now Woolworths). They built a small timber building there to serve as a prayer meeting room, Sunday School and a committee room to push forward the building of a permanent church. Through Mr. Gillam's leadership, this was eventually built in 1889 on the corner of Branksomwood Road and Fleet Road. Mr. Pool built it and the masonry to the door, windows and corner quoins were the first work carried out by the Mardles family, who progressed from stonemasons to builders. The one and only memorial tablet in the Heatherside Methodist Church, records Mr. Gillam's lifetime's efforts for the church. His helpfulness was very varied. It was said that if any exceedingly poverty-stricken member of the church died, he and his carpenter son, who lived in Albert Street, would work together all night to make a coffin and with other church members push it on the bier to the Victoria Cemetery and properly commit it to the soil.

Catholic Church

A tiny Catholic Church built early in 1908 able to seat a congregation of 20, was at first not open every Sunday. By virtue of the teacher priests of the Salesian College at Farnborough, a priest would bicycle to and from Farnborough, to celebrate Mass. This was usually fortnightly, but soon Father Noonan either bicycled or, by a kind lift in a motor car, established regular services and parish dates. As Fleet developed this church grew and, so well was it established, with a growing congregation, that it was enlarged in 1934 and again in 1948.

Parish Church

The Church of England Parish Church, with its burial place was built in Church Road in 1862 by the Lefroy family and the Reverend Plummer was appointed the first vicar of Fleet. He purchased a large old house with a farm and called it the Church Parsonage (now Church Road Car Park).

The churchyard was bounded by a wall bank about 2 feet wide and 2 feet high. On top of this were low posts and rails constructed of 6 inch by 6 inch white painted timber. The single rail was set at an angle with a sharp edge at the top. The school-master's cottage, small and thatched, opposite the church was similarly bounded. The sole purpose of this fence was to prevent cows getting into the churchyard. The banks around the churchyard and along Church Road, all as described, were made from brick-sized shaped earthen bricks. These were dug or cut from unoccupied land after the heather was burnt off. The heather roots bound the clods together and parts of these walls are still in existence after 100 years. No-one can be found who can explain exactly how these clods or sods were obtained, or who built the walls alongside Church Road. Mr. Addison, who built and lived in the house (now demolished) next door to the hospital, found these banks most useful for mounting his high penny farthing bicycle. Choirmen often assisted him by giving him and the bicycle a mighty 'push off'.

Burials also began in the new churchyard. The church had two bells in a small belfry which rang a rather mournful 'ding dong'. When someone died, the appropriate 'knell' was rung to tell the population of the death. The bells were rung by a single stroke at one minute intervals. The message rung out told that a child, and either a man or a woman had died. Three times three for a child, then slowly, one stroke of the bell for each year of life. When a funeral procession came within sight of the sexton at the church gate, the bell was tolled at one minute intervals, until the cortege reached the gate.

Parish relief During the early part of 1900 and until 1914, Fleet became a quite positive religious community. Every endeavour was made to increase these activities. The Church of England carried out parish relief for the poor, a sick and poor fund with 'visitors' for the sick and needy, Sunday School for children with an annual outing and annual tea picnic, Bible Classes for boys and a Church of England Mens Society.

1914-18 War When the 1914 War began to have numerous casualties, this bell-ringing was not to be used for service casualties and local deaths, but it did occur, quite unexpectedly, when General Lord Kitchener was drowned. This terminated the old custom. The two parish churches in Fleet posted-up and contacted Crookham and Ewshot Camps with invitations to church-going soldiers to attend the Sunday Services. Ex-choristers were offered seats in the choir stalls. After the evening service, the soldiers were taken home by the members of the churches for light refreshments. The music and singing reached quite a high standard. The choir was augmented by musicians who seated themselves in the front

seats of the church. Suitable music was played for important occasions such as the loss of Lord Kitchener at sea and the loss of the *Lusitania*.

The first Sunday after the Armistice, on the 11th November 1918, the Vicar announced that after Evensong the organist, choir and orchestra would all form together singing appropriate hymns and end by the musicians leading the singing and playing the National Anthems of each of the Allies. There was great consternation as, after frantic searches, the music of several countries could not be found. Our quartet of musicians took umbrage and, as far as is known, never played together again.

Social matters After the death of the Rev. Plummer, the Rev. Preston established a fair sized regular congregation. He was exceedingly popular, always helping with village 'occasions' – cricket, church outings, fetes. Choir outings and Sunday School children treats were varied and popular. Mr. Preston moved to Old Alresford Church and, because he was so popular, some churchgoers cycled to Alresford for several Sundays.

Another outstanding vicar was the Rev. Pugh. He decreed that Evensong on Sundays should end at precisely 7.15 pm, thus enabling choirmen and boys, especially those from St. Phillip and St. James Church, to arrive at the new vicarage by 7.30 pm for half-pint of beer or coffee for the men, lemonade and an apple or orange for the boys. Local matters were discussed with the vicar. Just before 8.00 pm the vicar thanked everyone for their assistance that day. This was a signal for all to leave and disperse.

The Parish Church was enlarged in 1934. Church services at both churches were well attended. The Rev. Waller filled the Kings Road Church. He was a great mixer with men. He played regularly for Fleet Football Team and travelled to away matches with the team players. After Evensong on Sundays, he went straight to the Fleet Social and Bowling Club for an hour's bowling and half pint of beer. He was well known throughout the whole of Fleet.

Master carver George Parsons was a master carver who spent most of his life working at Westminster Abbey. He carved a pair of doors for the Abbey which took four years to complete. He was regarded as amongst the finest wood carvers for the church and had photographs of eagle lecterns and many other wonderful pieces of craftsmanship.

In 1921 I visited the Dissenters building with George Parsons. We were looking for seasoned pieces of oak. Tom King showed us a very large oak table top leaning against a wall. George Parsons and I managed to convey this great piece of timber to his house in Pondtail Road. He, with a little minor help from me, cut the table top to size and in three months carved a most wonderful nativity panel for the altar of St. Phillip and St. James

Church, Kings Road. We revisited the now derelict building and took away a 5 foot main entrance door sill. From this timber we made a sanctuary bracket for the bread and wine for the same church. The shelf of the bracket was supported by a carved bunch of grapes. I remember this bracket shrinking and it had to be reglued together.

I recently visited the Church of St. Phillip and St. James in Kings Road, now moved nearer to Pondtail. There, the beautiful panel was hung in the entrance porch, and was very much in a drying-out stage and urgently needed waxing or a linseed oil feed.

Conclusion There have been several vicars and curates for the Church of England Parish Churches. One had a motor car subscribed for use in the parish, but he soon moved on with the car! Another elderly and white-haired vicar married a very young woman. One who moved to Bath had the guy on the bonfire named after him because he was so 'down to earth' and 'Low Church'. Together with the rapid growth accelerating after the last war, enlargements to and new Christian churches were built throughout the Fleet and Church Crookham area. However, the established Church of England, although also increasing, together with the other denominations, still does not predominate over the worshippers.

Bands

For years, previous to the 1914 War, 40 to 60 Boy Scouts with their four kettle drums and 12 bugles, marched from their headquarters in Albert Street to the 11 am service at St. Phillip and St. James Church in Kings Road. They were led by their first leader, Colonel Bainbridge, followed by his coal black batman 'Suddy'. Later, the Rev. Aspinall took charge and, in full and correct scout uniform, led the troop to church. This monthly church parade continued until the 1914 War.

Fleet Town Band, started by Mr. Parnell, was a public concern, but the Wesleyan Church formed a 40-member brass band with navy blue uniforms and silver braid. On Sunday, this band marched about during the evening, arriving at the Wesleyan Church at the corner of Branksomwood and Fleet Road in time for the evening service. The Baptist Church (beside the footpath from the car park) in Fleet Road flourished with a goodly congregation.

From 1900 to 1914 Fleet was quiet and traffic-less. The members of the Baptist Church used the Sankey and Moody Hymn Book and, led by their American organ, they put their hearts and souls into their singing. In the summer, with the doors of the church open, the hearty singing could be heard at the Oatsheaf crossroads.

The Salvationists also had a small brass band with about a dozen musicians, together with two or three lady tambourine players. Every

Sunday wet or fine, the band, all in uniform, marched about the streets of Fleet. This occurred both in the morning and the evening (afternoons in the winter). The band played a marching tune between stops. At each stop two verses of a hymn were played, then people were exhorted to attend service at their church, The Citadel. A further two verses were played and sung and the band moved off. They planned to play in every road in Fleet during a 12-month period.

After the 1914 War, several well-known retired Army officers often went to The Citadel and, during the morning or evening service, read a portion from the Bible. This was in recognition of the tremendous, almost front line, war service of the Salvation Army. Major Debenham was the last serviceman to attend these services.

Apart from the churches, hardly a Sunday passed by without a street corner exhortation to salvation by a saved and converted preacher. Every Sunday, exactly at 6 pm, outside the Oatsheaf, Mr. Tom Wilkey, dressed in sober black and with his Bible under his arm, preached salvation for half-an-hour. Rain and snow did not ever deter him.

The Institute

Just before the end of the 1800s, a very rich old lady gave a large brick and slate bungalow in Albert Street for the use of Fleet men and boys. Someone gave a full-sized billiard table and others contributed books for a library. Several well-meaning men, mostly church men, organised and kept it open from 7.30 to 10.00 pm. In the winter, the gas lights were lit and also fires to warm the place. A Slate Club was run for the benefit of members. Upon this site, retired Army officers had built a 20 foot square room for the Boy Scouts. Colonel Horniblow, in thanks for electing him a member and also Chairman of the first Fleet Urban District, built and gave a 30 foot square fully equipped gymnasium.

The lady who donated the now-called Institute, left Fleet to reside at Netley in a large house called Dew Ponds. She sent for my father when she was 90. I went with him. She was concerned that the Institute should continue. As there had been no District Council at the time of her donation, she had made the Church of England of Fleet Parish, trustees. Alas, the Church of England sold the site and the buildings thereon and kept the proceeds. I wonder what is now done by the local Church of England for men and boys who are not church members?

Chapter Ten
Fleet Schools

Early Schools
Dames School The very earliest inhabitants of Fleet whose parents wished their children to be able to read and write, sent them to a Dames School of which there were about three in Fleet and Crookham. Two elderly people, Mr. Arthur Voller and Mr. William Page, told me: "When I was a small boy the charge to attend the Dame School was 5d per week for the first child in the family and 3d for each other child." Slates and slate pencils were used until children were really capable of using a Copy Book, copying the first printed line of lettering onto the line below. The last Dame School was run by Miss Jones in the front room of a cottage in Fleet Road and several pupils who attended her school are still alive. Miss Jones did not take pupils over 12 years of age.

Methodist School As the National School had not yet been built, Methodists let their meeting room in Branksomwood Road for Miss Pickings to establish a school for local children, who paid a small sum of money each week. Miss Pickings spent many years of her life efficiently running this school with a daily attendance of about 20 boys and girls.

Church of England Schools
Fleet Parish Church in the now Church Road provided by the Lefroy family was completed about 1862. They were very surprised to find that the only local school was run by a dame in a tiny cottage. Mr. Lefroy purchased two incomplete cottages nearby the new church. The party walls were demolished and classrooms arranged. He also arranged for a schoolmaster, Mr. Ames, to live in a tiny thatched and whitewashed cottage opposite the church. Mr. Ames annual salary of £90 was paid by Mr. Lefroy and not the parish. His first assistant was Edwin Edwards, 16 years old. Soon there were nearly 60 children to be taught.

The building of the Fleet Parish Church and the local Methodist Church soon brought forward a body of well-meaning people who wished to see that *all* the children of the district were taught to read, write, and know a little arithmetic. Representations were made to the County Council at Winchester.

National School The Vicar of the Parish led the delegation and it was eventually agreed that the County Council would build a school. It was further agreed that the Church of England should have the right to sit on the committee selecting the teachers. Also that the Bible and the Prayer Book should be taught for the first hour of each school day. This concession was subject to the Church of England maintaining the exterior of the building and carrying out minor maintenance work, including the exterior painting. No other religion was to be allowed. Thus in 1884, the building of the Fleet Church of England National School in Albert Street began and two years later the education of the children of Fleet who were between the ages of five and 14 years commenced.

About 90 children attended the school after it was opened. School hours were 9 am to 4 pm. Boys and girls between the ages of 11 and 14 years were reluctant to go – many were obstinate, others were already earning a little towards their family upkeep. Some poor parents did not propose to lose the small contribution made by their working children. Such views were not confined to Fleet as more and more schools were being built throughout the county. It was eventually agreed that if by the age of 11 a boy or girl could read, write, and do simple arithmetic, including the use of money, they should deem to have passed the 'Labour Exam' and could leave school and go to work.

Attendance Officer Others, resentful of the daily discipline or by sheer obstinacy, stayed away from school. In Fleet a retired policeman was appointed as Attendance Officer. In 1890 there were very few bicycles, so he walked about the district often using a walking stick to poke and threaten truant boys. At that time boys who played truant, stole from orchards or shop displays, could be 'hauled' before the Aldershot or Odiham Court bench and persistent wrong-doing resulted in a sentence of so many 'strokes of the birch'. Perhaps this was because a fine could hardly be imposed upon an extremely poor family. It was several years before the Headmaster found that children from such faraway places as cottages along the Canal bank and cottages in woods and farms had never been to school. The school became part of children's life and girls and boys reluctant to attend, soon enjoyed going to school and making friends. Singing lessons and elementary physical training all helped and the rising number of pupils soon warranted a staff of about eight teachers.

Penny Bank Some Vicars insisted that their Curates assisted with the expounding of religious knowledge while Church of England officials helped in a very minor way by organising a Penny Bank. Each Monday pupils brought a few pence for savings. Pay-out was at Christmas. The Church paid a magnificent interest of two-and-a-half per cent on

maximum savings of £5 per child.

Roads The roads to the school were rough and unmade and often exceedingly muddy in winter. The Hepper children walked from Minley Gates to school in an hour, carrying a very light lunch, and after school hours at 4 pm walked home again, a distance of nearly four miles. Those from Pondtail and Velmead took about 35 minutes. Other children, some very young, walked from Sankey Lane near Bramshot Bridge to the school in Albert Street. As many people in the last century did not have clocks, the school bell was rung for 10 minutes before 9 am so that no child had an excuse for lateness.

The school had opened in 1886, but Fleet Council was not formed until 1904 and the roads not made up until 1908. With the building of the roads came storm water drains, but before this the corner of Church Road and Clarence Road was flooded each winter for many weeks, with water 18 inches deep. However, in those days there were lots of vacant building sites locally called 'Commons'. Crossing over these open sites allowed children to arrive at school with almost dry feet.

Fleet gradually increased in population with 200 children attending the National Schools and it became necessary to build a new Infants School facing Church Road.

Boer War When the Boer War was over, there was much excitement and jubilation. Fireworks were banging away and the school children all wanted to possess a Union Jack flag to wave about on a stick. Colonel Horniblow from The Views presented a large flag-staff to the school. This very large heavy standard 40 feet high was erected in its permanent position in the centre of the school square (facing Albert Street). Not to be out-done, the Ladies of the Church purchased several flags. There were 3 flags about 6 feet by 4 feet each. One was the Union Jack, another was the St. George's flag and the last bore the cross of St. Andrew.

Jackie Buchanon and Queen Mary At the east end of Elms Road was a small four-roomed bungalow in a very poor state of repair. At that time it stood quite alone as there was no development nearby. In this bungalow lived the family of Buchanons, Mr. and Mrs. Buchanon and three small children of school age. Jack Buchanon, as he was named, was a heavily-built burly man. He always seemed to be drunk and in a vicious temper. The family was poverty stricken with meagre food and almost ragged clothing. During one severe winter the man came home, the worse for drink, to find that there was no fuel or fire in the house. A passage ran through the house from front to back with doors at either end. In a fearsome drunken rage both exterior doors were torn down, chopped to

71

pieces and burnt in the fireplace.

The family continued to exist in these fearsome conditions. The oldest child was a girl nearly 14 years of age, the next was a boy of 12 and the youngest, named Jack was 11 years old. He was born with tiny legs making him a dwarf in stature, his arms stopped at the elbows finishing with a thumb and one finger to each hand. In all weathers these small children walked from Pondtail to Albert Street School, young Jack taking twice as many steps to the others, but always keeping close to his brother or sister.

At the school prize-giving dignitaries from the Church and Council were taken to Jackie's desk. At 11 years of age and with only one finger and a thumb, his writing was perfect manuscript with correct flourishes, thick and thin pen nib writing to each individual letter. A Christmas card that he had produced, painted either with his two fingers or with the brush held between his lips, was much admired. One of the prize-giving dignitaries asked for both items and put them in his pocket. The boy was asked his age and birthday.

When about to leave school at 14 years of age, a letter arrived from London addressed personally to Jackie. It was from a firm producing Christmas cards, probably Raphael Tuck. Jackie was informed that his fare would be paid if he would accept the firm's offer of free maintenance and apprenticeship to learn to be an illustrator for Christmas cards. The offer was accepted and the tiny crippled boy left home and nothing was heard about his progress for a year.

During the following year, the Fleet schoolmaster received a letter from the dignitary who had taken away samples of the boy's schoolwork. The letter stated that the firm was astounded by Jackie's ability. They had written to Queen Mary showing cards produced by the deformed boy. Queen Mary then wished to interview Jackie and told him what she desired for the Royal Christmas cards for the following year. He designed the cards which were royally approved and the firm duly executed the royal order. The firm was requested to send Jackie each year to Buckingham Palace to discuss designs with Queen Mary.

Scholarships

The only outlet for FREE additional education was by charity scholarships. The examinations for ability were held each year and Fleet School usually succeeded in obtaining about six places at Robert Mays Grammar School in the neighbouring village of Odiham. Successful scholars usually cycled the four-and-a-half miles to school. Pre-1914, tarmacadam was only used in towns and cities so the local roads were all gravel, with the top surface pounded to sharp grit by horses and heavy vehicles. In those days the bicycle tyres of scholars cycling to Odiham seldom lasted more than one term.

Private Schools

The population of Fleet has always been rather mixed as at that time there were nearly as many large houses as there were smaller ones. Because of this there was, and still is, quite a good section of the children attending private schools and paying fees for their education.

The first private school for the children from the larger houses was run from the first house in Elvetham Road (east end). The entrance to the school was by a small drive alongside the Station Garage. The entrance is still there, but the grass paddock at the end of the drive is gone. The children gave plays and were taught classical dancing during good weather. The paddock was an essential part of the school.

A Miss Gowan ran a small purpose-built School Room in Kings Road with about 20 pupils.

After the death of Miss Pickings, whose school was in the Branksomwood Methodist meeting room, two sisters, the Misses Ward, started to run a school in a fairly commodious house in Branksomwood Road. This house has been demolished to make way for Branksomwood Doctors' Surgery. The Misses Ward ran the school for about 24 girl pupils for 20 years, but was closed due to the death of one sister.

Within a year or two, in the same road, Miss Pritchard and Miss MacKensie opened up one large house for a girls' school. This school developed and grew until neighbouring large houses were taken over. This school, named St. Nicholas', is now 50 years old and is currently educating 450 girls.

As well as these schools several persons, usually spinsters, advertised for pupils to be taught to play the piano and to sing. Some ladies also taught deportment and French.

Mr Eric Stevens

During 1917 Mr. Eric Stevens was a Science Master, qualified with a BSc degree, teaching at Odiham Grammar School. He lived in a pleasant house near the north-east corner of Kent Road and Avondale Road. He was of medium height and very non-aggressive. Finding the cycle ride of four-and-a-half miles to school and then a similar return journey physically too much and very tiring, he purchased a small *open* two-seater motor car named *The Chatre Lea*. After using the car regularly for a couple of terms, he arranged with Mr. George Stratton to convey his daughter, Stella, to and from school. This arrangement continued for quite a while but one day, upon arriving at school with his pupil passenger, he found that the girl was dead. He remembered that, when passing over Dogmersfield Canal Bridge, two racehorses were acting nervously and came very close to the car. A curved bruise, found on the girl's forehead, could only have been caused by one of the horses. Mr. Stevens was so upset that he resigned his

teaching appointment and quickly sold the car.

Eriva Dene School In 1920 he and his wife, Eva, also a qualified teacher, purchased a suitable building and opened a private school beside their home. A combination of his wife's Christian name and his own was used to name the school *Eriva Dene School*, which soon had as many pupils as it was possible to accommodate. When new pupils were enrolled, both scholar and parents were told that aggression was not allowed and any trouble meant that a pupil would be instantly dismissed. The school flourished with a full complement of scholars. Many passed the Eleven Plus and moved on to Secondary Schools and quite a few seniors qualified with A Level ability.

Retirement As retiring age approached, Mr. Stevens closed his school. He was the only child born to his parents. His father died early in life and his mother lived a very frugal existence. Seeing his mother getting a little frail, Mr. Stevens used savings to build two small villas in Fleet Road and quite near to Tavistock Road. His mother occupied one villa and a Methodist Minister the other. Mr. Stevens continuously attended to all his mother's wants until she died aged 92. Nothing was known about the family affairs and Eric Stevens and his wife Eva were shocked and astonished to find that they were extremely well-off.

Soon Crookham House, once the residence of Sir Richard Morton, was bought by Mr. Stevens and converted into Crookham House Hotel. He then purchased Millbank in Kent Road and converted it into a retirement home for about half a dozen elderly ladies. This was given free of payment to continue to the benefit of deserving persons.

Mr. Stevens continued with property dealing and, with a partner, purchased The Beacon and changed it from a residence to a hotel. Like his mother he died at 92. He said that he hoped to leave a quarter of a million pounds to his favourite charity. He did leave his housekeeper his residence, but any legacies remain a mystery as he had never had any children or near relatives.

Award It was never known that Mr. Stevens, seeing the training of troops at night and using star shells or Very lights just beyond Pondtail Bridge, had given much thought to the short life of the star shells. He evolved a formula, including gas mantle material, and sent it to the War Office. The formula was successfully used and Mr. Eric Stevens received a letter of thanks and a medal for his aid to the war effort.

Chapter Eleven
School Memories Early This Century

The Church of England school in Albert Street, now sadly to be demolished, had many features so out of date, that in modern times many will not believe the circumstances in which thousands of local children received their schooling.

Classrooms Each classroom was large enough to accommodate 40 children and had a window measuring eight feet by eight, thus there was plenty of light and ventilation, but also a feeling of cold in the winter. There were no ceilings in the school, the underside of the roof rafters were plastered giving an average height of twelve feet. Each classroom was heated (?) by a circular cast iron Tortoise stove standing in one corner. The fuel was often damp coke which in rough winds filled the classroom with smoke and sometimes the fire went out, not to be relit until mid-day. Each teacher had a thermometer and if the room was too cold it was reported to the Headmaster ... nothing was done! Each class usually had one or two 'sickly' children ... the teacher sat them near the stove because the far corners of the classroom were only just above freezing. The children were seated in heavy eight foot long desks with cast iron supports on a seven inch wooden seat, some of the desks (?) had no backrests. Five children sat in each desk and shared three china inkwells in the woodwork. The bare floor was scrubbed (?) and the walls contained one large map and other similar hangings.

Water and lighting There were two porches, one for the girls and one for the boys. Each porch had 60 hat and coat hooks and also a slate slab with two tiny white enamel wash-basins. There was always a piece of carbolic soap and a coarse roller towel which was changed each Monday morning. The porch doors were always kept open as children from a distance had to eat their mid-day sandwiches in these cold places. The classroom doors were closed during the mid-day break. The 'toilets' were situated in the playground and about 50 yards from the main building. The boys had a cement wall and gutter and three 'closets' – galvanised buckets with wooden seats. The girls had just six such receptacles.

Miss Bennet a benevolent lady from Stockton Avenue, had a nice house built beside the school in Albert Street. This house was let to the school caretaker and cleaner at a nominal rent. A deep well for water was dug and fitted with a large cast-iron pump which had an iron ball about 7

inches in diameter on its handle. Each morning before school began, several big boys filled light galvanised buckets with water pumped from the well and carried them and placed them in a row beside the school building. From 1884 until 1912 this was the only supply of water to the school. In 1913 mains water was connected and each porch had two taps of cold water to the wash basins.

In those days, in the winter, school work finished if the daylight was too poor for lessons. In Fleet, the laying of water mains was followed by gas mains and the school was fitted throughout with gas pipes to each classroom culminating in *one* wall light with a gas glass globe and mantle to each room. Now for the first time in Fleet, the school was available for parish meetings, for local and parliamentary meetings and any other local congregation. With the Church and its School, Fleet for the first time became an active community.

Clothes Children were poorly clad, but efforts were made for them to be dressed and washed for school attendance. Girls of all ages wore cotton or woollen vests, cotton petticoats and knickers to the knees with elastic to keep up stockings, and heavy black shoes. Girls from 12 to 14 were well-dressed by parents, but the environment was always dusty and never clean. Pinafores were worn over their frocks by the 'big' girls. These home-made pinafores became a source of envy amongst parents and ended up being almost dresses with pockets, pleats, 'goffers' at the shoulders and belts with buckles.

The boys wore heavy, long-lasting suits of serge. Jackets were made with several pockets, small boys trousers came below the knees. Bigger boys wore 'knickerbockers' ending below the knee with an edging containing a button and buttonhole. Several smart big boys sported 'Norfolk jackets'. Small boys in the summer wore a washable striped blouse with a sailor collar. Because of the rough unmade roads many boys wore replicas of men's 'working boots', thick uppers, heavy soles with hob-nails and steel tips at toes and heels.

Illness If well-fed and healthy, nearly all the children were happy and absorbed in their daily life and schooling. Alas, this was not always the case. Serious illness terminated the lives of many children. Damp clothes, wet shoes, school windows closed to keep out the cold, caused not one, but many epidemics. The earth closets also probably helped spread infection. Measles often caused such absentees that school sometimes closed for a month. Scarlet fever terminated the lives of several children. Mumps and whooping cough were very common and unpleasant. Diphtheria was dreaded and also caused several deaths. Consumption did occur, but the occurrences were very few amongst children.

Miss Clotworthy This teacher nearly forty years old, taught the nine to ten-year old children. She was a tall, thin person who often walked about the classroom in a silent manner. In her right hand she always held a short stick, just less than two feet long. On the end of the stick was fastened a small cotton reel. The front rows of desks were for the boys. Girls were further back in the classroom. On one particular day in the front desk sat Fatty Goddard, with his hand hiding his face, he whispered something to his neighbour and whilst he was still grinning, the teacher silently stole up behind him and banged him sharply on the top of his head. Quickly the boy stood up. He said, "I don't like it here, I shall kill myself". He prized the small china inkwell out of the desk and drank its contents.

Lessons The five-year old children were seated in 'modern' chairs two to a small table. From the blackboard they were taught to recognise the letters of the alphabet and figures from 1 to 10. Towards the end of their first year *The Lords Prayer* was learnt. I remember my first day at school. I was brought up with five brothers and I gazed in wonder at girls with light blonde hair, also girls with curly hair and long 'pigtails' tied with ribbon. Many new-comers like myself fell asleep and were not disturbed. Several five-year olds must have walked more than a mile to school. We were not told about the toilets, so when I explained my need, I was pushed outside the door and the door closed. I wandered about and after 15 minutes was found by a teacher in the girls' porch. The exterior door was ajar and I pointed and said, "Is that the way home"?

The most enjoyable lesson was when the teacher read a story. I can only remember *The Water Babies*. Little games were played in the classroom and it took some time for shy boys and girls to come together and eventually learn names and mix together for the first time. As schooling progressed from year to year, one learnt the meaning of counting one to ten. Most important, we were shown coins of the realm and their names and values. At six years of age, ruled 'copy books' were used for handwriting the alphabet and to write your own name. We were also taught to sing. The teacher pointed to a large sheet of paper hung on the blackboard and we learnt to sing the scale of C as we saw the signs. Doh, Rah, Me, Fah, Soh, Lah, Te, Doh. At seven years of age we learnt *Men of Harlech*, *Sweet Lass of Richmond Hill* and *The Grand Old Duke of York*. Of course, the most important and regularly sung was the hymn *There was a Green Hill Far Away*.

From 7 to 10 years of age the following lessons were learnt. The WHOLE CLASS RECITED – QUITE LOUDLY, all 'The Tables' from 'twice one are two' – and up to twelve times twelve, the dates of accession of the Kings of England from Alfred the Great, the capital towns of the countries as they were known them, for example Russia – Moscow:

France – Paris: Spain – Madrid, etc.

At ten years of age, pens with steel nibs were handed round from a jam jar and writing and figures were written in copy books. Much time was spent over handwriting and good results were regularly praised.

Exercises I cannot remember the girls ever having any form of exercise, but once a week, boys of more than eleven years of age were marched to the playground for DRILL. (Although not in bad weather). A tall well-built man, correctly dressed in a suit and with a walking stick with a silver knob (Army issue) arrived in the playground promptly at 10.30 am. This was Sergeant Major Pearson (retired) who lived at the far end of Aldershot Road. Drill commenced. Two lines of boys – arms extended sideways for space. PROMPT SHARP COMMANDS "Arms up, down, sideways. Attention. Bend forward. Bend to right and left. Mark time. March in both directions – if very cold double around in a circle".

Sewing While boys were at drill the girls were occupied with sewing lessons. Each girl brought to school needle and white thread and a white piece of material, about handkerchief size. The first exercise was to sew together a hemmed side.

Exercise One – correctly fold then sew

Exercise Two – unpick

and so on until a correct hem was sewn with very fine stitches. This type of exercise was repeated and repeated. There was no other sewing lessons, but older girls sewed a buttonhole to match a white linen-covered shirt button.

Jack Baggot As a boy of 11 born and brought up at Springfield Lane, Jack picked up a baby jackdaw and not only reared it, but taught it to talk. It often followed the boy to school. During physical exercises in the playground, the jackdaw could imitate Sergeant Major Pearson's commands. The bird could not be sent away because it perched on a high fence or tree. Boys enjoyed seeing the Sergeant Major approach the jackdaw waving his stick. Bird and man turned away from each other and 'Jack' flew home to Springfield Lane. Boys marched back in to school for their lessons. It also made a habit of standing in a high open fanlight of its owner's classroom. It distracted the children's attention so the teacher threw chalk at it until it flew away. One day, when the master was at the rear of the classroom, the bird flew in and picked up chalk from the master's desk, flew to the fanlight, paused and then dropped the chalk on to the open ground.

Empire Day The 24th May was known as Empire Day. Before lessons, all the children were assembled around the flag. *Land of Hope and Glory* was sung by everyone. Colonel Horniblow spoke about the glory of the British Empire. After the speech everyone sang the National Anthem whilst two big boys slowly and ceremonially hoisted the flag. I do not remember it ever raining on that day. Not to be out-done by Colonel Horniblow, Mr. Levenson-Gower, the first MP for this and the Aldershot Parliamentary Division, presented a 'Giant's Stride' for the boys' playground. This was a great post about 12 feet high and 9 inches thick. Near the top of the post was a loose circular iron ring which could be freely moved around. From this was hung about 8 chains with heavy 2 inch by ¼ inch thick links. A circular patch was asphalted around the post. Big boys grasped the chains with their arms above their heads and galloped around as fast as possible. Soon they were swung off the ground and were flying through the air. Alas within 6 months a boy's arm was broken. A few months after that another boy broke his leg so all the chains were taken away. The centre post remained forlorn for many years.

Coronation Day On the Coronation Day of King George V and Queen Mary in 1912, almost every child in Fleet and Church Crookham was entertained to a wonderful tea party. After tea the evening's entertainment began with Punch and Judy followed by the Yateley Bell Ringers who played the then popular school songs. After ringing out the tune it was played again and the children joined in singing the verses. At the conclusion of the tea and entertainment each child was presented with a Coronation mug. These mugs were quite good quality and somewhere my mug is still to be found in existence.

Religion There was much emphasis on the fact that this was a Church of England School, chapel children were tolerated, not so Roman Catholics. For many years the Vicar, or more often his Curate arrived at the school at 9 am. After the register was called, any class from 11 years old on, were taught and questioned about the scriptures and Prayer Book. Several children from Catholic homes brought letters to school protesting against their children hearing Protestant views. I regret to state that one fanatical curate, before giving religious instruction said, "All Roman Catholic children will leave the room and stand in the porch until after my lesson". Thereupon these children were sent out of the classroom without any occupation in cold draughty porches, summer and winter.

At certain Festivals: Easter, beginning of Lent and Christmas, all the children walked in pairs to the Parish Church for a service. This occupied the time until 11 am and the children enjoyed the outings with much chattering on the way to and from the church and school. Before the

'breaking up' for the summer holidays, the vicar and church dignitaries came to the school for the presentation of scripture certificates. These stated that Jenny Woods, aged seven, could say the Lord's Prayer. Those aged 10 had to recite the Ten Commandments. Older children would repeat the Catechism! A Christmas prize-giving was held at Fleet Church of England Schools, probably the last time this occurred was in 1918. At one time a copper piece, like a penny, was presented for good attendance. It was inscribed *Fleet Church of England School* and on the obverse *Never Absent Never Late 1902*. The caretaker lived next door to the school and her daughters always received these tokens!

Before the end of the 1914-18 War, there was much emphasis on church-going and Sunday School. For example an annual Sunday School tea was held in the field by the Parish Church. An apple and an orange were given to each child to take away after tea. There were annual outings in horsedrawn wagons to Odiham Woods, near Broad Oak, or by barge on the Basingstoke Canal to King John's Castle. It took about three barges full of children and teachers. After a picnic tea by the castle ruins, there was a slow return with a horse pulling each barge. As the barges approached Reading Road Bridge, many parents and onlookers stood awaiting the return of the children. The children always sang together to an accordion accompaniment as they approached home.

Local newspaper report 1920 'An outdoor singing concert by the senior girls of Fleet Church of England School was much appreciated by quite a large audience.

'At that time there was nothing for the boys, no football or cricket. Just Hoops, Tops, Conkers and kicking tennis balls about.

'No bicycles for children until 1920.

'From a generally dubious state of health, matters are much improved. No child sent home with 'nits' in their hair. Hardly any epidemics of measles and whooping cough.'

Chapter Twelve
Harold Maxwell Lefroy

The Lefroys were Hugenots who left Cambrai, France in 1587 to escape religious persecution due to their Protestant faith. They settled in England, eventually inheriting Itchell Manor, Crondall in 1818. The important part played by the Lefroys in Fleet Parish Church and the Church of England School has been covered.

Harold Maxwell Lefroy born in 1877 was the fourth son of Charles James Maxwell Lefroy, squire of Itchell Manor and head of the English branch of the Hugenot family of Lefroys. In his too-short lifetime, this brilliant practical scientist, pioneered studies of insects and their impact on mankind and his wooden structures. He gave outstanding service to the nation in the 1914-18 War.

As a boy he was fascinated by insects he found around Crondall. He gained a First Class Honours in the Natural Science Tripos at Cambridge in 1898. This and his fascination with insects, led to a brilliant career as an entomologist. First in the West Indies he studied tropical insects, provided advice on insect pests, developed suitable insecticides, identified useful insects which should be encouraged to prey on pests and so minimise attacks on crops and cattle. Next in India, he was appointed Head of the Entomology Research Institute whose staff, under his guidance, significantly reduced insect attacks on staple crops. He compiled *Indian Insect Life* which still remains in print.

However in 1910 he reluctantly returned to London following the death in India of two of his children from fly-borne diseases. He did not wish to risk the life of his remaining son. In 1912 he was appointed Professor of Entomology at the Imperial College. He spent his weekends searching the woods around his old Crondall home for insects for his show cases as in 1913 he was appointed Honorary Curator of the Insect House at the Regent's Park Zoo.

His reputation and knowledge of insecticides meant that his advice was sought in 1913 on how to deal with attacks of the death watch beetle to the roof of Westminster Hall. This problem was studied by a committee, but no solution was found and it was disbanded. Lefroy's studies into this problem were interrupted by the outbreak of war in 1914. He advised the War Office on the control of lice and flies affecting troops' fighting qualities. In 1916 he was gazetted as a lieutenant colonel and went to Mesopotamia (now Iraq) to study the serious fly problem under field conditions. On completion of this task, he returned to England. He went

to Australia in 1917 to investigate the weevil problem affecting large stocks of grain awaiting shipment to Britain. His solution was a better stacking method and the application of heat by special machinery.

With the end of the war in 1918, he returned to England and with zest continued his search for a solution to the death watch beetle menace. At that time knowledge of these beetles was practically unknown and he studied their habits and life cycle systematically. He developed an insecticide which penetrated the wood and destroyed the eggs laid in wood crevices and the beetles as they emerged from their bore-holes. His first insecticide was toxic, but he developed a safe solution which when sprayed on to the timbers permeated all the crevices and burrows. This was successfully applied to the roof of Westminster Hall which was re-opened by King George V and Queen Mary in 1923.

Soon his help was widely sought to eradicate death watch beetles or woodworms from old buildings. Farnham Church was one of the many buildings on which Lefroy was consulted. Initially his fluid was known as Entokill, but there were objections to this name and it was patented in 1924 as Rentokil which he marketed with his assistant, Miss Elizabeth Eades. Never physically strong, his health began to suffer due to overwork, but as is common with dedicated people, he refused to ease up. He persisted in experimenting to find a gas to destroy flies, but was overcome by fumes in his college laboratory and never recovered.

After his death in 1925, Miss Eades continued to prepare and sell Rentokil commercially to architects, builders and later the public. The business grew and prospered and was bought up in 1960 by a large company specialising in pest control. Because Rentokil was so widely known and respected, the name was adopted by the company. Sadly Harold Maxwell Lefroy did not live to benefit from his pioneer work in the control of timber pests. However his memorial is part of our heritage in the preservation of countless fine centuries-old timber constructions which continue to enrich our lives.

Chapter Thirteen
Cricket, Entertainment, Guides & Scouts

Cricket

During 1865 the Rev. Plummer, first Vicar of Fleet Parish Church, was often seen walking and visiting members of his congregation. He was a well-known figure, short and stout with his long white beard contrasting his dark clerical grey clothes. At that time there was no organised football or cricket, although the gentry often enjoyed tennis and croquet. The vicar gave much thought to the absence of any public organisation of sports in Fleet.

First Cricket Pitch Rev. Plummer kept two Jersey cows opposite the old Parsonage (now Church Road car park). His fields stretched along Church Road and Fleet Road for about 200 yards past what is now Birch Avenue. Rev. Plummer, with help from the choirmen, formed a cricket team. The vicar supplied a set of wickets and bails. A little later Woodlands was built behind the church and the occupants, the Misses Watsons objected to the noise, so the cricket pitch, and now a football pitch with goalposts, were moved away and re-erected in the meadow on the west side of Birch Avenue. The games could be watched from Fleet Road. Bill Wake, a builder, was the first football captain.

Cricket matches were a fairly regular occurrence, especially interesting games were those against neighbouring teams such as Elvetham and Hartley Wintney. The Fleet team usually consisted of about eight local working men; also included were visitors of note and one or two choirmen. There were a few regular spectators who, if the sun shone, divested themselves of their jackets which were rolled up and used as cushions on top of the sharp edge of the churchyard railing. Rev. Preston, who followed after the death of Rev. Plummer, boosted most of the cricket matches insisting that any good cricketing public school boys be given an opportunity to play.

The Beeches About 1880 the cricket played near the church petered out. Mr. Bloore, who lived at the house and farm known as The Beeches (now North Hants Golf Club) had three sons who were keen cricketers; he organised regular summer fixtures to include his sons and local men.

FLEET REPORTER ½d.
September 1893

Fleet

J. King c Phillips b Baldwin	4
H. Holland run out	4
Bell b Kitchener	19
S. Griffin c Groves b Kitchener	15
A. Andrews c Groves b Baldwin	26
Barker c Choules b Baldwin	0
Faulkner c Groves b Baldwin	16
W. Blore c Baldwin b Dr. Maturin	1
E. Page not out	7
W. Goddard lbw Kitchener	0
Griffin b Kitchener	0
Extras	27
	119

Royal Engineers

Corp Headland b Griffin	1
Sap Bird st W. Goddard b Faulkner	11
Lieut Ratcliffe st W. Goddard	7
Cpl. Kilburn b Griffin	11
Lt. Lee b Griffin	0
Sap Purdis b Griffin	0
Lt. Mansfield b Griffin	1
Sgt. Crack b Griffin	7
Cpl. Hawkes c Goddard b Griffin	0
Sap Coil b F. Page	1
Sap Haddon not out	1
Extras	4
	44

Hartley Wintney

Leary c & b Griffin	35
Groves c Griffin b Bell	17
Seymour c Andrews b Barket	30
Beagley c Barker b Griffin	8
Dr. Maturin b Bell	20
Eli Beagley c & b Griffin	8
Choules c Faulkner b King	10
Phillips c & b King	14
Long b King	0
Kitchener not out	1
H. Baldwin c Goddard b Bloore	11
Extras	15
	164 **

Fleet

J. King b Kilburn	21
Faulkner b Bird	12
S. Griffin c & b Bird	5
F. Page b Kilburn	6
G. Bloore b Purdis	3
W. Goddard b Kilburn	1
Longmoor not out	19
Linsdell b Lee	3
F. Bloore b Ratcliffe	6
E. Bloore b Ratcliffe	0
W. S. Page b Kilburn	0
Extras	14
	90

Played at The Beeches Fleet, now North Hants Golf Club.
*** Lack of schooling perhaps? Total should have read 169!*

Crookham Cricket Team Previous to this cricket matches were often arranged by parents and sons from the larger houses, with the team sprinkled by local working men. It will shock cricketers to know that this team was known and locally reported as *Crookham Cricket Team*. This was because, at that time, Crookham had several wealthy families living in that Parish who, partly to occupy their sons home from public schools or serving as young officers at Aldershot, regularly loaned someone to prepare a pitch and willingly paid for any expenses, such as the rent of a field for the cricketing season. The cricket field was often in the vicinity of Crookham.

Fleet Cricket Club However with Fleet becoming so well developed with more and more residents, the present cricket ground became established. In 1904 a Cricket Club was formed with a committee of local residents. Willing helpers prepared pitches and erected a shed of corrugated iron about 12 feet square to store cricket gear, also to act as a 'rough and ready' changing room, and somewhere for the 'scorer' to sit and record event by event. This 'tin' shed as it was called, stood without betterment for 30 years. Several County class cricketers played in the Fleet team: Claude Buckingham, Leverson Gowers and two Wells brothers. Mrs. Wells from Windmill House, a charming lady, requested use of the cricket ground for mid-week matches as there were quite a few public school boys home each summer. Permission was granted for the first week in August. The staff from Windmill House organised chairs and trestle tables for a somewhat lengthy tea interval. Her two tall sons were great sportsmen and excellent cricketers. Each summer for several years Clement Attlee and his brother (a solicitor) often played. The Wells' brothers played regularly for Fleet as adults and the holiday matches were becoming a regular event for senior schoolboys.

Cricket Week Therefore in 1925 it was publicly announced in the local press, that the first week of August was to be known as 'Cricket Week' with daily matches and refreshments available. Often there were 40 to 50 spectators at these matches. Many improvements have taken place at the cricket ground, but years ago each member of the Fleet team was known to all the spectators. Sudden clapping and sudden silences really meant something. 'Herbie' Baldwin of Hartley Wintney became an outstanding county cricketer and played several times for England. Later, a grateful country made him a professional umpire both for County and Test matches. He umpired until he had to retire owing to his age.

John Kimber, from Pearsons Corner Off Licence, rented a tiny field which is now the entrance to Tavistock Road. This paddock was usually sown with rye grass and harvested green as a supplement food for his cab

horses. The soil being very light and sandy needed rolling after seeding. Mr. John Kimber borrowed a horse roller from his brother Mark, who farmed dairy cows on a farm at the rear of the Prince of Wales pub. For many years cricketers borrowed and *returned* this roller, but after John Kimber died the roller remained in the cricket grounds. 'Cricketers' remember when rolling the pitch how the roller was acquired. The usual time for a one-day match to end was never later than 6.30 pm. Close-fought matches often became tense and hectic during the final hour. Village pride encouraged deep concentration and effort.

Entertainment

Webbers Theatre This was a small, almost temporary, building on the site now fenced in almost opposite Poulters Estate Agents office. The residents of Fleet preferred their own concerts in the Pinewood Hall. End-of-season visits by seaside entertainers and itinerant preachers were ill-attended and the place was destroyed by fire in 1914.

Boxing Ring The site opposite Poulters Estate Agents remains vacant. After the end of the 1914-18 War this central site was just covered with grass. Demobbed ex-servicemen pooled a few pounds and built a boxing ring raised on 4 foot high legs. Boxing bouts were held amongst themselves, there was a little betting and as followers and contestants increased, matches for a £5 prize were regularly taking place. A crowd of about 100 was usual. Bad weather often 'washed out' the proceedings.

Fleet Hall For many years Fleet had a central hall built just before 1900. This brick-built hall with a temporary roof was situated in Fleet Road adjacent to the present Pearsons Estate Agents office. The hall was built for Mr. Watmore, the last owner-landlord of the Oatsheaf Hotel, by Pools for £600 and the site cost £50. The donor falling into ill health, the interior was poorly furnished with long hard seats comprising of a 7 inch wide seat of wood and a similar backrail upon iron supports. Lighting and windows were the very minimum. A few band or charity concerts were held and it became almost in decline until about 1900, when it was used for showing the first and earliest films.

Cinema The new council inspected the property and before regular cinema shows were held, adequate crash doors for use in fire were put in. A piano was installed for appropriate music to accompany the films. The first films were projected using electric power from batteries and the films were brightened up via the projection room by a carbon light beam. The trial run as a cinema lasted for about two years with films shown on Saturdays – mornings for children: admission 5d – evenings for adults:

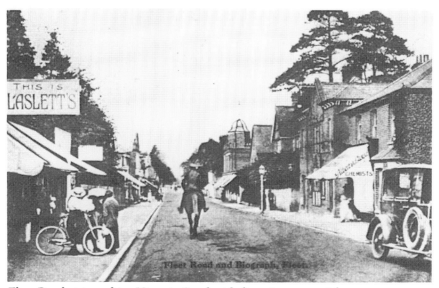

Fleet Road approaching Victoria Road with first cinema on right next to Chemists, about 1918. Site now Nos. 281-289.

admission front seats 7d, other seats 1 shilling. The brown and white flickering films were accompanied by a pianist playing the piano by ear and sitting in the dark. Miss Frisk took the money at the door. Miss Pusey and afterwards, a Miss Oakley, played the piano accompanying the films with suitable sounds! A rushing train or galloping horses received appropriate rapid thumps on the piano. Films often broke and had to be mended during stamping and cat-calls by the audience (young and old). Charlie Chaplin and Harold Lloyd comedy films were shown alternatively. A few Westerns, and frequent runaway trains with Pearl White or Mary Pickford tied to the railway track to be rescued from an approaching train. The Saturday matinee, as it was called, became very popular with 7 to 14 year-old children walking from Elvetham, Ewshot and Minley.

As time passed, films improved until it became a paying proposition to own and run a cinema and the old name Biograph became forgotten. In 1927 the original building was demolished and the new building, purpose built as a cinema, even had a small balcony. This building was rebuilt again in about 1930 as films had vastly improved. The talkies were just beginning to bring in larger audiences. For the first time in the life of the Fleet Cinema, a week's programme filled the building for each showing. The 'talkie' and colour *The Ten Commandments* drew many country people to the cinema for the first time and the audiences became larger and the

local cinema well established.

The Odeon Mr. Charles Donada, a reputed millionaire, purchased the cinema and extensive improvements were made. The original talkie apparatus consisted of a film attached to a large record about 16 inches diameter. The speed of both apparatus, operating simultaneously, was quite successful unless something went wrong. The needle on the record might catch or jump a line or two and there was no means for resetting, only to rewind the film and reset the record. Eventually the cinema, now named *The Odeon*, was quite modern with new projection and even carpets underfoot. The owner, pleased with the success at Fleet, formed a new company: the ABC. Funds were made available and the Farnham Cinema was built. However, the shareholders or the Principal disagreed as to whether to continue to expand or sell for a quick profit. The Fleet Cinema was sold and then demolished.

As a young man, I visited Mr. Donada's house in Guildford Road and saw the end wall of the garage covered with large cedar cigar boxes. These once held large Havana cigars and there must have been 200 boxes. I asked the owner if he would part with two boxes to be used to make a sewing box for a young lady: the request was refused. Three days later Mr. Donada said: "These boxes have gone to the East End to be made into sewing boxes and HARRODS are going to purchase the lot." My sewing box was never made.

New Hall Mr. Arthur Willmot, originally from the baker's business at the corner of Victoria Road, visualised an opportunity for business. He purchased a site and then bought, from the War Department, a large corrugated and timber building. This war-time building, now surplus, was quite large – about 40 feet by 60 feet. The interior walls and ceiling were match-board lined. Temporary low-powered electric lights hung from the ceiling and the only heating was one round tortoise stove just inside the entrance. A band of local people was formed and consisted of a pianist, two violins, a double bass and a drummer. After the war dancing was very popular, the old dances such as the Quadrills and the Valeta were still danced, but the new Foxtrots, Two Steps, and the Waltz were all part of a modern programme. These dances were extremely popular. The Saturday evening dance continued throughout the year: admission 1 shilling. Enough people attended so that the wintry interior atmosphere soon warmed to a comfortable temperature. Young couples went there simply to dance from 8.00 pm until midnight. There were no refreshments or drinks available.

This 'New Hall', as it was named, served the young people for many years. When Poppy Day collections began, the collections were augmented

by concerts held each autumn. Local singers, female and male, sang popular songs interspersed with very old favourites. Duets were sung; playing the piano and singing by one person was very popular; sometimes choruses from Gilbert and Sullivan concerts filled the hall. After about 14 years, the hall gave place to the very first purpose-built telephone exchange. This exchange eventually proved inadequate for the growing district and the present exchange was built on the rear of the site. It is hoped that the site will eventually become a new and commodious Post Office.

Scouts and Guides

Scouts The Baden-Powell Scout Movement was well established, having been in existence since about 1910. The first troop of Boy Scouts became a great success with a permanent scout room in Albert Street. Boys were proud of their uniforms and subscribers bought a trek-cart and organised summer camps. The Scout movement had many pursuits to occupy their time. Different knots were tied in cord, all according to a series until a proficiency badge was obtained. They had courses of drill, gymnastics, marching with bugles and kettle drums and trekking away from Fleet for a week's camping under canvas tents in a farmer's field. At one time, Mr. Rodney Lefroy, as Scoutmaster, allowed the Fleet troop of Scouts to camp in the parkland at his residence Itchell Manor, Crondall. It was said that he set an example to the young Scouts by insisting that everyone retire to their tents for the night's sleep at exactly 9.30 pm. He himself retired to his personal tent as an example. The Boy Scouts treated it as a great secret joke that he left his tent at about 11.30 pm and quietly made his way to the Manor House, returning quite early in the morning wearing his Scout uniform.

Guides With much enthusiasm, Mrs. Griffiths-Baker undertook to form a group of Girl Guides as she thought the Girls Friendly Society did not have enough outdoor activities. Meetings were held and soon 20 girls were being enrolled as Guides. At first, Mrs. Griffiths-Baker was the only person involved, uniforms were now in use, but weekly activities were somewhat too much for their enthusiastic leader. A committee meeting, presided over by the originator, selected an extremely pleasant and efficient young lady just under 20 years of age to become the official leader. This person's name was Miss Bodd.

Gradually, during 1918, Mrs. Griffiths-Baker allowed Miss Bodd to run the group which was soon very efficiently carried out. The County Commissioner, Lady Helen Whittaker, came to Fleet and commissioned the leader in her position. A guard of honour was made by the local troop of Boy Scouts, all in full uniform, including wide brimmed North West

Mounted Police hats, and each Scout armed by a 6 foot long stave known as a scout pole. It was decided that an archway of poles was not possible as some of the Scouts were very young and small and Lady Whittaker was quite 6 feet tall without her hat. The Troop Leader, Miss Bodd, remained leader until her marriage and the subsequent birth of a son and daughter. Her daughter, Phyllis Firrell, is Secretary to the Doctors of Branksomwood Surgery.

At the time the Girl Guides were formed, there were few such activities as camping and other outdoor pursuits. Mrs. Griffiths-Baker's house had an extremely large kitchen with a huge scrubbed table about 10 feet long and 4 feet wide. A large fire in the kitchen range kept the place comfortable and warm. In the winter Girl Guides numbering nearly 20 sat around the table from 7.00 pm until 9.00 pm: Mrs. Griffiths-Baker and Miss Bodd planned or created a piece of foolscap paper upon which was pasted the head, hands and feet cut out from large advertisements in the daily newspapers. Guides were told to pencil in between the cut-outs their designs for clothes. At the next meeting the girls were given crayons to colour their fashion designs. Again, at a later meeting, snippets of material were cut out and pasted thereon. Towards the end of the winter, small circular raffia containers, eight inches across, were plaited together and stiffened with a cardboard base.

As the weather improved, simple forms of classical dancing lessons took place. Heath Lodge gardens were opened to Guide parents and other adults for a dancing exhibition. Guides looked after stalls selling their raffia containers filled with all kinds of fruit from parents' gardens, cherries, plums, gooseberries and later, hedgerow blackberries. Two or three such garden parties took place and the meagre takings carefully saved. Usually there was not sufficient funds for a visit to the Christmas Pantomime in Aldershot. In any case, at that time, the journey to theTheatre was a problem. However, at the end of the summer seaside season, it was usual for a small travelling group of actors to give a show to various inland places. Mrs. Griffiths-Baker would then bargain for a group of seats. For the Guides it was a tremendous event. The theatre was sometimes held in the open on a raised stage, but usually the performance was in the local hall. Dramatic acting presented *East Lynne* or *Maria of the Red Barn*. At that time very few, if any, concerts for children were held in Fleet and the young audiences almost lived parts in their minds and participated in the plots. I have been told about the appreciation of such concerts. A 70-year-old women could almost remember the plots and acting and the spoken words after more than 50 years.

Chapter Fourteen
Hospital, Fire Brigade & Police

Fleet Cottage Hospital

The Fleet Cottage Hospital was opened in 1897, two years after Lady Calthorpe had given the site for that purpose. At first it was a quite small, dark bungalow, built of local red bricks and a slated roof. A matron and a nurse comprised the original staff. The gas mains were not then laid in Sunnyside which then included the road beyond the bottom of Church Road hill. Church Road was, at that time, known as the darkest part of Fleet. The whole of the two roads was bounded by heather turf banks and large mature fir trees which appeared to meet overhead and increase the gloom. The whole area was overgrown and the hospital could not be seen from the road. Sanitation was much more than primitive. Oil lamps, and not many, were used in the hospital. In fact, the matron and the nurse were real Nurse Nightingales, moving at night about the hospital carrying by hand small oil lamps. Important local people subscribed towards the building costs and this was recorded in gold leaf lettering on a board in the hospital entrance. Dr. Freere, often in a jovial mood, pointed to these names, saying: "These are people with a certain seat in Heaven."

The early years of the hospital were not very busy. A few broken limbs, especially those of elderly people, were the early patients. Because main drainage for sewerage was yet to come, there were annual cases of children with scarlet fever, perhaps nearly a dozen children with diphtheria and whooping cough. About a third of the last two complaints were fatal. Accidents were often caused by horses and horse-drawn vehicles. Also, patients were admitted from the numerous gravel pits. Operations other than lancing boils were seldom carried out.

Just before the beginning of this century, the future King Edward VII underwent one of the first successful operations for the removal of his appendix. Two years after the occurrence, Alice Wright, a four year-old child at Fleet Mill, was diagnosed as suffering from appendicitis by Dr. Balgarny of Hartley Wintney. After a great deal of persuasion, they agreed to operate upon the child. At that period of time many, or the majority of such cases, died from this complaint. At the Mill it was decided that Elvetham Road was in such a poor state that a horsedrawn conveyance would further aggravate the child's condition. Male employees carried her to the hospital. Dr. Balgarny arrived in his horse and trap, the matron and nurse scrubbed the wooden hospital kitchen table and all preparations –

very few – were made. With the nursing staff each holding oil lamps, the operation was successfully carried out and Alice Wright lived beyond 80 years of age. Early in 1900 the hospital became lit by gas lights, 20 years later, by electricity.

Midwives Dr. Slade at Chernocke House owned a horse and trap and often rode a cycle to cover the large area of Fleet and Church Crookham. He held a surgery at his house and a lady dispenser mixed and gave out medicines. The Doctor did not call unless the sick person was very ill and unable to go to the surgery. Certain women, usually widows with children to support, volunteered to assist as midwives. Their knowledge was extremely limited; they learnt by experience.

My family often recounted the following very early experience: The mother was about to give birth and the so-called 'midwife' arrived. Two aunts had also arrived to assist with feeding the family, the husband and two children. An enormous soup tureen full of lamb stew with home-grown vegetables was partaken at mid-day by all the family. A little later the midwife came downstairs and said: "Everything is going well – I am going home to feed my children." The woman was asked if she would like some lamb stew. The offer was accepted. She promptly and quickly went to the kitchen and returned with several sheets of greaseproof paper. Tucking the bottom of her calico apron into the waist tapes and lining it with the greaseproof, she stood there and proceeded to pick out all meat and solid vegetables from the tureen. A quick word of thanks and off she walked clutching her apron containing food for her children.

Donations Early copies of the *Fleet Reporter* later the *Fleet News*, reported weekly in full and item by item, contributions of food received at the hospital each weekend at the closing of shop business. Thus Mr. Ernest Cane, rice, dried fruit, broken biscuits. Mr. Cox, Kings Road, similar groceries. From greengrocers and nurserymen, apples and the fruit in season followed by cabbages, carrots and potatoes. The dairies: Kimbers, Adams and Cubbeys sent milk and butter. Volunteers chopped firewood and logs. Gifts of coal maintained the place. There appeared to be intense rivalry between the shopkeepers and other businessmen to have their gifts itemised and recorded in the local newspaper. On Saturday evenings, after shop closing at 8.00 pm, several hand-pushed delivery trucks wended their way to the hospital, often only illuminated by a small oil lamp. Many were pushed by young lads who hated the intense darkness of the road in the winter time. The publication of the gifts was printed inside the paper. On the front page in a prominent position was a similar recording of gifts from large establishments, surplus garden produce, and surplus milk. Each itemised list was recorded as from Lady Calthorpe, Lady Mildmay, Messrs.

Chinnock, Figgis, Latham and others. This happened each week, but the hospital was gradually improved and enlarged and needed much more.

Fetes and carnivals Each summer, fetes were held in local meadows by the branches of the Friendly Societies, the Hampshire and General, The Oddfellows and the Foresters. All worked hard. There were roundabouts and swings etc. owned by the travelling showman, Mr. Matthews, who gave all his takings to the hospital after 8.00 pm until 10.30 pm. The local band paraded at the head of a procession of the Friendly Societies, who, with their great banners marched from The Oatsheaf to the meadow where the fairground show was. Prizes were given by the shopkeepers for children and adults to win by racing, hurdles, egg and spoon races and by tilting the bucket. Sometimes the members of the Hampshire Yeomanry and the Frontier Force, both mounted and uniformed Army reservists, rode on their horses along the streets and then entered the fairground, usually beside Birch Avenue. Displays of horsemanship including jumping and peg sticking took place. There was always a free tea for children. The end result of this effort for fund-raising for the hospital was enjoyed by the majority of the local population which succeeded in raising £100 plus Mr. Matthews £90 for the hospital.

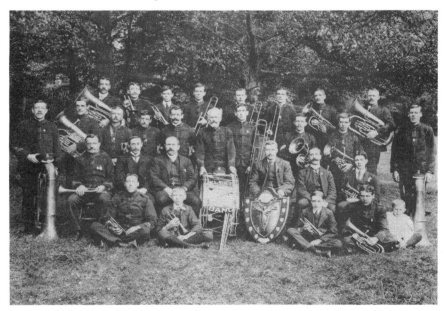

The first Fleet Prize Band. Instruments were obtained by Mr. Parnell over two years by visits to Petticoat Lane. Band uniforms were deep red.

This yearly fete was quite separate from the Annual Street Carnival Procession, which was always held in aid of the hospital. Prior to 1914 the carnival was totally run by horse-riders and horse-drawn vehicles, plus those on foot. Competition and smartness was keenly contested as everyone was known to each other. By 1914 Fleet Town Band paraded in scarlet uniform and the Wesleyan Prize Band in navy blue uniform. Both the fete and carnival were purely local, but Odiham and Hartley Wintney also held similar events and all in aid of Fleet Hospital.

Improvements From 1897 to 1939, the Fleet Cottage Hospital was continuously enlarged and new modern facilities installed. During all this time the population of Fleet, including the local doctors, regarded the hospital almost with affection. The atmosphere was quite unusual. All the nurses and staff were more than friendly. Patients and their relatives were always met by nurses and doctors who expressed their true interest and by being cheerful emphasised a 'Get Well' attitude. It would not be known that each Sunday morning several doctors visited the hospital and sat at the scrubbed nurses' table to drink a cup of coffee. They then discussed with the matron, and the sisters and amongst themselves the future treatment and the condition of seriously ill patients. Surely this was more beneficial to all concerned that the visits and prayers by local clergymen. One vicar made a vow to never visit the hospital unless so requested. He said: "I am so apprehensive – patients I visit seem to die. Why?"

From the original very small bungalow the hospital was continually improved with additional accommodation, also accommodation for the nursing staff to 'live in'. X-ray and operating facilities were installed and over the years many and numerous operations, sometimes very serious ones, have been carried out by visiting surgeons. Alas, it was officially decreed that the hospital must no longer 'operate' because of lack of special recovery facilities. As from 1975 the hospital was to be mainly for geriatric cases or very simple surgery.

Benefactors Many Fleet people willingly gave their time for the benefit of the hospital. Benefactors left sums of money in their wills. A large committee of hospital workers collected each month a set amount from most of the families in Fleet – 5d each for adults, 3d each for children (per week)– and entered payments on the family card. This committee worked hard for 20 years and their efforts added with all other contributions managed to keep the hospital out of debt. Now all their efforts are forgotten.

Fire Brigade

In the 1880s the public were horrified at the disastrous fire in Richard Pool's stables in which several horses perished. The stable overseer, young Charlie Vickery, was especially upset. The concern resulted in public subscriptions towards forming a fire brigade. Just before the stable fire, Velmead House had been burnt down, also Windsor Cottage, Kenilworth Road. The subscription list was headed by Earnest Oakley, whose shop and house (with public clock) was close by. The appeal resulted in the purchase of a pony-cart loaded with fire hoses and fire fighting equipment. Richard Pool kept a fast young pony always available at his stables. Charlie Vickery always speedily harnessed the pony and was quickly away to any fire. Firemen, all volunteers, left their work and hurried to a fire, usually on bicycles.

After Fleet Urban District Council was formed early in 1906, a fire station about 15 feet by 14 feet was built on the corner of Upper Street and Albert Street close to the Council offices, uniforms and brass helmets were obtained for the volunteers. A telegraph-type pole stood at the extreme corner with an 18 inch bell for use as a fire alarm. This fire fighting voluntary brigade carried on until 1919, when a model T Ford Fire Engine was purchased from the Guildford firm – Dennis. Mr. Earnest Oakley was so pleased with the Fire Brigade that he provided a drink of wine at 12 midnight on every New Year's Eve to all members of the

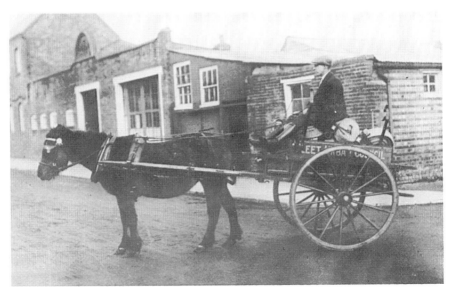

Fleet's first Fire Appliance, 1903.

Brigade who stood under his clock to hear it strike in the New Year. Auld Lang Syne was sung and all joined hands. This was repeated yearly until the County established a fire service.

Police

About 1880, the first policeman, PC Alderton was sent to live in Fleet. He was a very tall man who was not often seen because his duty alternated with day and night shifts. At night he carried a stave, a wooden staff about 4 feet long and if the night was extremely dark he had a bulls-eye lamp attached to his belt. The lamp contained lamp oil and a wick and the glass at the front was a solid half sphere of glass always known as a bulls-eye. This glass was covered by a metal shutter.

There was practically no crime in Fleet except by poverty-stricken men with families who often, at early sunrise, raided and stole vegetables and fruit from the very large houses. Sometimes a horse dropped dead and the policeman ensured that it was quickly carted away to the Knacker's Yard. PC Alderton was much in evidence if the Coroner held an Inquest upon a 'sudden death'. The Coroner and a 12-man jury held a 'Sitting' in a room at the east end of the Oatsheaf. The policeman had to walk 'all over' Fleet to impress the jurymen and advise the Coroner who lived in Aldershot. Unwilling jurors pleaded extreme teetotalism and objected to entering the Oatsheaf. The policeman did not accept this excuse.

Drunkards were not apprehended and were usually left, day or night, to sleep by the roadside. If inebriated men fought in the street and sometimes came home drunk and threw their families out of their houses, the policeman was 'never around'. In 1927 Arthur Henry Bishop, a Fleet born boy, who had attended Fleet School, was hung for murdering his titled lady employer. An influx of detectives arrived in Fleet and pieced together salient facts about his very early life for submission to the Home Secretary. Several years later, in about 1930, a gang of Irish labourers in a drunken state, left the Plough at Cove and began to walk along the railway lines to the Station Hotel at Fleet. They never arrived. An express train decimated everyone and the local police had to clean up the remains for transport to the large mortuary at Basingstoke. Apart from some tough unruly Canadians who, in 1940 set a very bad example, the foregoing events were exceptional in a very law-abiding locality.

Nevertheless, between 1880 and 1980, the police force has gradually increased and Fleet now has a commodious Police Station with all modern facilities such as patrol cars and radio communications.

Chapter Fifteen
Fleet Mill & Fleet Pond

Fleet Mill

Fleet Mill is the oldest building in Fleet. It was known to be a working mill
in 1660. From a small thatched building it has been altered so much that
old drawings are quite different from the time when the mill last worked.
The occupation of a miller appears to have been a closed shop with its skill
handed on to different generations. Although stonemasons shaped the two
grinding millstones, the miller and his sons cut the grooves for the ground
substances to pour out of when milling was completed. At Fleet Mill there
hung a bag containing the different stonemasons gouges known as bills.

Wright family of millers The family were millers for several generations.
George's father must have been living and working Farnham Mill during
the 1700s. A branch of the family, The Bartletts, were the last persons to
work the very large mill at Thatcham. Rezin Wright, the last miller at
Dogmersfield, lived to reach nearly his century. He married twice and
perhaps created an unusual record by celebrating two silver wedding
anniversaries. The unusual Christian name's origin is not known; it is
sometimes met with in Austria. Previous to George Wright, a John Wright
lived at Fleet Mill.

The miller at Fleet Mill controlled the height of the water by means of a
penstock, enabling him always to have enough water at the mill head for
working throughout the year. During 1800-1900 the mill was exceedingly
busy. The miller and several sons were helped by about six employees.
Flour, horse and cattle feed and chicken food were milled and sold. After
the early autumn harvest, the mill worked day and night because in winter
the roads were too poor for heavy horse-drawn wagons. Prolonged hard
frosts enabled wagoners to go to and from the mill in mid-winter. The
miller could always advise about floods and impassable roads which were
common in January and February. The mill was rented for a small sum
from the Lord of the Manor. All milling for his lordship was to be done
free and all large eels and fish caught in the mill race or mill pond were to
be offered to him.

At Fleet Mill and at other local mills, small-holders and gleaners
brought sacks of corn, usually wheat, but quite often rye, to be milled into
flour. No money changed hands. The milled flour was trickled from the
mill stones into a wooden one gallon measure. Immediately the flour had

filled the measure, including a pyramid of flour above the top of the measure, the miller with outstretched hand swept all the flour above the measure onto a clean sack. This surplus to the gallon measure was retained by the miller to pay for the grinding. The old joke was that the miller had a wart or lump growing on the palm of his hand. The great 240 lb sacks of flour were heavy to move and each mill had several ropes over pulleys to assist movement. It was said that strong men were dared to lift a 240 lb sack with one hand. One such dare was to lift a sack by the teeth. This was accomplished, but as the sack sank to the floor all the front top and bottom teeth fell out.

Gilldown When the millers retired from Fleet Mill, they were offered, at a peppercorn rent the tenancy of Gilldown, a homestead-cum-farm in Pale Lane, Elvetham. Gilldown was a small detached farm house with land of 40 acres. It had a stable, cart shed, cow shed for six cows, a barn and purpose-built pig sties. John Wright made brushes and besoms and also sold his handiwork. At the appropriate time he sold freshly felled birch wood to the Andover Brush Company. I found in the roof of Gilldown Farm a curved board probably from a vehicle such as a pony trap. The board's signwriting stated *John Wright Broomdasher 1790.*

During Victorian times, the Lord of the Manor (Calthorpes) held shoots for pheasants which were reared by the 1,000. Mostly titled people were invited. One year it was decided that the mid-day break for refreshments should be held in Gilldown. With help from the butler and other servants and the wife of the tenant farmer (George Wright), a sumptuous spread was offered. Mrs. Wright had previously been a cook at Brook House. The guests ate well and drank well. The Lord of the Manor becoming somewhat mellow, called in George Wright and thanked him for his effort and enquired what his rent was. The rent was £10 per annum. Paper, quill pen and ink were produced and a statement was written and signed to the effect that while a Wright, or a descendant of a miller Wright lived on the farm, the rent was never to exceed £11 per annum. This rent was held at £11 until 1940.

Fleet Pond

King James the First ordered that the causeway (now Cove Road) by Fleet Pond should be maintained in good order.

The London and South Western Railway had a punt stored beneath the railway arches. This was often 'borrowed' by small boys, much to the wrath of the chief ganger. The Army (or Officers' Club) had a boat house at the east corner of the pond for the safekeeping of three punts for fishermen (always padlocked). Col. Kerrick built a pier and had a small boat at Grasmere. Mr. George Meredith, novelist, had a boat house for two boats

This part of Fleet Pond, known as `The Flash', was later infilled by Pools and is now the trading estate adjacent to the station.

near Chestnut Grove, one for his son and one for his daughter. During 1912, several hundred mounted Royal Engineers camped on the flat heather-clad land between the railway and the pond. Horse lines and field kitchens enthralled small boys. Hundreds of mature fir trees were felled and a timber T-shaped pier was constructed into the pond for about 80 feet. Large Army pontoon barges were floated and the Army practised loading and unloading wagons and horses from the pier.

Cody's Hydroplane In 1913, a contingent of workers arrived at the pond from Farnborough Balloon Factory. The aforesaid pier was demolished and a long slope was made from the railway far into the pond. The small steam locomotive was brought from the Factory together with several railway lines. A rail track was laid from near the railway to well into the pond, using material from the old pier as a base. This inclined railway, nearly half-a-mile long, was completed. The writer, as a small boy, watched the following events. The workers from the Balloon Factory assembled a very strange machine with a fuselage, biplane wings, an engine and a driver's seat and with two 10 foot floats beneath. The steam locomotive got up full steam. It pushed a flat railway bogie in front, upon which the strange

object rested. The bottoms of the floats were well greased. Mr. Cody sat in the driver's seat at the controls of his hydroplane. The locomotive took off at high speed pushing in front the plane, engine and propeller. The railway engine abruptly stopped at the water's edge and Mr. Cody and his plane flew for about 100 yards above the pond. The plane then struck the water, the floats were broken off and the plane nose dived into the water. Mr. Cody and parts of the hydroplane were rescued and taken away. The writer swam and rescued one of the aluminium floats and took it home. Several unsuccessful attempts to make it into a canoe failed. However, when the pond was frozen, it was transported there and used as a sledge. Four boys standing with outspread arms and overcoats were windswept across the pond and to the destruction of the float.

Drought During 1921 there occurred a great drought from spring until the autumn, accompanied by very high temperatures. For months Fleet Pond was 90 per cent dry. At that time, except for the eastern portions, there was no silt on the pond bed. Gravelly soil was compacted quite smooth by a flat star-shaped weed. Many people walked and exercised their dogs, even walking across the pond from side to side. When the school holidays for the summer recess occurred, boys and young men laid out a golf course, almost three parts around the now dry and pleasant area. Boy caddies from the local golf course were much in demand as coaches and they demonstrated with great ability.

Before the drought, there was an abundance of fresh water fish. As the pond dried out, hundreds of stranded fish could be easily caught. The pond gradually became a small area near to the railway and the Little Pond, north of the railway. Many large pike more than three feet long with large and heavy tench were easily caught. Countless frogs in large droves covering much land began to follow any deep ditch and stream. Several hoards crossed the road between Fleet and Aldershot, the majority surviving because they travelled at night as, in 1921, there was hardly anyone using the roads late at night. As the pond diminished, the frogs croaked and croaked throughout the night – the sound could be heard more than half-a-mile away.

Just before this great drought, a very curious affair occurred. The heather-clad land between Pondtail Canal Bridge and the Foresters Inn became the home and breeding ground for a great flock of nightjars. Their continuous evening calls could be heard over a distance, but the birds remained completely invisible.

Silting The pond was completely refilled during the winter. Owing to the excessive dryness during the drought, the bed of the pond remained completely free of any growth of reeds or seedlings. Throughout the

following 45 years, Fleet Urban District Council drained a considerable amount of surface water from many of the roads and large amounts of gritty silt were carried far into the pond. The War Department seemed to forget about the pond and gradually silt, both from the roads and more so from the streams, settled over the base of the pond. The end result could be seen when the pond was emptied at the beginning of the last war. An average of a foot in depth of silt covered the whole area. In the war period of 1939-1945, this drying silt almost allowed growth of reeds and tree saplings to reach a height of 4 to 5 feet.

Duck decoy Bordering the Fleet Pond, about 100 yards east of Chestnut Grove, is a man-made canal 12 feet wide. It is U-shaped and about 150 yards long, with both ends of the waterways connected to the pond. The dry area in the centre and the surroundings are well wooded. I purchased this area in 1930 and it was described as a 'private duck decoy'. Also near the pond, a lake had been dug quite circular and about 25 feet in diameter. At the far end of the U-shaped canal, 220 feet from Avondale Road, were several very deep circular ponds about 12 feet in diameter. All these water areas were carefully constructed and the banks and sides show no evidence of subsidence or collapse. The War Department, owners of Fleet Pond, knew nothing about this area as it was outside their stone-marked area. The original use was certainly as a duck decoy. The large pond would have been stocked by small fish caught in the pond and there left to grow in size. The several small circular ponds could have been used for keeping fish until sufficient quantity was available. This would have been done by covering the ponds with netting before the fish were placed therein. It is surmised that the inhabitants of Brook House may have made use of this special man-made area as a means of a winter food supply. Tales were told that the decoy was used by monks who carried fish and other food to local monasteries, even to Winchester. It was said that the monks constructed the decoy and small ponds especially for their own purpose.

Wildlife Until the emptying of Fleet Pond during 1939, swans thronged there in large quantities always exceeding 100 in number. They often congregated together and flew back and forth to Dogmersfield Park Lake. Moorhens, coots and grebe were in such abundance that it was impossible to make a count. Each year, the Officers' Club usually held two or three duck shoots for young officers. Hidden in the reeds, sportsmen in a few minutes accounted for 50 or 60 ducks. In the Fleet section of the canal, several couples of swans built their nests and reared their young. Fleet Pond in season, became a hunting ground for boys who, by wading amongst the reeds, could collect 30 to 50 eggs in about one hour, sometimes selling them to householders for a few pennies. Years ago, with

few inhabitants the pond could produce an abundance of fish, ducks and eggs.

Pond purchase After the 1939-45 War, the military authority responsible for the pond, informed Fleet Urban District Council that refilling the pond with water and consequent freezings would cause these growths to die. Fleet Urban District Council bought the pond and, to prevent flooding of low lying inhabited parts of Fleet, lowered the water level by almost 12 inches. A pleasant walk has been provided and now it is possible to walk right round the pond with a dry path for those who appreciate that portion of the countryside.

Crocodile Island

Having described the Fleet Pond decoy area, it may be of interest to mention the curious man-made structure which was situated 300 yards south of Fleet Cricket Ground. Here was a man-made circular pond about 10 to 12 feet in diameter which was surrounded by a 12 foot wide moat. A spring in the centre always maintained a water level to the pond and moat. Local children were taken for a walk in the woods to see this spring which was often named Crocodile Island.

The Forest of the Verne

The family of Limings were known to have lived in Crookham for at least 300 years. Jack Liming, a descendant of this old family, was a policeman who was jailor at Farnham Police Station. After retiring he became landlord of the pub named The Horns, near Crondall. He showed me a very small old book; by its type of print it may have been printed in the 1700s and it was called *The Forest of the Verne*. This forest stretched from Hitches Lane to somewhere near the top of Beacon Hill, Ewshot. A road in Church Crookham has been called *The Verne* and the area must have been a central part of this forest. The book described the forest in detail especially footpaths and lanes. The forest was the home of several herds of deer. Mention was made of their watering places, and Jack Liming told me that his grandfather remembered much about the forest and he also mentioned the "watering hole at Fleet made to provide water for the deer and drinking water for passers by". This ancient earthwork was demolished without trace by recent development. Before the local storm water drains and sewerage drains were laid, there were quite a few springs. These have all disappeared because the spring water no longer rises above ground as it finds an easy way of dispersing its water by following a course just above the local drainage pipes.

Chapter Sixteen
Basingstoke Canal & the Railway

Basingstoke Canal

The Basingstoke Canal was completed in 1794. The Fox and Hounds public house became a favourite stopping place, as the landlord, Mr. Nelson, went out of his way to accommodate the bargees. He even built a row of stables with water, hay and other requisites for the horses. The bargees purchased plenty of beer. In summer, some slept on their barges, others in the stable loft. The bar in the pub, like many others, had the bar counter carried up to the ceiling by the stout construction of individual drinking nooks, all of which could be closed off with stout little doors and locking bars.

In severe weather in the depth of winter, bargees were allowed to sleep on sacks of straw on the pub floor. For bread and other food they had to walk from the Fox and Hounds to Mr. Jessett's bakery and grocery shop in Crookham Street. Two years after the canal was built, Mr. A. Voller who came from the 'middle' of Hampshire, paused to watch and study the busy

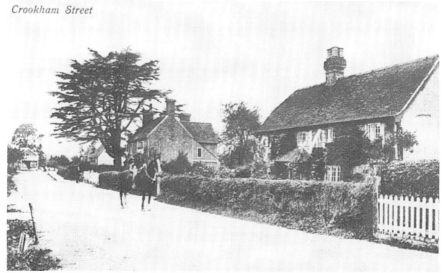

Crookham Street

The Street, Crookham Village, looking West. 1906.

pub. He built a temporary bakehouse close by, installing a brick, bavin-fired oven about 4 feet 6 inches wide by 5 feet 6 inches deep. A year later, he built a little shop beside the bakehouse and soon after built himself a three-bedroomed cottage.

The canal was very much in use, especially later for horse-drawn barges bringing bricks and other materials, usually to help in the construction of Aldershot and adjacent military camps. Later steam traction engines, then used for threshing, gradually became roadworthy and used for heavy haulage. In Aldershot, half-a-dozen hauled bricks, sand and gravel for the camp construction. Simmonds, the Aldershot millers, began to use steam for flour milling and corn grinding; for transport they used three steam *Fodens*. This was the beginning of the end for commercial use of the canal. The London and South Western Railway built large sidings for heavy goods at Basingstoke, Winchfield and Fleet and gradually the canal was only used for pleasure and fishing.

Pleasure During summer weather boys searched for, and found, spots in the canal with clear and clean sandy bottoms. Many boys learned to swim in the canal. A favourite spot was near Eelmoor Bridge and this was a place almost overshadowed by the 60-foot tall chimney built for the burning of military waste from Aldershot and Farnborough. The project was a failure and the position became quiet and isolated. However many youths between 14 and 16 years of age managed to climb to the top via the iron ladder; the vertical climb needed a lot of enthusiasm to reach the top. The chimney and the area known as Pyestock became a homing landmark for the very early aeroplanes flying in and out of the Royal Aircraft Establishment. In the mid-1930s, scare of war brought about the demolition of this landmark – the only tall chimney in this northern part of Hampshire.

The canal at this time was still clear of weeds which in later years virtually clogged the greater part of the Hampshire section. Fishing was very popular with mature pike and perch. Until 1921 most of the water under the bridges became the home and breeding ground of freshwater crayfish or crawfish. It was a common sight to see children with meat bait on a piece of string enticing the crayfish to grab the bait and to be hauled in and caught and placed in a bucket. Boiled red, the meat from the claws and tail were quite a delicacy for a weekend tea. In 1924 all the stock of crayfish from the canal disappeared!

Boating The beautiful portion of the canal between Aldershot and Odiham became a well known and busy area for boating. Wharf Bridge near Aldershot had always been a staging stop where barges had been repaired or altered for special loads. Trade declining, two and four-oared

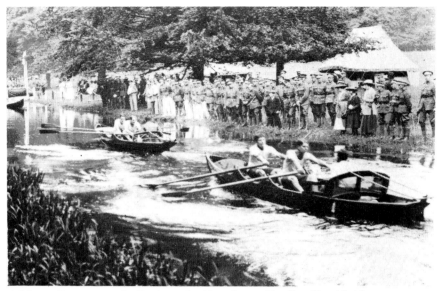

Military Regatta on the Basingstoke Canal near Reading Road bridge.

pleasure boats were built there, also punts and a few canoes. At Fleet Mr. H. Cox of Rochester Grove, built a large shed near Reading Road Bridge. He bought several boats and punts from Wharf Bridge, then, being a very enterprising craftsman, he began boat repairs and eventually built boats himself. Together with Mr. Cox's son, Harold, I became interested and helped build a new boat. The work was very precise with ship-lapping sides of teak with copper rivets. Unless built to exact perfection the craft was useless as absolute water tightness was required. From spring throughout the summer until early autumn, Mr. Cox moored about six boats, six punts and four canoes near Reading Road Bridge. These were let out for hire by the hour, the charge was three shillings per hour and returning boats had to be in by 9.00 pm. It was a busy pleasant time especially if a light tea could be bought in from the rear of the Fox and Hounds.

Mr. Raynor, who owned two tiny shops near Pondtail Bridge, built a tiny lockup place at the rear end of his garden and opened up for the sale of soft drinks and cigarettes to the boats from Fleet and sometimes from Aldershot. Beside the Chequers Inn, on the Crondall Road, can be seen the decaying boathouse where the landlord (always named Ivel) stored at least 12 boats. Parties of adults with children walked or cycled to the Chequers Wharf with the intention of rowing to King John's Castle to have a picnic. All this gave great joy and a pleasant outing for whole

families as, at that time up to 1914, there were no motor cars and very few buses. Horse-drawn barges could be hired for the day for Sunday School outings, and for children, members of Friendly Societies such as the Oddfellows or Foresters. A tea was always part of the outing. The return journeys, often with tired children, were enlivened by singing songs accompanied either by a fiddler or a melodeon. It was very pleasant to stand by Reading Road Bridge and hear the sound of singing and music before the boat or barge became visible.

The London and South Western Railway

The London and South Western Railway first consisted of two tracks laid in 1830. The locals said: "One up to Waterloo, One down to Southampton." Fleet Station was originally two platforms just north of the Fleet Road Bridge. The station was entered by 'Station Approach'. Early in 1880, Ernest Brown, of Bracknell, built the Station Hotel for the accommodation of rail travellers. A large yard and stabling was much in use. During the better weather, the 'well to do' rode on horseback and in the winter drove in their carriages to the station. Intending travellers came from as far away as Crookham and Ewshot. North Hants Golf Club was then only just being planned by The Officers' Club so, for a while, the Station Hotel prospered.

However in less than five years the London and South Western Railway built a new station on the pond side of the bridge. The new station was completed in 1896; it had many facilities including a 'covered way' across the tracks, a very large siding for heavy goods, especially coal, and there was accommodation for a goods clerk and a parcel office. A signal box was manned by three signalmen, and there were four uniformed porters and a top-hatted stationmaster with his own house. Many of the residences in the district were owned and occupied by businessmen who went by rail to London, principally to the Stock Exchange. Senior Army Officers often retired and lived in Fleet and quite a few were 'retained' at the War Office and other defence places in Whitehall. This led to the often used quip:

7.30 am Train for the WORKERS
8.30 am Train for the CLERKERS
9.30 am Train for the SHIRKERS

Usually six cabbies with their horse-cabs (called flies) waited in the cab rank: Jimmy Bushel, Frank Hester, two Kimbers and Cabby May from Crookham. In cold and wet weather several cab drivers went to the Station Hotel. All rushed back to the station at the sound of a train stopping. Travellers, just arriving, were astonished to witness a free fight amongst the cabbies as to who got back to their cab first and was thus entitled to a fare paying client.

London paper (in bulk) arrived at 6.30 am; fish from Billingsgate at 7

am. At that time the Royal Mail was very expensive for parcels, so Gamages and Barkers advertised 'Goods promptly delivered to your nearest railway station'. Enterprising people soon built up a livelihood delivering goods and parcels from the station.

The railway signals between Farnborough and Basingstoke were just oil lamps with green and red glass, which changed colours according to the position of the semaphore arms. The stationary railway engines situated in an engine house on the original station site, provided movement of the signals by powerful pneumatic steam pressure along pipes beside the rails. Track rods activated by the signalmen in their control box were moved exactly at the precise time a train approached each signal gantry.

The stationmaster, Mr. Anderson, supplied free oil for the first ever street lights. Mr. Blacknell gave 4 foot by 4 inch posts, together with oil lamps. Two lamps were on the station gates, another at Blacknells yard gate (now Sandell Perkins), one at Fleet Parish Church gates, one by the Oatsheaf Pub, one at Victoria Hill Chapel. Mr. Albert Hankins, official lampman to the London and South Western Railway, lit and attended to these lamps until gas street lighting was installed throughout the district. Mr. Hankins, a devout man, maintained the street oil lamps every winter and cleaned and maintained the Baptist Chapel for almost a lifetime: the very first unpaid community service ever known in Fleet.

The Old Age Pension was then only 5 shillings a week: occupational pensions were very rare until 1945. Employees of the London and South Western Railway, in recognition of a life-time's hard work of about 35 years, were paid a small pension. In 1920, Mr. Lovelock, Mr. Dicker, Mr. Hooker and Mr. Pratt had to go to Fleet Station to collect 1 shilling and 6d per week pension. When these men became old and decrepit, they travelled to and from Fleet Road to the station to collect their pension by bus. The bus fare was 3d each way, so upon arrival home they each had 1 shilling.

Autumn pheasant shooting During the original construction of the railways, the master builders, Brunel and Stephenson, built personal sidings for their own trains to visit speedily the new tracks and tunnels under construction. Such a siding was built at Fleet in front of the stationmaster's house. This siding was just a half-mile loop joining the main track on either side of the station.

At the commencement of the Autumn Pheasant Shooting season, a special train arrived in the siding. This train consisted of a catering carriage, a dining carriage, a carriage for social purposes – drinks and conversation, also two carriages of sleeping accommodation, one for the gentry and one for the servants.

During the day, horse-drawn shooting brakes were continuously going

to and from Elvetham Hall and Minley Manor, conveying enormous quantities of food and drink in hampers, napery, cutlery and every kind of dining table necessities; also bed clothes for the sleepers. These shooting brakes were in the charge of coachmen, dressed in black riding boots with brown tops, whipcord breeches, bottle green frockcoats, cravats and top hats. The conveying of the contents was carried out under the supervision of a butler and several men servants, all dressed in black suits and white shirts with stiff collars. The dining tables were laid with beautiful napery, silver and flowers.

By mid evening, carriages arrived, bringing the Calthorpes, the Curries, Sir Richard Morton and Baron Nugent. In all, about 20 female and male guests were all conveyed to the station by smart horse-drawn carriages. Bertram Chinnock arrived driving a two-horse vehicle. There was also the first and only early motor car driven by young Dr. Freere. By 8 pm all the guests were seen to be drinking and conversing. This was followed by a sumptuous meal served by the butler and footmen. For some unknown reason, not a single blind was ever drawn and the 'special' carriages were extremely well lit by gas lights. This enabled about 40 or 50 inhabitants of Fleet to stand and watch these proceedings from across the rail tracks or from the road bridge over the railway. Exactly at 9 pm the stationmaster, in uniform and top hat, walked the length of the train and then signalled to the train guard who rang a bell. The train pulled out of the station and, by magnificent planning, travelled via several different companies direct and non-stop, reaching Scotland by morning.

As an aftermath of this splendid occasion, any small boy would be compensated for his patience by being allowed to enter the station platform and check the time of departure by the 24 inch dial railway clock. Then, perhaps, a penny would be spent by inserting it into a red painted slot machine, thus obtaining a wrapped 1d bar of Rowntrees chocolate. Woe betide anyone discarding chocolate wrapping paper on to a scrupulously clean platform. To a small boy, there always seemed to be a lurking porter ready to sternly pounce and shout.

Chapter Seventeen
Local Newspapers & First Newsagent

Fleet Reporter

At the left-hand side of Dewhurst's shop front is a 6 foot high green gate. This gate was erected soon after 1850 because the Caleys built in their garden (at the rear of the shop) a brick workshop approximately 25 feet by 15 feet. They let it to Mr. Josiah Morgan, who from about 1850 regularly printed the two-page *Fleet Reporter* on a clanking printing press powered by a noisy steam engine. Later the name was changed to the *Fleet News* – still only two pages. Two men were employed to assist the production of print work. The noise of the press and engine could be heard a quarter of a mile away and knowing people nodded and said "The Fleet News is being printed".

This was the first newspaper and the only one ever to be printed and

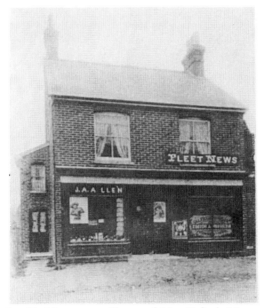

In 1902: Mr. Crick's Newspaper Shop and Mr. Caley's Harnessmakers Shop. The only two shops on the south-east side of Fleet Road between Church Road and Upper Street.

Fleet Reporter
AND
CROOKHAM AND HARTLEY WINTNEY ADVERTISER.

EDITOR & PROPRIETOR:—ALFRED MORGAN.

No. 90. SEPTEMBER, 1893. One Half-penny. Issued Monthly.

published in Fleet. Many poor people did not consider the cost of the *Daily Mail* at 2d a worthwhile expenditure so the local weekly news, also 2d, was always purchased, therefore a goodly circulation was ensured. Visiting cards, leaflets, invitation cards and similar work caused this undertaking to exist until the proprietor died. After his death the local newspaper was considered to be absolutely essential, so early in 1900 local shopkeepers and prominent residents formed the North Hants Printing Company, building pleasant premises opposite the post office. However Gale and Poldens of Aldershot soon produced a larger local paper. Printing plus the sale of stationery continued until recent years. A few surviving original shareholders were repaid their shares and the premises sold and converted into a shoe shop by Frisbys, a truly Hampshire company who originally came to Fleet many, many years ago.

The Fleet Reporter and Crookham and Hartley Wintney Advertiser
Editor and Proprietor Alfred Morgan – 1893
One Half Penny Monthly

Cottage Garden Show
Lovely weather favoured the promoters of the annual show of the Crondall, Crookham, Ewshot and Fleet Cottage Garden and Amateur Show Society, which was held in the grounds of Stockton House, Fleet (by the kind permission of the Rev. Logan) on Thursday, 17th August. Three spacious marquees had been erected, in which the exhibits, which were very fine, were beautifully arranged. The duties of the judges were discharged by Mr. Trinder, gardener to Sir Henry St. John Mildmay Bart of Dogmersfield Park and Mr. Clewee in a very fair and satisfactory manner.

G. Marker Esq. the indefatigable and courteous Hon. Secretary was most active in discharge of his multifarious duties, his efforts being ably seconded by the Rev. W. G. Wickham, C. J. Maxwell-Lefroy Esq. and Col. Richards. The band of the 1st Batt. Kings Own Regt. (by kind permission of Col. Lugard and Officers) was in attendance, and greatly added to the day's enjoyment.

Besides the exhibits there was a heartful collection of plants, etc. – not for competition, which was shown by Messrs. Shuttleworth and Company, and which added to the general attention. Mr. H. Wigley F.R.S.H. personally supervised the arrangements.

There was also a great variety of amusements, etc. in the grounds under the supervision of Mr. Mathews which appeared to be very well patronised. Mr. H. Blacknell satisfactorily assisted in fitting up and decorating the marquees. Messrs. Day, Mosdell, Miller and Phillips were the working committee, and the thoroughly successfully fete shows that their efforts

were not unappreciated. The refreshment department was ably carried out by Mr. G. Phillips of Fleet Road. Large numbers of all classes were present during the day and a very enjoyable time was spent. Among the prize winners were: J. Ralph, Miss Stevens, Mr. Goodyear, B. Higgins, G. Mellersh, G. Stevens, T. Jones, J. Kimber, Mrs. Day, H. Parnell, Mr. Potter, F. Robinson, G. Randall, Ann Taylor, Louisa Allen, J. Baggott, S. Wackett, C. Cranstone, J. Hoar, R. Grenham, G. Dimes, W. Gunner, Mrs. Potter and W. Vince.

1893: Mr. Philpott, late police constable at Hartley Wintney, and for many years stationed at Fleet, has just retired from the Police Force after 30 years service and will still reside in Fleet.

1893 August: Several thousand cavalry, infantry and artillery in full marching order, passed through Fleet during the latter part of the month to take part in the autumn manoeuvres, now taking place under the command of Lieut-General Sir Evelyn Wood VC.

The beautiful country for miles around Fleet has been covered with the tents of our CITIZEN soldiers who have been having their annual week's training at Aldershot. The VOLUNTEERS have very creditably passed through the trying ordeal, in some instances performing a march of 30 miles under a scorching sun. About 20,000 volunteers were under canvas from the 5th to 12th of August, and have taken part in every variety of manoeuvre culminating in a grand SHAM FIGHT in which Regular and Volunteer troops to the number of 40,000 were engaged. His Royal Highness the Duke of Connaught witnessed this impressive spectacle.

Church of England Temperance Society – Mission Van at Fleet

A Mission van of the above society stood on an open space in Fleet Road on Friday evening, 18th August. Mr. Aplin, a working carpenter from London, being in charge. The chair was taken at 7.30 pm by Commander Sullivan, RN who opened the meeting with a short prayer. Mr. Aplin addressed the audience stating there would not be any lack of employment and there would be a great reduction in the number of inmates of both the workhouses and prisons of this country if temperance was more universal. The speaker also observed that the contents of one pint of the best beer was said to contain: 17oz water, 2oz alcohol, 1oz sugar and gum. There was not so much goodness in beer as was supposed. The term Liquid Bread applied to beer was far from being a fact. The meeting was fairly well attended.

Fatal Accident at Crookham

A sad accident which unfortunately proved fatal, occurred to Herbert Kinge, 27, a flyman in the employ of Mr. J. Liming of the Wyvern Inn, Church Crookham. From the evidence given at the inquest which was

held at the Wyvern on Friday, 11th August, before Mr. Spencer Clark, County Coroner, it appears that the deceased had been engaged with William Cranstone and William Prizeman in doing some night work. After completing the job the three men went down to the pond in Gally Hill Brick Yard to wash their buckets. Prizeman left first, Cranstone directly afterwards leaving Kinge washing his hands. Cranstone waited about for some time for Kinge, but not seeing anything of him returned to look for him but saw no sign of him. He at once went off for Mr. Liming. On arriving at the bank of the pond, this gentleman saw a man lying on his face in about seven feet of water. He at once got the body out and it proved to be Kinge who (he thought) must have accidentally fallen in the water. Medical testimony was given by Dr. James Brunton, living for the present at Fleet, and the jury returned a verdict: That the deceased was accidentally drowned in a disused clay pit filled with water.

The Fleet Recorder 1893

Recorders' Jottings
The lighting arrangements at the Vestry Meeting at Crookham were – to say the least – somewhat primitive, there being no artificial light whatever provided until towards the close a lighted candle was brought in to throw a flickering light on the scene. Under these circumstances it was very difficult for the representative of the Press to take any decipherable notes and I trust on future occasions this drawback will be remedied.

On Friday, 21st April, 1893 the scholars attending the Fleet Schools gave a very interesting display and entertainment under the direction of Sgt. Major Pearson, consisting of Military, Swedish and Bar Drill. The children gave a selection of songs, recitations, etc., the musical portion under the direction of Mr. W. Wright. At the close Mr. J. Lindsay Johnson presented each of the children with a prize.

On Friday evening, 12th May, 1893 Mr. and Mrs. Gladstone arrived at Farnborough Station on their way to Minley Manor where they were entertained by Bertram Woodhouse Currie Esq., Mr. and Mrs. Gladstone left for London midday on the following Monday.

We understand that the Fleet, Crookham, Crondall and Ewshot Ratepayers' Association are to be reformed on entirely new lines, the first meeting is arranged to be held in September (1893). A well attended meeting under the presidency of Mr. G. Hill was held in the Fleet Hall when Messrs. C. Long and H. Blacknell, two of the retiring members, came forward as candidates for re-election. Both gentlemen gave an account of the various beneficial measures that had been adopted in the interests of the ratepayers.

First Newsagent

To the left side of the Waitrose Stores, there is a newsagents and stationery shop. This shop is within a few yards of where the very first newsagents shop and living accommodation was built just before 1890 by Mr. W. Crick. Before he ventured into business selling stationery, there were no daily newspapers available in Fleet. Mr. Crick arranged with the proprietors of the Times, the Daily Mail and the Daily Chronicle to have parcels of newspapers placed in the guard's van of the London train passing through Fleet Station at 6.50 am. By arrangement the train slowed down and the parcels of newspapers were thrown from the guard's van onto the station platform. Mr. Crick made it known that morning editions of the daily newspapers were available from his shop counter. Newspaper deliveries were made early in the morning by boys before going to school. The first newspaper boys were paid 2d for delivering 12 newspapers.

Mr. Crick, a most enterprising man, corresponded with the Headquarters of the Royal Mail Offices in London and, eventually, he succeeded in becoming a 'Collecting Place' for letters and parcels. An official Mail Bag laid on the floor in a far corner of the shop. Mr. Crick purchased and sold postage stamps just to facilitate use of his Mail Bag. Twice a week the mail bag containing letters and small parcels was conveyed to Fleet Station by willing shopkeepers who owned and used a pony cart. The mail train slowed down (not stopping) and the mail bag flung into the guards van, the guard throwing out an empty mail bag. W. H. Smith Limited opened a stall at Fleet Station and, at first only sold, but later delivered daily newspapers.

Now Mr. Crick had one son who had a remarkable career. From Fleet Church of England Schools he won a scholarship to Odiham Grammar School. He passed all examinations with distinction, proceeded to University and eventually was awarded a very senior Civil Service appointment as an advisor to HM Government. Although very old, he is now living at Ludshott Manor and is entitled to the following honours: CBE, B Comm (London), Hon LLD and FIB.

Chapter Eighteen
The Squire of Yelverton

Mr. Edwards, the Squire of Yelverton, decided to move nearer London as his only son, Jeffrey Edwards, had just become a qualified barrister and his three daughters needed more scope than village life. Before leaving Yelverton he donated a home for sick and distressed persons, which is still in use, according to his wishes.

Elmwood Approximately about 1890 a plot of land with about 500 feet frontage was bought in Branksomwood Road by Mr Edwards. A large house was built and named Elmwood. A staff of several servants were engaged, also a gardener and a groom to attend to the horse and carriage. The family left Yelverton and soon became well known in Fleet. Young Jeffrey Edwards seemed to have much spare time and regularly played cricket for the Fleet Cricket Club. His sisters were often seen at church and out shopping. All three Miss Edwards were well educated, could play the piano and sing and were brought up to assist and lead in the Yelverton Village Concerts.

Soon after moving to Fleet their parents died and so the son and three daughters continued to live at Elmwood and maintained the property with the original staff of servants. Sometimes Jeffrey Edwards rode a horse to the Station Hotel and then proceeded to London by train. He was proposed for and elected to the newly formed Fleet Urban District Council in 1904.

Legal dispute Soon after the Fleet Council was formed it became very heated over a right of way, and eventually went to the Royal Court of Justice in London. Mr. Jeffrey Edwards, as a barrister, assisted in the court proceedings. Mr. Chinnock inherited Dinorben Court, a miniature little mansion, which had stood for many years in splendid isolation, surrounded by thick pine trees. The house was approached from a lane which ran from Reading Road to Coxheath Road. Mr. Chinnock proceeded to spend a considerable amount of money excavating a pond for skating, and a range of stables for his son Bertram's polo ponies. He then improved the approach lane by planting rhododendron shrubs on both sides.

Villagers and other residents became alarmed as to their very old right of way. Agitation became heated on both sides and in 1906 Fleet Council went to High Court. The day was lost, despite Mr. Jeffrey Edwards and other legal experts. Mr. Chinnock then built entrance lodges and gates at

either end. A leather bound copy of the proceedings at Court were filed with the Hartley Wintney Rural District Council. After this court case, Jeffrey Edwards appeared to become busy with legal practices in London and became a fairly regular commuter.

Concerts The three Miss Edwards, still not married, began to organise concerts and amateur theatricals. Mr. Richard Pool had built a large building almost attached to Alfred Pearson's new offices at the junction of Fleet Road and Kings Road intended for a furniture depository. The Miss Edwards prevailed upon Mr. Richard Pool to allow concerts to be held there. A temporary but substantial stage was built, and each time a concert was held chairs were borrowed from many sources including places of worship. Gardeners and coachmen were expected to do some overtime, transporting chairs to and from what was beginning to be known as 'the concert hall'.

At Elmwood the three Miss Edwards regularly held a tea party for interested friends, and script writing of miniature plays was suggested. The scripts were written and carefully corrected ready for production. As a small boy I can remember taking part in these plays. Just picture the stage: a large table laden with tomes and scrolls of paper. Behind the table sat a General (an actual General) in full dress uniform, including medals and sword and assisted by five or six other soldiers in colourful uniforms. The script was 'cribbed' from the *Children of the New Forest* and the tableau lasted 20 to 30 minutes. The General and his men marched round the stage before leaving by the wings. The General's servant returned for his helmet, left on the stage, he then turned to me, standing all forlorn, and told me I was free to return to the cottage in the forest.

Another time *Westward Ho* was written into a playlet. The settings of the stage for both these items were supposed to be copies from well known paintings. The third play was a tableau taken from *William Tell*. I was then 11 years of age, and had to stand on stage with the apple on my head. A bow and arrow was too dangerous and difficult to use so the apple was cut through horizontally in half and then put together and placed upon my head. It was extremely difficult for an 11 year-old boy to stand still with an apple on top of his head. After interrogation by a tall officer in suitable uniform, lasting nearly 20 minutes, the officer drew his sword and made a mighty swipe horizontally an inch or so above the apple. I nodded at the precise moment and the apple, in two pieces, fell at my feet. My father a very quiet man, never interfered with his children's pursuits, but he did allow me, after the foregoing event, to be released from performing on the stage.

Several plays by adults were organised by the Miss Edwards. The principal man was always Mr. Harvey, whose son became Geoffrey Harvey

of the BBC, and featured in many broadcast plays. The indefatigable Miss
Edwards, having nothing to do, laid siege to Generals in Aldershot with
the result that an Army band in dress uniform arrived and gave a concert
for the Gordon Boys Home. This was an orphanage for boys whose fathers
were killed in action. These boys, although still quite small, were dressed
as soldiers. Several Army bands were shamed into giving musical
performances, usually in aid of charitable organisations, especially the new
and highly publicised Barnardos Orphanage. The Miss Edwards were very
much preoccupied to amuse themselves, often in public playing the piano
and accompanying concert singers, sometimes playing solo pieces or
themselves actually singing, mostly for church concerts or other good
causes.

The Great War To the north side of Elmwood was a piece of land large
enough for the site of another house. The Miss Edwards and their brother
always hoped for weddings to occur in their family. Mr. Jeffrey Edwards
agreed with his sisters to build on the land adjacent to Elmwood. A large
corrugated iron room was built and match-board lined, all especially
constructed for the entertainment of suitable cadets from the OCTU camp
at Tweseldown. Many of the young cadets rushed into marriage knowing
their chances of death were high. The grand piano from Elmwood was
moved into the building and their brother helped with a full-sized billiard
table. The place was well heated in the winter and tables and chairs were
placed at one end for dispensing tea and snacks. Undoubtedly the place
was fully used, especially at weekends. The Miss Edwards almost gave all
their time to running the social and catering side of this good project, but
at the end of the war all three were still single!

Jeffrey Edwards death The oldest sister ran the domestic affairs at
Elmwood. The second sister spent much time painting in water colours.
The youngest sister became the district representative of the RSPCA.
About 1929 Jeffrey Edwards died. After his death it was found that during
his visits to London, he withdrew many large sums of money from the
bank and, as cash, it disappeared without trace. The three sisters were now
too poor to continue at Elmwood, servants were dismissed and the house
sold. A much smaller house was built in the grounds north of Elmwood.
The sisters did not live together in their new house called Fircroft. The
eldest died first, followed by her next sister, the youngest after a short spell
at the Yelverton Home died in 1960.

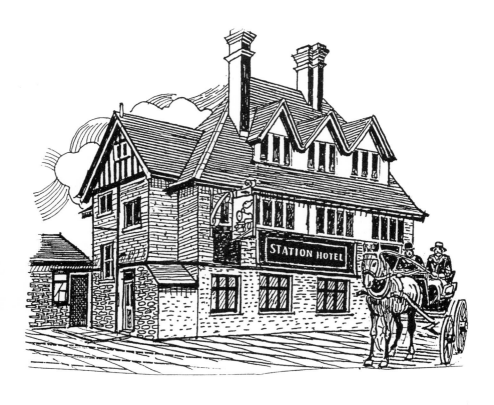

Station Hotel.

Chapter Nineteen
The Calthorpes & Mildmays

Calthorpe Estate

Home Farm and Elvetham Hall The Calthorpe Estate relied upon its Home Farm at Hartford Bridge to supply agricultural produce to the many inhabitants of Elvetham Hall. In addition to those living in the Hall, probably 20 persons, the place was surrounded by cottages for the butler's family, three gardeners, several grooms, two chauffeurs, and a house engineer to keep the gas, electricity, water supply, cooking and sanitary apparatus in good working order. Men were continuously employed mowing lawns, keeping the large park tidy and well fenced.

Before the advent of the Forestry Commission, several foresters as well as gamekeepers helped to maintain the estate. On the outskirts of the estate were more than 12 cottages to house these workers including those employed as agricultural labourers. There is little evidence of hunting activities on the estate, but gamekeepers reared several thousand pheasants each year. Many titled persons and members of the aristocracy attended the shoots when hundreds of pheasants were shot.

It is worth mentioning that although the Hall was restored in 1800 and again improved at the latter end of the 1800s, the estate cottages, many visible today and extremely pleasant to see, are externally as they were in Elizabeth I reign. Early in 1900 the household staff were paid by the butler, but the estate and agricultural workers were paid at mid-day on Saturday at the office of the Home Farm. A queue of men and youths stretched from the office door right out into the road. A man's wage at that time was £1 16 shillings per week of unspecified hours; long hours were often worked at seed-time and harvesting. A boy was lucky to earn 7 shillings a week.

The early conditions were always bordering upon hardship. A farm worker married with three children told me that his bread bill had prime importance. The baker with his pony and van called at Rotten Green twice a week and his wife paid cash each time for seven large loaves costing each in old currency 2½d. Rabbits, chicken and eggs helped feed the family. Two families in semi-detached cottages might share the upbringing of a pig which, when fully reared, provided meat for several weeks. A farm labourer would work from breakfast time until dusk with a mid-day break to consume half a loaf, a large raw onion and a few minute scraps of bacon or pork. Barley water was drunk straight from a bottle,

perhaps cold weak tea without sugar and milk.

During the last 100 years it must be said that the Calthorpe Estates at Elvetham were very progressive. Farm houses and farm buildings were well maintained and improved. Company's water was made available as soon as possible with a network of supply pipes to every farm and cottage. Retired and possibly infirm workers have been housed in a small complex of bungalow type accommodation.

Rectory When the Hall was restored, a Rectory was provided for a residential Rector, whose duty was to lead the household in prayers early each morning. Often there was a Communion Service held for the family. The Rector held Sunday services at the small church near the mansion and the estate workers and their families were expected to be present, many families walked more than two miles to get to church. These daily acts of worship were probably instituted in the reigns of Henry VIII and Elizabeth I as the Calthorpes can be traced back to Catherine Parr.

Cricket The young male members of the family were educated at public schools and this led to the building of a small well-designed cricket pavilion and the laying down of a cricket pitch within the park. Young men of the family, together with guests, augmented by several estate workers, played regular matches during the summer season. It was considered a very pleasant occasion by members of the Fleet and Hartley Wintney Cricket Teams to play Elvetham. Lady Calthorpe and friends often watched matches and play almost stopped as these important persons arrived attended by the butler and footman bearing chairs and cushions.

School The estate workers, all living in estate cottages, were so numerous that a village school and schoolmaster's house was built near Fleet on the Hartford Bridge Road. The last schoolmaster was Mr. Titt, who taught several dozen children. These children walked nearly three miles to school, some taking short cuts across country. Lady Calthorpe often visited the school and end-of-term teas, plays and singing were also held in the village hall situated behind the school.

Michaelmas Rent Session Years ago the Estate owned the Whyte Lion Hotel at Hartford Bridge and here, each Michaelmas, a male member of the Calthorpe family, accompanied by the Bailiff, spent all the evening receiving a year's rent from the farmers and other rent paying tenants. Many discussions took place appertaining to both farming and other similar projects. After consumption of refreshments, speeches were made, sometimes broad hints were uttered and everyone went home knowing

that a pleasant and amiable time might be anticipated at the next
Michaelmas Rent Session.

Changes Alas during the last 40 years, mechanisation of farm work and
the closing of the Hall as a family residence, and then the sale of Hartley
Wintney cottages, meant the end of Elvetham as a village. Church and
school closed, estate workers were not needed and now less than 12
workers are employed around and near Home Farm. The large staff once
required to run the Hall have all disappeared. Now the few men who do
the same agricultural work, have their own cars and usually have bought
their cottages. Mechanisation has depleted the work force and one man
can now do the work previously done by 10 men. Modern agriculture, with
machines and large fields have diminished the population of Elvetham
despite the continuous good husbandry emanating from Elvetham Hall.
The extreme changes which have occurred at Elvetham and Hartford
Bridge have really been a levelling-up process.

The foregoing illustration of the change at Elvetham shows that, even
with progressive schemes of adequate maintenance, even over a very large
area, cannot prevent changes occurring all caused by extensive
mechanisation throughout the farming world. These facts illustrate the
extreme difference between the two localities. Elvetham: truly rural and
diminishing or with stagnant growth. Fleet: during the past 50 years
increasing its population from 4,000 to almost 30,000.

Leawood In 1947 when the local council bought the Leawood land as a
site for a Council Housing Estate, the land opposite the small general shop
consisted of heather, gorse and broom with fir trees approximately 15 to 20
feet high. The Deeds, dated about 1900, were of an exchange of land by
Mr. Keep of Crondall, exchanging this site with the Calthorpe Estate, as
the Estate owned the surrounding land. The Deeds described the area
from Stanton Lodge to Whites Farm fronting the north side of Crookham
Road, as farm or agricultural land. The proposed council site was described
as a field for grazing but capable of producing crops of corn!

A 100 years ago a large portion of the land, adjacent to Tavistock Road,
consisted of different areas about field-size bounded by ditches and banks.
Apart from a few large oak trees the whole site was covered by bracken.
As this area had very many horses and ponies, used as means of transport
and for haulage, the bracken was reaped by sickle each October and stored
dry for bedding cows and horses during winter. The dried bracken formed
a dry bed, made excellent manure and the animals did not eat it like hay
or straw. Tenants of the Estate were allowed to gather the bracken free of
charge.

Dogmersfield and the Mildmay family

Catherine of Aragon To the west of Fleet and just beyond Pilcot, is the hamlet of Dogmersfield wherein is the large estate and the past home of the Mildmay family. The history of the park and mansion is well known and recorded. School children were shown a few pieces of stained glass in a leaded window pane and told that this was a portion of portable windows which always accompanied Princess Catherine of Aragon wherever she travelled and temporarily resided. It was said that the tiny bits of coloured glass were part of Catherine's armorial bearings. It is recorded that Prince Arthur, son of Henry VII, kept her waiting at Dogmersfield for quite a long period. Years ago this building was a small cottage adjacent to the Queens Head Pub: the name Catherine of Aragon's Cottage has been so mentioned for a very long time.

Dogmersfield Hall Sir Gerald and Lady Mildmay lived 'in style' in the Hall with a about 60 staff of domestic servants and agricultural estate workers at Home Farm. At one time the whole of Dogmersfield was the home of families attached to the estate, including the blacksmith's cottage and forge, also a large laundry employing several women. One Easter the church organist was too ill to go to church and play the organ. This was early in the 1900s. My father bicycled to Dogmersfield to officiate as organist. When he arrived he found the path from the church gate lined on either side with children, girls on one side all wearing Red Riding Hood cloaks and hats, boys each wearing black brimless, rather large caps.

Sir Gerald and Lady Mildmay arrived at the church gate driven by a liveried coachman in a smart open brougham carriage. The Rector, already robed for the 11 o'clock service, waited at the church door. Lady Mildmay preceded Sir Gerald along the path. Walking slowly, she gave each boy a very keen stare, then, turning to the girls, she completed her counting. Should a child be missing she enquired its name and the reason for its absence. Should a missing child be ill, someone from the 'Hall' was sent to the child's home to enquire about its health. This was followed by a basket of invalid food. If an older girl became pregnant without marriage, she was immediately sent away to a distant estate owned by relatives of the Mildmays.

Christmas Ball During the late 1800s, Mr. Edwards a schoolteacher at Fleet, was known to be an accomplished musician and he was approached with a view to help with the music for the servants' Christmas Ball. Now the earliest known builder in Fleet was Mr. Page and his two sons who built the oldest houses near Fleet Hospital and in Avenue Road. His two sons were accomplished 'Fiddlers'. My father, Mr. Edwards, obtained agreement with these two young men to help with the dance music. Mr.

Chivers agreed to play his cello or double bass. This quartet met and practised in the cellar of Vollers shop at the corner of Church Road.

A shooting brake, an open horse-drawn vehicle, built with four seats facing each other just behind the driver, was sent from the Hall to convey this 'orchestra' to the Hall. From 7.30 pm to 8.00 pm refreshments, or rather food, was served in an adjoining room. Plenty of plates piled high with cold beef, venison and ham. Hot bread rolls and beer, all from the estate, were consumed until 8.00 pm. No spirits were available. Right on time the music struck up, the piano, two violins and cello. All the old dances and the waltz were danced. The last but one dance was the Quadrills or Lancers. At nearly 2.00 am the Post Horn Gallop was played and danced. The music was fast and furious, assisted by someone in the doorway playing a fanfare on a mail coach horn. The last dance was followed by the playing and singing of John Peel. The pianist changed to playing a large whistle pipe, the coach horn joined in, also several huntsmen's horns were playing a call, even a very young man with a bird scaring rattle! A good time for all was over. The return journey of the musicians in mid-winter was long, cold and tedious with the horse having to walk slowly up each hill.

Trafalgar oaks It is worthwhile to record the following fact about the Mildmay family. John Cobbett, who wrote *Rural Rides*, recorded in his diary that: "Just three years after Trafalgar he was riding his horse through Hartley Row, and stopped his nag to observe Lady Mildmay superintending a gang of labourers planting oak saplings all over the village commons and greens."

Post 1914-18 After the end of the first war, the family gradually began to peter away. During the last years of the 1914-18 War, the elderly Sir Gerald cycled into Odiham each Thursday to take his place on the Bench at the Magistrates' Court. The family consisted of a son and a daughter. The son, Anthony, was commissioned into a Guards Regiment. Anthony and his sister, Dilly, were keen horse lovers and were often seen riding in the countryside. The parents were very old when Anthony lost his life in his late 40s. The only daughter married Col. Wallington, but neither appeared the type to manage an estate. Dogmersfield Hall and Estate became vacant property. Gradually all the staff employed there dwindled away. The estate workers cottages in Chatter Alley became empty and were converted into four and five bedroomed residences.

The foregoing experience is mentioned to show that, until 1918, Dogmersfield was a complete unit, self-supporting in every way. The estate had farm produce, corn milled into flour, a great vegetable garden, carpenters, wheelwrights and a blacksmith. The village carpenters, Neville

and Trimmer, helped to maintain the buildings and act as undertakers. The large laundry became vacant and the name of Mildmay is almost forgotten.

Postscript Not only is Fleet changed out of recognition, so have the parishes of Elvetham and Dogmersfield. However, they do still remain as almost beautiful hamlets, as they have done for several hundred years. Fleet will soon become a completely different place. I write about how pleasant it was for everyone to stroll about the pavements of Fleet Road. No continuous crowd movements, but space and quietness to talk to neighbours and councillors and to enjoy the pure atmosphere and sunshine. All food requirements purchased from willing small shopkeepers in a leisurely manner. Every food necessary for day-to-day consumption readily and quickly delivered regularly to the customer's address. Life moves on, but not everything can be called improvements.

Chapter Twenty
Local Families

Barker and Cooper

Two of the oldest names going back for many generations were Barker and Cooper. The Barkers were mostly carpenters and one member, George Barker, became a builder and built quite a few houses in the Pondtail area. His residence and yard were in Kings Road, immediately opposite Albany Road, and the workshops have now been converted into living accommodation. George Barker died in his old age in 1930 having many well-built houses to his credit. In Guildford Road he built The Lodge, Leyburn, Coomete for Lady Chichester, Homelands, Pondtail Lodge, Guildown for Lady Boyce and Woodside. In Wood Lane, Tettenhall and Lobswood. In addition to these fairly large houses, he built several three-bedroomed houses in the centre of Fleet. The last generation of Coopers moved to Farnham about 1935. I mentioned this family early in this record as the first man to cut gent's hair in Fleet.

Blacknells

Mr. Harry Blacknell built himself a house in Albert Street and married the housekeeper of the first Vicar of Fleet. He had one son and two daughters. By the end of the 1800s, he had formed a thriving business, giving work to about 30 men. His yard (now Sandell Perkins) was about 150 feet wide and stretched from Fleet Road to Albert Street. At first he employed men to do 'odd jobs' – fencing, plumbing and building additions to houses. His yard with large timber sheds stocked and sold many requirements to build and to repair local properties. Mr. Blacknell must have supplied and fitted hundreds of well-pumps and also attended to their upkeep and repair.

Ironmongers Before 1900, Mr. Blacknell had established himself as a supplier of general ironmongery sold from his large black sheds in his yard. The timber business had greatly expanded and the yard was so congested with his timber merchants business, that it was too dangerous for the public wanting nails, etc. With his men, he built a shop in Fleet Road and soon stocked and sold an extremely large range of ironmongery. He ran a large sawmill adjacent to the ironmongers, the sheds and sawmill were powered by three great Wallis and Steevens steam engines and these monsters provided sufficient power to run a generator thus enabling the shop, sheds and yard to be illuminated by electricity. Loose wires were

strung about in all directions with light bulbs attached, but as soon as the engines were out of use the lighting became very dim as there was little or no storage.

Timber yard In the yard were now three large steam engines, one inside a huge shed, two standing in the yard. Several long leather belts, five inches wide and several feet long, transmitted power from the steam driven flywheels to large circular saws attached to long benches for placing tree trunks in position for sawing into required sizes. The whole place was a busy hive of industry with many men hard at work. There were no regulations for safety precautions and none were even thought of. If was a most dangerous place with fast driven belts, without guards, and large logs of timber being manhandled about by means of crow-bars. Children, or rather small boys, were shouted at and wrathfully waved away. Every inch of ground was used and the men often had to clear a way for horse-drawn vehicles bringing in unsawn trees or taking away sawn timber. At this period, there was no other saw-mill in Fleet, so almost daily various kinds of trees were hauled to the premises, usually by a pair of horses to each timber trolley. Spare horses could be harnessed to assist with haulage over hills or bad roads.

Sawn timber of various kinds: oak, ash, larch and fir were much in demand throughout Fleet and adjoining districts. The firm of Blacknells bought Scandinavian timber from the Southampton importers *Tagget Morgan and Coles*, who placed the timber on the London and South Western Railway for haulage to Fleet Station. The short lengths of Scandinavian timber were usually included in each purchase. This was usually 4 inches by 2 inches yellow deals up to but not beyond 12 feet in length. Sawn timber, particularly hardwoods, were quickly sold, especially to numerous wheelwrights throughout the district. The means of transport were all horse-drawn vehicles, carts, wagons, carriages, traps and delivery vans, as well as wheelbarrows. All necessitated a seasoned supply of oak and ash as supplied by Blacknells.

Nothing in the yard was wasted; small odd pieces of wood helped to fuel the steam engines. Other small pieces of wood were sawn into given lengths and stacked ready for use. As a boy of 13, the writer of these words would, in the school summer holidays, go to Blacknells Yard and sit on an 18 inch high stump of wood. Beside him were neatly stacked small pieces of wood and a box of nails. Given a hammer, he was instructed how to make a seed box using a given number of nails in the right places. Payment for a dozen seed boxes, all properly made, was 3d. Four dozen completed boxes and one went home with the magnificent sum of one shilling. After completing three days of monotonous work, it was usually deserted for a game of cricket or a swim in the pond or the canal.

Boxes for fish, fruit and groceries were all made and carried to Fleet Station and thereby to various destinations. Mr. Blacknell was a very astute man, very enterprising and also full of good works. Dressed in black and wearing a Churchill bowler hat, he regularly attended church. He supplied several 10 feet by 4 feet 4-inch oak posts with oil lamps thereon and these were the first ever street lights. In Fleet Road, near his new shop and towards Church road, three small shops had been built. The road was there but the footpath was non-existent, so Mr. Blacknell laid hardwood offcuts as a dry walk. Whether decisive or not, this became an official address and known as 'The Pavement'.

Mr. Blacknell owned a grass paddock in Albert Street, now the site of the Albert Club. Here, he grazed his own private riding horse. He had three saw pits dug about 8 feet long, 3 feet wide and 7 feet deep. Cross timber bearers were placed across to take the weight of large oak tree trunks. Two ex-drunks were given a 6 foot cross-cut saw to saw through the centre of a tree from one end to the other end. One man stood on top of the tree, the other down in the pit amongst the falling sawdust. Mr. Blacknell knew a day's work and if this was carried out, the sawers were each paid about 4 shilling and 6d. Beer was then 2d per pint!

Councillor Mr. Harry Blacknell was one of those elected to the new Fleet Urban District Council upon its formation in 1904. He certainly helped to get the Council going and each project was analysed to know if the subject was a possible improvement attainable without exceeding the Council's limited budget. He became to be what was known in those days as 'a leading light' and was respected for his fair-mindedness in dealing with all other persons.

Farnborough He purchased a new yard between the cemetery and Farnborough Railway Station. However, he died early during the 1914 Great War. His only son, Harry, was also killed and Mr. George Crowhurst, his managing clerk, who had married his daughter, Bertha, became responsible for the business. The 1914 War was not helpful to progress, which was slowed down by the loss of the hardwood trade. Gradually, the Fleet business was closed down and only the sale of softwood timber was continued at Farnborough. Mr. Blacknell's youngest daughter, Ella, who was a qualified schoolteacher working at Fleet Church of England School, married Mr. Chris Liming, a member of the well-known Crookham family of Limings. Chris became a naval commander and was awarded a medal for meritorious service. It became known that he commanded a submarine during 1914 and he was responsible for the very first German ship to be torpedoed by the Royal Navy. After the 1914 War, the whole business declined and in 1930 it was acquired by a company

which retained its old name. Eventually, this company moved to Queensmead, Farnborough, and became quite prosperous. However, in 1986, its future is again uncertain.

The Blundells

Mr. and Mrs. Tom Blundell had two sons, Walter and Ernest, who were born during the last 10 years of the 1800s. As soon as they were at school, Mrs. Blundell purchased a tricycle from Mr. Collis, who assembled and sold bicycles in a shop in Church Road, quite near to the schools. Mrs. Blundell, a rather short and plump woman with an extremely pleasant manner, rode about Fleet on her tricycle with baskets 'fore and aft'. In those early days when Fleet only had a few hundred inhabitants, everyone seemed to know their neighbour's business. This quite kindly woman would call upon any sick person and would act as a nurse, giving every assistance possible. It was more than 20 years later before a District Nurse was appointed. Mrs. Blundell was exceedingly helpful maintaining a strictly clean hygienic manner coupled with a Christian outlook. Her continuous helpful actions were maintained for many years without thought of reward.

X-rays By the time her two sons were to leave school, electricity was becoming available in Fleet. The two boys served their apprenticeship as electricians and before they were of age, they were installing electric wiring systems to the larger houses in Fleet.

During 1928 Kodak sent a complete X ray apparatus to Fleet Hospital. The consignment also included assembly directions and some instructions for its use. The Blundell brothers assembled the equipment into working order. Meanwhile, Kodak had written requesting Fleet Hospital to send a suitable young female to a neighbouring hospital to take a course of practical work under a radiographer. The doctors and hospital staff were impatient to make use of the X rays. Quite unknown to the public, Walter Blundell abandoned his work when the doctors requested his help, and proceeded to the hospital and satisfactorily acted as radiographer for almost a year. (Trade unionists or radiographers should not read the above paragraph).

Walter Blundell had a son and daughter, the son, Herbert, grew up and also became an electrician. Both father and son were respected and liked for their good work and reasonable charges.

War service In the last war Herbert served in the RAF as an electrician. After the successful battle for Caen, he went to a meeting to arrange the telephone wires from a captured airfield to be reversed in the opposite direction. He had previously been engaged on similar work. The officer

stressed that the urgency of completed work was imperative. After the meeting, Herbert arranged with his officer that he would go to the nearest village and obtain a third kit bag of cotton reels. Later he successfully grouped wires through marked cotton reels and the reversed wiring was completed in three days. He was awarded a medal for this enterprising work. Later he received another medal for similar helpful work. He died in early middle age being missed by his contemporaries as a very modest person who lived and died in Fleet.

Brothers

Ironmongers Mr. Charles Brothers purchased the original general ironmonger's shop, built and successfully run by Mr. Blacknell before 1900. Early in the century, Mr. Brothers rapidly increased the business. In the yard of his shop was a workshop with a blacksmith's forge together with equipment and heavy tools, especially designed for repairing and replacing worn parts of hand-worked water pumps. Well water was the only means of a water supply to houses both large and small, and if a pump 'broke down' it was very serious. Mr. H. Blacknell and then Mr. Brothers employed two skilled men to go and repair these pumps. Two men were necessary, one down the well and one at the top. Tools and spare parts were let down the well, or up, by a piece of sash cord. Heavy tools were usually put into a canvas bag as a precaution against any accident occurring. The pumps worked in a similar way to a bicycle pump having a clack valve two inches in diameter sealed by a specially greased leather washer. Continuous daily use of pumps in large households meant replacement of the leather washers every few months. The two men from Mr. Brothers' yard often worked late hours. Also Mr. Alexander, Mr. Edmonds and Mr. Prizeman were plumbers who spent 50 per cent of their time repairing well pumps throughout Fleet and its neighbourhood.

It has already been explained how, in the course of time, open fireplaces and ranges for cooking were replaced by the Gas Company installing black cast-iron cookers with burner rings on top. This was also the death and end of the general use of the heavy cast-iron kettle. Cast-iron kettles of all sizes, some very heavy and large, others only pint size, were found in all households both in cottages and large residences. These black kettles have all disappeared and can only be found in use in remote places such as parts of the Shetlands and Ireland. The pumps and the water buckets have also disappeared.

A minor sideline of work for Mr. C. Brothers' 'engineers', who were very skilled men, was brought about by and with the popularity of the gas cooker. Tin kettles appeared on the market and came into general use. A pint-and-a-half capacity tin kettle could be bought for one shilling and sixpence. Poor people bought their broken tin kettles to Mr. Brothers'

workshop and waited while Mr. Tom Blundell resoldered on a broken spout or patched a leaky kettle bottom. Tom Blundell was extremely clever and capable of all types of repair, always undertaking repair work from pump repairs, sharpening garden and farm implements, replacing broken handles to spades and forks, fitting keys to locks and making special large and heavy hinges for coach house doors. Two types of work were constantly demanded: sheet iron cover-down plates with soot doors for sealing the flue off over a kitchen range, and the renewing of sash cords for sliding sash casement windows. Nearly all the houses built between 1860 and 1910 had windows needing sash cords.

Builders merchants Vastly increased stocks with deliveries were made by horse and van. After the 1914 War, Mr. C. Brothers' business rapidly expanded into the builders merchants type of trading, with ample stocks necessary for building work and farm maintenance. The firm's horse vans delivered heavy goods such as galvanised sheets of iron and plumbers requisites which, in those days, was mainly galvanised steel tubes and heavy brass fittings. One van delivered paraffin from a 200 gallon tank, also methylated spirit, linseed oil and turpentine. The stocks included kitchen utensils, screws, and every type of hinge from half-inch brass cabinet hinges to great 'hooks and rides' to use on coach house doors.

Attached to the large shop were somewhat rambling stores or warehouse accommodation. Here, suspended from the ceiling, could be seen old blackened electric light bulbs. These loose hanging fittings were 'relics' from the original owner, Mr. H. Blacknell, who built the shop and ran a large sawmill adjacent to the shop. Mr. Brothers' business prospered until, in its heyday, four or five men were employed in the shop, several more in the yard, also a permanent clerk in the office. Plumbers and fitters for house repairs including pump maintenance, locksmiths including a carpenter brought the total staff to 20 – all men.

Edwin Brothers and radios Mr. C. Brothers had one son Edwin born in 1906. During his school days he became intensely interested in radio, and before leaving school had progressed from making a 'cats whisker' radio receiving set to making a radio set with valves and a speaker – alas not a 'loud speaker'. His interest in this field did not abate and he was soon making radio sets for friends and neighbours. Originally there was great difficulty in energising or supplying power for these receivers.

By 1925-27 Marconi and Mullard and others were manufacturing or selling radio receiving sets with loudspeakers all combined in one cabinet. Motive power was still a problem, but was overcome and for several years radio sets were powered by a small accumulator. These acid plate accumulators were made in their thousands and according to use, the

power, therein lasted 10 to 14 days. These small accumulators in their glass containers, complete with handle, were taken to Brothers' shop for recharging. Radio became very popular, principally because the sets were within the price range of everyone's purse. For several years Brothers' must have recharged hundreds of these accumulators and had to employ a boy and a man to attend to the timing and linking up dozens of accumulators each with the owners name thereon.

However, within a few years, quite a few firms were manufacturing radios which were capable of being energised from a lighting plug found in the normal household system, now rapidly being installed throughout Fleet and almost all the country. Mr. Brothers' son Edwin now followed the up-and-coming everyday use of radio by heading a separate department in the shop for the sale of radio sets and, most important, the repair and adjustment of any faulty sets. At that time there was no other radio shop in Fleet. Mr. Brothers senior had additional accommodation built with a plate glass window at the right-hand frontage to his ironmongers shop to house the new radio department. Edwin, who had an extremely good knowledge of these new products was most interested in the new television project and received much information and knowledge direct from Marconi's. About 1935 he perfected his own constructed television set and, in 1937, he sold the first Marconi television set to be bought in Fleet. The sales of television sets were fairly slow and at the outbreak of war in 1939 all transmissions of television were completely stopped.

Radar and television Mr. Edwin Brothers' knowledge enabled him to serve his country to assist in the urgent rapid build-up of the Government's radar systems. After the war, in 1945-46 Mr. Brothers senior, who was reaching retirement age, planned to sell his now large builders' merchants business and retire. His son purchased a property in a central position in Fleet Road (now Cockram and Day, jewellers), and for nearly 10 years he was the only source of supply for television sets. Gradually other radio and television shops appeared and now in the 1980s, shops selling radios, televisions and recorded tapes proliferate everywhere. Here was a father and son who, however small or large was their business interest, were always constantly available to advise their customers.

Hankins
Cartage In 1902 Mr. F. V. Hankin came to live in Fleet from Poland Mill. At first he rented a cottage, but purchased a fairly large plot of ground in Clarence Road. Stables and cart sheds were built and with two or three horses and carts a cartage business was commenced.

Fleet only expanded at that time by the reason that large houses were being built, and for the first time these houses were sited well away from

the roads, usually approached by a driveway leading to a well secluded position. During the period 1900-1914, there were extensive gravel pits in different parts of Pondtail where gravel was excavated by hand and readily sold for house foundations, drives and sometimes liberally laid on roads to facilitate means of approach to house building sites.

Mr. Hankin hired out a horse and cart, including a carter, for a shilling a job. The cart-horse and cart could carry nearly a ton in weight, usually three-quarters of a ton mainly because of poor roads, especially where the road sloped or went via a hill. The hill just past the Oatsheaf often had its top gravel surface washed away in stormy weather and cart-loads of corn for Fleet Mill and loads of bricks and roofing tiles from the Crookham, Crondall and Ewshot Brickyards were sometimes impossible to pull up the hill. The drivers assisted each other by harnessing two horses to one cart or wagon. Coal by the ten-ton truck-load and London Fletton bricks arrived each working day at Fleet Station. The majority of these heavy goods were hauled away via Fleet Road. The Fleet Road, approaching Kings Road, is a steady up-hill pull for a heavy horse-drawn vehicle. Should a 'gentleman' or 'lady' see an overburdened horse struggling along at this part of the road, a noisy altercation often occurred, very much to the enjoyment of any small boys who happened to be nearby.

Near the crest of Beacon Hill, Ewshot were many sand pits where fine building sand was dug. This sand was always much in demand as it was especially used in plaster-work. Mr. Hankin charged one shilling for hauling a cart-load of sand from Beacon Hill to any part of Fleet. He paid cash for the sand at the pit, the cost was 2 shillings for one cubic yard. In 1918, with his horses and carts, he carted London Fletton bricks from Fleet Station Yard to anywhere in Fleet and Church Crookham for 3 shillings a load of 500 bricks. Usually the majority of these bricks were 'inside' bricks costing 52 shillings per 1,000 in truck-loads to Fleet Station Yard. A red brick for facing cost £3 per 1,000.

Builders merchants and haulage From 1920 onwards the building of small houses rapidly increased. This spate of business increased Mr. Hankin's trade and he and his two sons purchased the very first Bedford motor vans ever to be used in Fleet for any type of haulage work. Building commodities were still very cheap, Mr. Hankin could buy earthenware glazed drainpipes and fittings from Pool Potteries delivered to Fleet Station for about a railway truck load costing say £7. These purchases to sell again gradually made Mr. Hankin a budding Builder's Merchant. After many years of hard work the motorisation of his haulage business was much accelerated, but generally speaking it entailed much hard graft.

Immediately after the end of the Great War, Fleet Urban District Council completed the sewer drainage of 90 per cent of Fleet. Therefore,

every house endeavoured to be connected to the main sewer.
Houseowners with little spare cash often with the help of someone who
was a tradesman in the building trade, connected their houses to the
sewers. Usually about three days work was entailed, digging the trenches
and laying the drains. In 1925 the cost of 50 foot run of drains necessary
for a three bedroomed house was just over £20. Many odd drainpipe
fittings plus cement could be obtained during Saturday mornings by going
to Mr. Hankin. Hundreds of earth closets with often queerly constructed
cesspits with open air overflows ended about this time. A wonderful step
forward!

Wiggins Sankey from Hayes Wharf had rented a site and opened a
depot for the sale of bricks, lime, cement and drainage ware. This depot
was in Fleet Road beside the Off Licence. Wiggins Sankey employed Mr.
Hankin's vehicles for all their deliveries. However, the firm suffered from a
'take over' and immediately closed their Fleet depot.

Mr. Hankin was quick to stock a large quantity of heavy building
requirements. He and his sons often unloaded by hand 10 tons of cement
in hundredweight sacks before attending to the daily schedule of work and
deliveries. A house was built in his yard for one of his two sons to live in
and keep an eye on the free standing stocks. The business became greatly
expanded because all goods ordered for delivery at a certain time and
place, were certain to arrive exactly as requested. The Builder's Merchant
and Haulage business of F. V. Hankin expanded into a thriving concern,
using more than six Bedford lorries for deliveries also employing several
drivers and yard-men. At this time there was no local opposition and
'Hankins' became a by-word as a stockist and reliability for all materials
used in the rapid expansion of houses in Fleet. After many years of hard
work and personal supervision and accounting, Mr. Cyril Hankin, now as
sole proprietor, sold out to Robert Adlard who continues the still thriving
business.

DIY shop After several years of retirement with an interest in growing
orchids, Mr. Hankin and his son Roger came out of retirement and
purchased the property and business in Fleet Road now trading under the
name of F. V. Hankin and Son DIY. The growth of Fleet before 1950 owes
much to quite a few persons who, by hard work and constant attention
and enterprise, not only assisted the local people in many ways, but also, at
the same time, brought a certain prosperity to themselves.

Kimbers

On the corner of Fleet Road and Kings Road (opposite Pearsons) stood Kimbers Off Licence. It was demolished in 1985 for the construction of a large block of offices. Kimbers corner was known as a bus stop for the Aldershot Bus Company and remained on their timetable until recent times. 'Kimbers' must have been one of the very oldest buildings in Fleet. The roof and the original window timbers were constructed of English oak. I write these words at the age of 80 years and my grandfather always remembered Kimbers as very old. The windows were small and a small verandah on two posts stood in Fleet Road. Years ago, in summertime, a 4 foot long stool was sometimes put out under the verandah. The family of Kimbers can be traced back as living at the Off Licence for near 200 years.

Horses In 1860, John Kimber the tenant, bought nearly two acres of land adjacent to the Off Licence. He 'broke in' carriage horses and ponies and needed the land for intermittent grazing as wild horses do not take kindly to stables. The rear of the properties in Fleet Road, between Avondale Road and Kings Road, left the area bounded by Pinewood Hill quite undeveloped. Pearsons Auction Rooms and other properties now occupy this ground. Here from 1860 until 1900 John Kimber broke-in young horses tethered by a long rein. Gradually the natural heather was worn away and the ground manured by the ponies and horses, the site right down to Avondale Road became green with grass, kept short by the ponies. It was a lovely oasis of green with one or two large chestnut trees.

Carriages and cabs John Kimber progressed from breaking-in horses and ponies to building a range of stables and sheds for his use, as he was to commence a business of 'Carriage Proprietor and Cab Owner'. Soon he had two cabs (known as Flies) regularly plying to and from Fleet Station. Soon after he became established, the Officers' Club was built at Aldershot. Many retired officers lived in Fleet and the Club, with its tennis courts, croquet lawns and cricket pitch, became a centre of entertainment for young officers who welcomed young lady guests from Fleet. Introductions were quickly established as the daughters were born and fathered by officers who had served in Aldershot.

During King Edward VII's reign, a continuous spate of dancing occurred and there seemed ample cause for Balls and Dinners to be held. Motor cars were not in use. John Kimber purchased horses and broughams (closed or open carriages), a continuous use was made of these vehicles to ferry young ladies to and from Fleet and the Officers' Club. In the winter terrible conditions prevailed; the road was rough; the vehicles' oil lamps gave little light. At the Club, horses and carriages stood waiting until 2.00 or 3.00 am. The horses were rugged and the drivers found shelter, often

from bitter east winds and snow. John Kimber remained up and about until the vehicles returned. In the harness room a tortoise stove heated hot bran mash for the horses. Living nearby, as a child I was often woken by a fierce altercation between John Kimber and his drivers who were threatened with dismissal if all the harness and the horses were not thoroughly cleaned and dried.

Mardles

Stonemasons The building of the Methodist Church in 1899 at the corner of Branksomwood Road and Fleet Road, brought the family of Mardles to Fleet. The church was to be well built as a permanent place of worship with a considerable amount of stone masonry incorporated in the structure for strength and architectural merits. Pools, late of Hartley Wintney, secured the contract and advertised for stonemasons for site works. Stonemasonry, one of the oldest skilled trades with the 'know-how' handed down for generations, was a science all of its own. With a rule for measurements, a straight edge, a set of trammel pins and bricklayer's lines, the most difficult stonework such as rose windows, turrets and spires were made, assembled and completed.

When Mr. Mardles and his two sons, Sidney and Harry, arrived in Fleet the two sons were just under 20 years of age. At that time they were gradually taking over responsibility as stonemasonry requires much strength, being predominantly heavy work. The church being completed the three men decided to settle in Fleet. A site for a yard, works and house was purchased in Fleet Road, almost opposite Stockton Avenue. Many contracts were obtained and slack times were given to the making of tombstones, memorial stones, crosses and kerbs for local churchyards. Their trade name may be seen in churchyards and cemeteries throughout the district. The two sons married and family life continued until 1914. The business had prospered having completed several important contracts for restoration, notably at the St. John's Church, Cove, which had been allowed to get into a dilapidated state with much of the exterior stonework needing renovation.

Soon after war was declared, in fact still in 1914, Sidney and Harry volunteered and rode off to Aldershot to join the Hampshire Yeomanry. Both men returned home at the end of the war in 1918, but found the re-opening of their former business rather difficult. Times had changed and now had little use for stone lintels and beams. Steel beams and rolled steel joists could be ordered and delivered within a few days. By 1920 the Cenotaph at Whitehall had been built as a National Monument to those who died in the war. The dedication ceremony was performed by the Archbishop and Royalty received great prominence with pictures in the daily newspapers. Memorials or Rolls of Honour became something

required by those who served and also the relatives of those who died on War Service.

War Memorial The three Mardles designed and modelled a memorial which was submitted and approved by the British Legion and the local council. An estimate was submitted and approved. The site of the memorial was selected on the corner between Fleet Road and Station Approach. The Station Hotel gave the corner of their property so that it would be impossible to approach the railway station without passing by the memorial. The firm of Mardles ordered the Portland stone and in due course blocks of stone weighing half to three-quarters of a ton arrived at the railway goods siding. In 1920 mechanisation was unheard of. A tripod of shear legs with a chain hoist was erected and, with iron and steel rollers, the stones were slowly and carefully unloaded and conveyed to Mardles yard. This man-handling and slow moving occupied several days. Each part was selected and marked for cutting. Being interested, as boys will be, I visited daily and quietly watched the proceedings.

Please try and picture the following: a great bow saw was made measuring about 7 feet in length and 5 feet high. Heavy timber framing held a steel blade 7 feet long, the blade was about 7 inches in depth and just less than an inch thick. There were no teeth on the blade. A block of stone to be cut was carefully placed in position. Two strong labourers sat upon blocks or stood one at each end of the bow saw. After very careful alignment, the men began a steady push and pull movement occasionally damping the stone with water. At first the Mardles maintained careful supervision watching the cutting and the general upright position of the bow saw. The two men quite steadily laboured on with very few stops for a day of nine hours. Cut to size, the stone was carefully moved upon wooden rollers into the workshop for the finish dressing. A smooth surface was obtained by a prolonged and careful rubbing process with hand-held pieces of stone.

When completed, each piece of stone such as, base, plinth, individual panels and centre piece being the cross, were quite perfect to size and measurements. The completed sections were assembled upon the prepared foundations. One could gaze upon the accurate inscription of hundreds of names all beautifully inscribed as if printed. These individual portions or sections were not pre-assembled. Masons working high up on a large building or church never need to make any adjustments. This could not be done half way up Salisbury Cathedral spire! The 1920s were the days when many laboured for little pay. The cost of the Fleet War Memorial was between £400 and £500. The accurate and skilled craftsmanship of the Fleet War Memorial enabled the firm of Mardles to obtain contracts for similar work for nearby communities: Church Crookham, Hook, Crondall,

Elvetham and Hartley Wintney.

Builders Having completed the erection of these public memorials, the firm branched out to undertake building work. Mr. Hamilton-Bell, chairman of Fleet Urban District Council, persuaded the Elvetham Estate Office to sell him a site for a house in the Blue Triangle and allow him to have his own choice of builders. Mardles proceeded to build this large residence known as West Hill and then many others in the same area. They secured the contract to rebuild Fleet Hospital. Eventually the sons of Sidney Mardles continued with the business, building Pheasant Copse and enlarging and carrying out improvements and maintenance to the Lismoyne Hotel.

Frank Spear

During the 1890s Mr. Frank Spear came to Fleet. He was a young enterprising man descended from ancestors who were members of the Society of Friends. He married a Fleet woman and then decided to become a builder. He purchased the land from Pinewood Hill corner with Kings Road, along Kings Road as far as Clarence Road. The rear frontage ran along Dunmow Hill. He built himself, a house at the corner of Kings Road and Pinewood Hill which is still there.

He purchased a large quantity of freshly felled and sawn timber for seasoning. This was stacked alongside Kings Road. He then built, in Pinewood Hill, a larger house now known as Haviland House, followed by a house in Dunmow Hill now known as Landford; also Cramond, Fingalton, Dorling House, Morayvale, Dunmoorland, Lucerna and Greycourt. The great logs and sawn timber were now becoming seasoned and fit for use. A builder's yard and joinery works were planned for the land fronting Kings Road and Mr. Spear built a second house and moved into it in Pinewood Hill (opposite Dunmow Hill) now known as Carisbrook. However, Mr. Spear secured the contract to build a fairly large Methodist Church at Crowthorne. He saw quite a large tract of land suitable for a builder's yard, so he abandoned his Fleet projects and established himself as a builder centred from his newly-built residence and yard.

Nurses Home Before finally moving to Crowthorne, Mr. Spear built a fairly large house in Kings Road opposite the Broadway shops. This house, now called Tregenna, was purpose-built for the convalescence of nurses from the London hospitals. It was named and known as the Nurses Home. At that period of time and until 1914, the nurses wore long dark frocks, ankle length, with a stiff white bib apron. 'Going out' apparel was an ankle length dark navy blue cloak and a similar coloured straw bonnet type cap

with navy blue ribbons. For several years these nurses could be seen, usually in pairs, walking for exercise or for shopping. Eventually the London hospitals transferred this type of residence to the south coast, so the Nurses Home was sold for private occupation with its new name.

Spear and King At Fleet his foreman of works was a Mr. King. This man followed the firm to Crowthorne and Mr. Spear made him his partner. Much of Crowthorne was built by the firm Spear and King. Today the firm is still in existence having moved to and built many places in Camberley. It is now the third or fourth generation of Spears. Mr. Spear and his family were very respected in Crowthorne. For years at Christmas, every poor person in Crowthorne received coal and food. The secret of who donated these gifts never became known, but the Christmas after Mr. Spear died gifts stopped.

Chapter Twenty-One
Vehicles

Heanes

Jim Heanes Successful enterprise is always worth mentioning especially if it happens twice in one family. Jim Heanes who was born in 1908, was educated in Fleet Church of England School. He had a pronounced attitude towards the saving of money. He paid into a monthly saving account with the Hampshire General Friendly Society starting at a very early age. These shillings and pence were earned from odd jobs or paper rounds and when he became a teenager he took out a short term endowment policy for £100 payable in two years at three per cent. When he contemplated getting married, he bought a three-bedroomed house in Kings Road and obtained a permanent mortgage at four per cent and eventually cleared the mortgage with several £100 paid-up Endowment Policies. He continued saving in a similar manner after his marriage.

He became a proficient motor mechanic with a flair for motor cycle riding; winning many first prizes in such trials as the Hazeley Heath cross country event. By careful harbouring of his money, his finances were such that he was able to open a small garage in partnership with Jack Foster. The business prospered and moved to premises in Dogmersfield in 1949 where a Morris Agency was obtained. Eventually Jim Heanes retired in 1973.

Kenneth Heanes He had two sons who were brought up with their father's ideas and example of carefulness in all money matters. Kenneth Heanes, born in 1933 inherited his father's keenness for motor cycle riding and at 12 years of age won a cross country event. He was so successful that he was engaged by Matchless as works rider and then graduated as works rider for Triumph. Eventually he was able to ride 'privately' until 1971. Between 1956 and 1971, Kenneth Heanes rode yearly in world-wide Olympic Motor Cycle events, riding in Poland, Czechoslovakia, Russia, East and West Germany, Italy, France, Belgium, Sweden, Austria and America. During this time he was wonderfully successful, for he won 300 events including 12 scramble runs, 10 Olympic Gold Medals and two Silver Olympic Medals. He retired from riding in these important events in 1971 and became England's Motor Cycle Team Manager for three years.

During all this time Kenneth Heanes had, from 1957, run a motor cycle sales business from a shed at 27 Reading Road, Fleet. The business

continuously expanded until the existing shop and business was built. For many years he sold only British motor cycles, but gradually Japanese and other foreign models were stocked and sold. Kenneth Heanes became a very successful businessman even selling motor cycles to certain concerns who required to make bulk purchases. He expanded in a most successful way, opening and profitably running branch shops in Aldershot, Gosport and Newbury.

Now, in 1987 he has decided to retire from all these motor cycle concerns. He considers that 30 years is sufficient and that now is the time for a more leisurely approach to run a small farm and acquire a stock of riding hoses. He stated, with a twinkle in his eyes, that probably he will be unable to resist a speculation or two, should it come within his KEN!

Stevens Bros.

Crookham Street blacksmiths Just before the coming of the motor car, the family of Stevens living opposite The Black Horse, Crookham Street, were very progressive shoeing smiths. Horses were then as numerous as the motor cars of 40 years later. The younger sons, all conversant with the trade, always willingly rushed to farms to mend broken ploughs, harrows and any broken ironwork. It was very much worthwhile that these capable men could forge together two pieces of iron or mild steel. This common practice enabled ploughshares, grub-axes and picks to have their blades renewed by what was known as 'cut and shut' method. I even had a new blade cut and shut onto a pair of hedge shears. This clever 'welding', for welding it was, had to be done while both pieces of metal were heated to the same exact colour and then hammered together. I have been unable to find any expert 'welder' from the Royal Aircraft Establishment who could do this by this extremely old method.

Fleet Road forge and wheel-wright shop To expand the family business, Mr. Stevens purchased cheaply 100 foot frontage of land in Fleet Road right through to Albert Street. The position was opposite the future Post Office. About 90 feet back from Fleet Road a forge house was built with two or three forges for several blacksmiths to work together. Passers-by in the summer could be in Fleet Road and see the smiths busy, usually with several horses waiting to be re-shod. In those days Church Road was full of 'parked!!' horses and carriages on Sunday mornings.

Another extremely clever task carried out by these smiths was the making of iron tyres for carts and wagons. Mr. Stevens laid down a flat circular and heavy sheet of iron. The ash wagon wheel was mended and trued up by the wheel-wrights. For a farm wagon, a 4 to 6 inches wide iron tyre was made from ½ inch thick iron. Both the wheel and the tyre were made to extremely accurate measurements. The wagon wheel of ash

timber was placed upon the flat iron circular plate. At least two smiths carried from the forge the iron tyre, red hot and glowing. The tyre was carried by means of 3 foot long pincers. Quickly the red hot tyre was placed exactly over the wooden wheel and then hammered onto it. Buckets of water were then thrown onto the hot tyre which quickly cooled and shrunk. The whole wheel and tyre was a perfect tight fit together and would last for many years of hard work over rough farmland without loosening.

The only other place where iron tyres could be fitted on cart and wagon wheels was at Hartley Wintney, so Stevens forge was extremely busy. The wheel-wright's shop expanded and soon was capable of making heavy wheelbarrows for brick yards and repairing carts and wagons. Although carriage wheels were fitted with a hard rubber tyre, these tyres sometimes needed renewal. In the course of time, Stevens could undertake to make or repair carriages. This was also extremely difficult and clever work.

Coach painting A paint shop was built as 'Coach Painting' was a specialist trade. Coaches and carriages, also other personal transport of persons such as pony carriages, traps, governess traps, were all painted for years of use. A priming coat of a mixture of red and white lead priming was covered by five or seven coats of hard gloss paint, each coat being smoothed by very fine and almost worn out emery cloth. Some carriages were lined by fine lines of contrasting coloured paint and then treated to two coats of coach varnish. The painting shop was carefully maintained as dust in the air was the coach painter's enemy.

Milk floats Ninety years ago several milkmen drove horse-drawn milk floats to deliver their milk. The expanding wheel-wrights shop of Stevens Bros. would undertake to make these conveyances, which were beautifully constructed and painted in several colours. The frontispiece board was sign-written with the owner's name. The wheel-wrights required seasoned ash and oak and very special timber for carriage shafts. Seasoned wood from old barns and houses was purchased and several saw mills throughout North Hampshire were visited for suitable wood. After the 1914-18 War, Stevens Bros. designed a new milk float which caused much interest at agricultural shows. Stevens were well known at these shows as they always entered the horse-shoeing competitions and won many prizes. For the first time this float sheltered the driver and the whole carriage ran on car type wheels with tyres. More than a 100 of these were built for London United Dairies.

Motor cars Just before 1900 there was general excitement as the motor car had been, for the first time put into slow but continuous production.

Col. Wilkes, Squire of Ewshot, at Ewshot Hall had several sons. Two of them moved to Birmingham and designed the first ever Rover cars. The very first car (thought to be satisfactory) was presented to their father at Ewshot. This car often refused to start. There were no garages or motor mechanics – they were not even heard of! Stevens Bros. were known to be able to repair parts of steam thrashing machines, so they were contacted. With great excitement, Cyril and Redvers Stevens dashed to Ewshot on bicycles and gradually became proficient in making Col. Wilkes' Rover car function.

Soon two other people in Fleet purchased motor cars. Lord Calthorpe and Dr. Frere could be seen driving about at a steady 20 miles an hour. Looking ahead, Stevens Bros. built a showroom with large glass doors as shop windows. These were eventually to open to take in the first cars for Fleet. Maintenance and care of Col. Wilkes' car continued for several years and the two Wilkes' brothers had progressed into motor car manufacturing.

Rover distributors In recompense for servicing the Colonel's car, Stevens Bros. were made distributors for Rover cars in this area. Repetition orders for the cars resulted in Stevens becoming franchised distributors for the cars for an extremely large area, extending nearly to Brighton and Bournemouth. Five brothers, all working and supervising, considerably

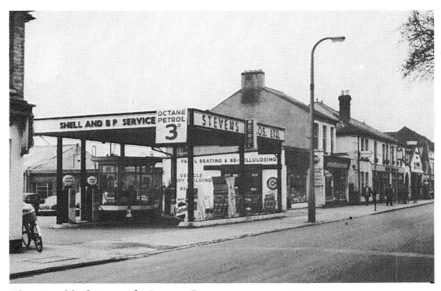

Fleet Road looking south, Stevens Bros.

advanced the firm, which by 1939, gave employment to nearly 50 to 60 employees. Coach building and wheel-wrighting continued. Now cars instead of carriages were painted. Specialised motor vehicles were successfully designed and made to order, such as removal trucks and mobile libraries. As the brothers reached retirement age, they decided to sell up. This was now a considerably large business upon a valuable prime site and fetched a very high price. The large Rover distribution rights were sold for a considerable sum of money but, within two years, the Government took over Rovers and wiped out distribution rights. Days Garage still use a remnant of the original site. Stevens' workshops, showroom, office and petrol pumps opposite the Post Office have gone, leaving no trace whatsoever.

Ernest and Percy Tapp

Two brothers, Ernest and Percy Tapp, were living and running a business in Balham. This was known as Market Transport. A considerable amount of their business included moving goods to and from the nearest docks.

Milk delivery vehicle In the late 1920s, the brothers spent much time designing and inventing a three-wheeled truck or box, driven by an electric battery. The control consisted of a 'joystick' at the back of the vehicle. Pushed forward the truck moved on at walking pace; pulled back meant stop; movement to either side for turning right or left. The body of the truck, about 5 feet long, 4 feet wide and 4 feet deep, was designed for the delivery of milk. Milk bottles had just come into use. The Tapp brothers spent much time perfecting this project. The United Dairies were contacted and it was agreed that they would give the idea practical tests. This meant that each brother had to rise at 3.00 am to assist milkmen delivering milk via the use of the new vehicle. These test deliveries continued for several weeks. It was agreed that United Dairies would gradually change from horse-drawn deliveries to the use of these 'electric wheelbarrows'!

Fleet works In 1929 the Tapp brothers decided that the Market Transport business would continue to be run by Percy, but Ernest would move to Fleet to go into manufacturing these vehicles. After buying a house, he started in a small way by renting the original old Fire Station and Council Yard at the east corner of Albert Street and Upper Street. Mr. Joseph Davies had helped design and build the milk delivery wheelbarrows and he also came to Fleet. The original Fleet Urban District Council Offices adjoining the little works were taken over. Much 'midnight oil' was burned by these inventors perfecting Ernest Tapp's design for a double rear axle for heavy lorries. No such thing existed anywhere in the world in 1930.

Fords of America Trials were a great success and, after exhaustive tests, Mr. Ernest Tapp went to America and obtained an interview with the Ford Motor Manufacturers. After trials by Fords of America, they offered to use the double axles in their lorries. Mr. Tapp hurried back to England and safeguarded the invention by taking out all copyrights necessary for their protection. He then offered to manufacture and supply Fords with complete axles manufactured and delivered from their Fleet Works. Thus County Commercial Cars came into being.

Market Transport vehicles were used for conveyance for several years. Percy eventually followed his brother to Fleet, but not until the 1950s.

County Commercial Cars The first and second years' production models were named by Fords after English Counties, thus the name of the company. A long association with the Ford Motor Company began in 1931, an association 'completely without written agreement or undertaking on either side' resulting in the production and sale of 55,000 tractor and truck products. The power units were all of Ford manufacture.

During the war a large number of rear transmission assembly units were produced. These were transported daily to the Ford Company at Dagenham and assembled on their production line. Fifteen Ford delivery trucks were in daily use. The completed 2,000 vehicles were supplied to the RAF for the purpose of transporting and supplying all the equipment for the Balloon Barrage Defence System. In addition County Commercial Cars axles were used for the production of ambulances. A two-man tank vehicle was made during the war years; one is in the Tank Museum at Bovington.

In 1946 County designed and built a tractor with 7 foot high clearance for working in orchards of cordon apple trees which were supposed to grow to a maximum height of 7 feet. Their publicity photo showed Geoff Eggleton (still a serving employee) bicycling underneath. Other members of staff, including women, also rode underneath. One ex-employee remembers that the driver was on a level with passengers on the top deck of a double decker bus.

In the early 1960s County built a tractor (yellow in colour as opposed to the usual blue) which was fitted with special tyres and had certain modifications. After trials at Birchington, it was successfully driven across the Channel to France by Mr. David Tapp (youngest son of Ernest) in July 1963. This tractor was named Seahorse. By June 1975 the output became in excess of £1,000,000 per month (truck parts and tractors) plus indirect sales of £7M. Eventually County Commercial Cars Ltd became one of the world's largest producers of agricultural four wheel drive tractors. The double axles were first incorporated in track tractors and then superseded by four wheel tyred tractors. County made a range of seven basic tractor

models from 62 to 150 horsepower. Large tyres were fitted, some quite large for high clearance. During 1976 the firm dominated the UK four wheel drive market.

County exported, usually via Ford outlets or affiliates, 70 per cent of their production into about 140 different countries all over the world, even to Finland, Zambia and Austria. Mike Gormley, John Heathers and Ken Ree visited many farmers and estates in Zimbabwe giving advice on traction problems and instructing workshop staff on tractor maintenance. In Zimbabwe County tractors are used in forestry and agriculture both for cultivation and transport especially for sugar cane crops which are immense. These crops are processed to make an alternative fuel named ethanol. County tractors were used in road making in Zimbabwe and the firm stated that they were pleased to open a new market and, therefore, help develop that country.

Goodyear low ground pressure 'Terra-tires', designed for use on boggy ground, could operate as low as a ground pressure 3 psi. Some special tractor tyres were 48 inches wide for use in peat bogs, others with extra large 7 foot wheels were in use in Africa for driving between crop rows. Track-trucks were designed and made for crop spraying and aircraft towing.

The Head Office in Albert Street consisted of 7,700 sq. ft. and factory space of 68,000 sq. ft., in Aldershot the 6,000 sq. ft. accessories department; additional works of 21,000 sq. ft. at Andover. In all places, light fork lift trucks served assembly lines and generally transported parts and materials. The average working staff consisted of about 300 men; office staff including technical staff another 100 persons. These figures rose to 500 staff during their peak in 1976. Mr. Bruce Coles, Production Manager, received the Queen's Silver Jubilee Medal in 1977.

A true tractor story: A small farm near Fleet, run only by the farmer and his wife, ran into difficulties. A bailiff called and noted two County Commercial Cars Ltd tractors, one very old and one nearly new. Next day the bailiff arrived with a transporter truck and announced that the new tractor was to be taken away. The farmer and his wife implored the bailiff not to take away the new tractor, but were told the old tractor's value would not clear the debts. The aforesaid tractor was taken away. Several hours later the Forestry Commission men appeared and asked: "Where is our tractor?".

J. T. HACKETT,

(From Messrs. Negretti and Zambra, Crystal Palace)

PORTRAIT

Architectural and Landscape

PHOTOGRAPHER,

"VICTORIA" DAY & FLASH-LIGHT STUDIO,

Opposite the School,

ALBERT STREET, FLEET, HANTS.

Portraits and Groups are taken (all sizes up to 12 x10 inches) every day in the Studio by the New Instantaneous Process from 10 a.m. until sunset.

No extra charge is made for photographing children, pet birds, or animals.

On dark or foggy days during the Autumn and Winter months, late in the evening or after sunset, the New Instantaneous Magnesium Flash Light will be employed, thus avoiding long sittings.

Pictures of every description are carefully copied, any size up to 10 x 8 inches.

The New Series of Views of Local interest are now ready and may be obtained at the Studio, price 1s. each, either Cabinet size or as Lantern slides.

Indoor and out-door photography up to 12 x 10

THE FLEET REPORTER

AND

Crookham & Hartley Wintney Advertiser.

ADVERTISEMENT CHARGES:—

Small DISPLAYED ADVERTISEMENTS, from 1s. per Insertion. Three do. 2s.

LARGER SPACES BY ARRANGEMENT.—SPECIAL QUOTATIONS TO ANNUAL ADVERTISERS.

FIVE PER CENT. DISCOUNT FOR CASH WITH ADVERTISEMENT.

ACCOUNTS RENDERED QUARTERLY.

FLEET ROAD, FLEET.

146

Chapter Twenty-Two
Victoria Road

Several small houses in Victoria Road are well past a century in age. The rapid expansion of the district can be seen by a map of Fleet, dated 1950, showing approximately 64 named roads and cul-de-sacs, and a recent map giving the total named roads and cul-de-sacs as approaching 200. Having resided in Victoria Road for nearly 40 years, I will mention a few of the early houses and their occupants.

The Victoria Road entrance to the car park necessitated the demolition of two houses. The first house named Rosebay advertised in 1893 the services of Mr. Hackett, Portrait and Landscape Photographer and owner of Flash Light Studios. Pinewood, a large house with stables and coach house was the residence of Mr. Gardener, the first Manager of Lloyds Bank. This house has disappeared and the grounds are now the site of 16 flats. At the north end of this site is the pathway from the old Council Offices, The Views. This pathway, eventually leading to the Parish Church, was donated by Col. Horniblow to the public and was, at first, only used on Sundays by him and his wife, followed by about seven servants trailing behind. All had to attend the 11.00 am service. Col. Horniblow strictly forbade the use of his horse and carriage and no cooking or gardening was to be undertaken on the Sabbath at The Views. His two cows, grazing in his meadow, must have been milked *every* morning and evening!

Until 1930 the cricket field was the home of almost a plague of wild rabbits. These rabbits spread from the west side of Reading Road to Branksomwood Road, causing damage to vegetation in gardens. About 1982, a pair of foxes lived in a small secluded wood between Springfield Lane and the Baptist cemetery. Nightingales and several species of owls could be seen and heard in the vicinity.

Northcote now No. 23, was originally the home of the Chivers family. Mr. Chivers, as surveyor, supervised the early development of Fleet. A retired Londoner built 1, 2 and 3 Abingdon Villas in 1889 and the family remained in possession until recently. Burnham, one-time residence of Mr. Ormorod, who with the Graham-White brothers made Great Portland Street the centre for the sale of Rolls-Royce and Bentley cars. The Grey Cottage, once the home of the Misses Leveson-Gower, who were often visited by their two nephews who were County Cricketers, and they sometimes played on the Fleet Cricket Club ground. Knowl Cottage, a small wooden bungalow, was the residence of Rear Admiral D'Aeth CB.

In Sunnyside lived the coachman from Peatmoor, and he had a son and daughter. His son, Horace Parsons, left school and became an errand boy employed by a local butcher. When Horace was 18 he was allowed to drive a pony and trap for deliveries. One day, at the Kings Road end of Albert Street, he fell into an argument with a young milkman about the same age. It was agreed to race to Fleet schools to decide which was the fastest pony. Alas Horace's pony fell and was unable to get back on its feet. With his butcher's knife, he slashed sufficient harness to pieces to enable the pony to get up and pull the trap home to the stable at the rear of the butcher's shop. He told his father what happened and was told that he had damaged the harness so much that it would take a year's wages for repairs. Horace panicked, opened his money box and caught the train to Portsmouth and joined the Royal Navy. After three months training he was to become part of the crew of a new destroyer. This ship was commissioned and the crew were paraded on deck for an Admiral's inspection. The Admiral and his entourage slowly inspected the ranks. Arriving opposite Horace, the lad spoke up and said: "Good Morning Sir." There was a long pause with the Admiral fixing Horace with a silent glare. Horace said: "I knows you – Admiral D'Aeth. I delivered your meat to your house in Victoria Road, Fleet, and you told me to always say 'Good Morning Sir'." The Admiral turned to his escort and said: "Make this man the smartest sailor in the Royal Navy."

Another notable residence in Victoria Road is The Garth. Here for many years lived two sisters, the Misses Kaiser. They were intimate friends of Mrs. Emiline Pankhurst and her daughter Sylvia. The Garth became the secluded headquarters of the Suffragettes and monthly meetings were held with the Pankhursts. Also attending were many ladies who arrived in their horse-drawn carriages from the surrounding districts. As many as a dozen carriages were waiting for hours all along Victoria Road. This agitation for votes for women was taken notice of by the local people. During the terrible times of the 1914-18 War, feelings ran very high and the Misses Kaiser did not have their orders for groceries and meat delivered. They lived in seclusion until after the end of the war, but they were not liked by the trades-people, so in 1919 they changed their name and then moved out of the district.

The end house at the top of Victoria Road, west side, is a very early Victorian residence named St. Claude, now occupied and owned by Dr. Scott. On the east side of Victoria Road there were only two houses near Fleet Road and then about 200 yards of grassland for grazing John Bray's pony. John Bray was a coachman to Queen Victoria, retired on a pension of 3 shillings per week and bought land and built a bungalow in the year 1869. He maintained a pony and governess carriage for about 20 years. Part of his land was for grazing his pony, the other was planted as an

orchard with beehives. He said his wages from Royal source were very meagre, but Royal tips, and tips from the landed gentry, were never less than a golden sovereign, sometimes a fiver! This money was always carefully saved for security upon retirement.

His wife had a sister married to a gardener employed at Windsor Castle. This couple were persuaded, upon retirement, to come to Fleet and a plot of land was purchased upon the other side of the footpath, and in 1873 Leigh House was built for just less than £200. The garden was deeply dug and an orchard was made containing about 16 various apple and plum trees. A row of beehives stood at the bottom of the garden. In 1950 I bought this solidly-built Victorian Cottage. At shoulder height at each side of the chimney breasts were recesses, about 9 inches square and 9 inches deep, probably for candlesticks or night lights. A bracket was found consisting of a pair of candlestick holders either side of a brass parrot. The hinged head opened and tinder and flint were still inside. A well with a pump was situated quite close to the back door.

Three Victorian cottages were also sited on the east side of Victoria Road. Life in these cottages was very hard and primitive. Well water had to be obtained daily, stone sinks and earth closets were attached to each outbuilding or scullery. The garden produced the majority of fresh vegetables and most of the fuel for cooking and heating consisted of wood gathered from nearby trees.

Gradually, life improved and in 1950 *two car owners* lived in Victoria Road! Mention may not be made of present affluence, with every householder possessing a car, some with two or three.

Leigh House.

Chapter Twenty-Three
Miscellany

War Experiences

Fleet was so horse-concerned that a granite horse trough was erected near the Oatsheaf to commemorate the end of the South African War. Fleet, before the 1914 War was full of horses, almost as many horses as adults. A squad of local Hampshire Yeomanry and a mounted 'Frontier-force' was in existence. Many members, with their horses, joined up at Aldershot during the 1914 Great War.

The Great War Thurlston House was used as a Red Cross Hospital for wounded soldiers from France. Ninety per cent of the staff were local women called VAD nurses, these and women domestic workers, about 20 in all, completely staffed and ran the temporary hospital. The Miss Edwards just helped with a little clerical work and by visiting sick soldiers in bed.

Tweseldown Camp at Church Crookham became an Officers' Cadet Training Unit, OCTU. It expanded continuously to replace casualties from the great slaughters of the Somme and Paschendaele where the young officers' lives were measured in weeks. During the first two years of its existence, many young potential officers came from what was then known as 'better class' families. Knowing the extent of fatalities, they decided by hook or crook to marry. They frantically searched for furnished or unfurnished accommodation, sometimes with help from their parents, who besieged Alfred Pearson's office. It is not only sad, but a tragedy that some of these houses were sold several times during the war. This tremendous and continuous demand undoubtedly made Alfred Pearson's a prosperous business which continued to flourish until 1986.

The expansion of Tweseldown and Ewshot OCTUs was very apparent to the people of Fleet. These young men already dressed in officers' uniform, but with a white band around their hat, arrived several times a day at Fleet Railway Station. Transport was not provided by the Army and motor cars were in their infancy and few and far between, but Mr. Charles Cranstone somehow obtained two T model Ford taxis. He himself set the pace by driving all day. His second driver was a woman, Mrs. Sayers. These two taxis plied to and from Fleet Station and the OCTUs. Sometimes a well-heeled cadet paid for the sole use of a taxi. If not, the taxi was almost commandeered by a group of seven or eight cadets who

stood or sat at the cost of a shilling each. This taxi work continued all day with the end result that the owner amassed a good profit.

Dardanelles The following events are very little known, but many names on local 1914-18 War Memorials were caused by these occurrences, and it seems worthwhile to recall how so many soldiers died for their country. In 1914, while Kitchener's posters were everywhere, the Hampshire Regiment recruited thousands of men including many from the area between Fleet and Basingstoke. The 2nd & 4th Hants Regiment trained on Salisbury Plain and were then immediately shipped to the eastern Mediterranean. Here they spearheaded the attempted landing at the Dardanelles. The landing was a great disaster and the Hampshire men were decimated to just a few hundred men. The surviving remnants were afterwards shipped to India. Probably their names on the memorials are a majority of the total thus inscribed.

I met Henry Richardson of Hartley Wintney, and Daniel Groves born in Albert Street, Fleet. They told me how they and a few other men landed at the Dardanelles and were cut off and unable to reach the sea. About 40 of them began to walk and live on the land. From Turkey they trudged to southern Russia and then began a walk northwards hoping eventually to arrive at the Port of Petrograd, later called Leningrad but now St Petersburg again. How they fed and slept would not be spoken about, but they did survive. Six months after the end of the 1914-18 War, our Intelligence Service in Bolshevic Russia reported that a group of soldiers were known to be in the vicinity of Petrograd. Mr. Winston Churchill had sent an Expeditionary Force to Russia which tried to find and rescue the men. Many hundreds of miles had been trudged and several men did not survive. Eventually they were found and brought safely to England arriving home many months after the end of the first war. As far as can be ascertained, none of the group recorded their happenings and, apart from the rescue, there are no official records of the courage of these local men and their long trek.

North Africa During the 1939-45 War the same regiment of Hampshire men were sent to North Africa where the Germans were already established in Tunisia. At the battle of Majuba, the local men were entrenched forward of a wooded area. A few small tanks such as the Cromwells and Churchills forged ahead in support. Suddenly many great heavy German Tiger tanks (previously unknown) arrived and with their huge guns simply, as if practising, far outranged our efforts to retaliate. The large German guns and tanks overturned our inferior tanks and then came forward and ground the majority of the Hampshire men into a defeat.

Preamble to the Ely

War Department motor cycles A year or two after the 1914-18 War, a batch of Army motor cycles were offered for sale. These had all seen service in many parts of the world and could be purchased for about £20 from the War Department at Aldershot. Two young men, James Pool Pearson, son of Alfred Pearson, the Estate Agent at Fleet, and Alex Pool, son of Richard Pool, the Removal Contractor in Fleet, each purchased a second-hand Douglas twin cylinder motor cycle in about 1923. These two young men, both below 20 years of age, were summoned to appear before the Magistrates Bench at Aldershot, charged that they: "Did ride their motor cycles along Albany Road, Fleet, in a very dangerous manner as seen by Police Constable Series who observed them exceeding the statutory speed limit of 20 miles per hour at an estimated speed of 30 miles per hour or thereabouts."

As a young man of about 17 years of age, I saw the report in the *Fleet News* and decided to buy one of these, then rare, motor cycles. After purchase, to avoid trouble for 'speeding', I rode to Hartford Bridge Flats to try and get the utmost speed from my motor cycle. Just near the Ely Pub I saw that my rear cylinder was red hot and my trouser leg was smoking. Stopping at the Ely I banged on the door until an old man opened it and let me in. Beside an open fireplace was a witch's round pot hung over the fire. The pot contained some kind of a soup. In the room was a large heavy table and several heavy chairs. The old man, without speaking, brought a pint of beer for me at a cost of 5d. I soaked my burnt leg with the beer, drank the rest, and departed. All this for just over 40 mph!

The Ely The licensed premises on Hartford Bridge Flats called The Ely, gets its name from a famous racehorse of the 1860s. It was a bay horse foaled in 1861 by *Kingston* out of *The Bloomer* and it belonged to a Mr. W. S. Cartwright, whose colours were a scarlet jacket and a black cap. As a two year-old, *Ely* won the Champagne Stakes, the triennial Produce Stakes, and a sweepstake at the Newmarket Houghton Meeting. In 1864 he scored on eight occasions including the Doncaster Stakes and in 1865 he won eight races out of nine starts including the Ascot Gold Cup, the Goodwood Cup and the Brighton Cup.

At that time a man by the name of Jack Rackstrow was working for one of the many public houses at Blackwater. He is said to have won a considerable amount of money at the Ascot meeting in 1865, and he resolved to spend the money to build a public house up on The Flats. In due course he moved into the house and is said to have run the pub for himself for some 30 years, and only opened it to his friends. He never married and was found drowned in the River Blackwater at Sandhurst. It was thought to be suicide, but it is more likely that he had a heart attack

whilst following his hobby of fishing. He was interred at Hawley Church.

The house, in a terrible state, then belonged to H. Hewitt and Company, of White Waltham, Berkshire. A Mr. F. W. Lawrence, regular soldier in the Royal Artillery Mounted Band, was just leaving the Army, and went with many others to see the house and was offered it rent free. He decided to take the house and spent more than two years getting it clean. It was a very lonely place but, at that time, extensive building was being carried out at Minley Manor for Mr. Laurence Currie, a banker of Glyn, Mills and Company, and the Ely business prospered. In 1905 he applied for a Wine and Spirit Licence and obtained it rather against the feelings of the day, when many houses were being closed down.

In the early days of motoring Hartford Bridge Flats became a centre of motor racing, before the building of Brooklands Motor Track. In midsummer the racing fraternity came to test their vehicles on the 'dead straight mile' of the road in the early mornings. The first recorded speed of 100 miles per hour was so achieved. They slept on the bar floor of The Ely and closed the road off to themselves before sunrise. Mr. Lawrence, the landlord of The Ely, became a very early motorist when an irate car owner gave him a broken down vehicle. He subsequently had other cars and was the owner of the first Model T Ford in this part of the country.

Mr. Lawrence retired from the business in 1927 and came to live in Fleet. He had always said that alterations should be made to the house and that it should be 'pulled down and rebuilt'. This did actually occur in 1937 when the new Ely was built some 300 yards towards Basingstoke. The site and orchard of the old Ely can still be seen – this being returned to the Common Authorities.

Weights, Measures and Money

During the hundred years from 1880 to 1980 many important changes occurred. Most commodities in shops and elsewhere were sold by Imperial Measure and this was 16 oz=1 lb (pound); 14 lbs=1 stone; 28 lbs=1 quarter; 112 lbs=1 cwt (hundredweight) and 20 cwts=1 ton.

In addition to weight, many found it convenient to use a Bulk Measure using a one gallon wooden container. 8 gallons=1 bushel and these larger amounts were measured in a specially made basket called a bushel basket. Potatoes, apples and other similar fruits were measured and sold by the bushel. Shops sold 1 lb and 2 lbs bags of flour. Wholesalers sold by bulk i.e. 1 sack=240 lbs. These great sacks of flour, cement and lime remained in use until towards the end of the 1914-1918 War.

Land was measured by the length of 12 inches=1 foot; 3 feet=1 yard; 5½ yards=1 rod, pole or perch. Land area was also measured by the rod, pole or perch equal to a square of 5½ x 5½ yards or 30¼ square yards.

Money – 12 pence (12d)=1 shilling; 20 shillings=£1. 1p=about 2½d.

Chapter Twenty-Four
The Writer's Family

Birkenhead 1788 Samuel and Lucy Edwards owned and ran a warehouse and shop in the working class area and in the vicinity of the ship building yards. The shop's principal services were to sell groceries and everyday necessities to the shipyard workers, their families and to supply victuals and goods to small shops, and to any local garrison of soldiers and coastguards.

Samuel and Lucy's son, another Samuel, and his wife Martha, were staunch Quakers, strictly observing the rules and requirements of the Society of Friends. Samuel and Martha had four children, all born within about seven years. The oldest Lucy, then Edwin, Eny and Alice. Samuel, my grandfather, was born in 1814 and died in 1903, Martha was born in 1822 and died in 1903. Their children were all born between 1844 and 1852. When all the children were of school age, it was decided that it would be to their great advantage if they could be educated at Doncaster, where there were schools run by the Quakers. These schools were highly recommended and known to be efficient in education and establishing the principals of the Society of Friends.

Doncaster In approximately 1850, the shop and house were sold fetching such a good price that Samuel and Martha were able to buy a prominent corner site in Doncaster, and to build another shop and warehouse with living accommodation. The position, close to Thorn Colliery, was passed by the miners on their way to work. It was quite prosperous. Thorn Colliery is still working. Experience was that the premises had to be built with small windows and very strong doors. All doors and windows were closed by heavy shutters and fastened by strong iron bars. During strikes and depressions, the shop limited credit to two weeks' supply of food to known customers. After the strikes, much thrown filth had to be cleared away.

The large shop sold many goods which are now unknown. Apart from sacks of wheat flour, there were sacks of oat flour, crushed oats and rye flour. Sacks of sugar were just molasses or candy and this was blobs of honey coloured sugar, sometimes 10 inches long, solidified upon a piece of string. Sacks of rice were carefully weighed and sold to those who were better off. Dried apple rings were sold during the whole of the year. Medicines were held in stock, liquorice powder, alum and boracic, also horse liniments and tins of embrocation (used for animals and humans). A

long shelf held many pairs of clogs made of shiny leather tops and 1½ inch beechwood soles shod with iron shoes and tips. Boots and shoes made by a cobbler cost nearly a year's savings. All working people, male and female, wore clogs to work as made-up roads and paths were rare and usually deep in mud.

It is said that a beautiful string box, circular and made of mahogany, containing string and a cutter stood on the very first shop counter. This being the only original is much prized.

The children were duly sent to their religious schools. Excellent Grammar School type education was given. The schools and the Meeting Houses were extremely close and efficient and further opportunities were carefully arranged to enable pupils to obtain advantageous situations. Eny was taught French, the piano and to sing. Alice was sent to a large drapers' establishment in Shrewsbury, here were about a dozen girls and women all living on the premises learning and sewing to make superior ladies' clothes. This establishment is still in Shrewsbury. Edwin was 'bound' to a firm of Solicitors to eventually live by the law.

The Lefroy family, Itchell Manor, Crondall Lucy finished her training and was to be found a situation. Mention has already been made of the well-to-do Hugenot family of Lefroy who came to England and lived at Itchell Manor, Crondall. They were exceedingly prosperous and built Fleet Parish Church in 1862. The Rev. Plummer was appointed as the first Vicar of Fleet. He purchased a large old house and farm and advertised for a complete staff for the now Church Parsonage. The advertisement, probably in the Church Times, reached Doncaster and Lucy applied for the situation of cook, later to be advanced to housekeeper. This was the first of the 'Edwards' coming to Fleet.

Edwin

My father, now between 15 and 16 years of age, had grown to be restless and contrary to his parents' wishes, mixed with the colliery lads. He was quite musical and as a boy played a whistle pipe and his parents' harmonium. One Sunday afternoon he threw his football boots and gear from his bedroom window to go and play with the colliery lads' team. This untoward conduct of breaking the strict Quaker Sabbath entailed severe penalties. Edwin was very upset and almost frightened by his parents' severity and to the ostracism of the Society of Friends. He quietly packed his bag and made his way to Fleet.

He related how he *first* arrived at Fleet Railway Station in 1880 and walked along an empty, gloomy and muddy road, bounded and shaded on either side by high pine trees. The only building was Kimbers Beer Off Licence at the junction of Kings Road. No building until Church Road,

here was Vollers shop and bakery on the left-hand side, a horse pond on the right-hand side. Mrs. Richardson had the only other shop, opposite the Doctor's Chernocke House – she sold household hardware and ironmongery. Opposite the Oatsheaf at the corner of Fleet Road was a small timber built shop selling groceries.

His arrival at the Parsonage upset his sister Lucy who much perturbed, hurriedly arranged with the head gardener to take him home to Church Cottages where he and his wife would keep him for a few days. Edwin, during this first week in Fleet remained very quiet and partially hidden in the church cottages.

On Sunday afternoon he asked Mosdell, the gardener, if he could play their harmonium. A hymn book with music was produced and soon Mosdell was singing the bass, Edwin the tenor and Mrs. Mosdell leading, and the sound carried to the road: *Rock of Ages* with plenty of gusto! The Rev. Plummer, out for a quiet Sunday afternoon stroll, listened most intently. On Monday morning Mosdell, Lucy and Edwin were sent for and the Vicar requested an explanation. Edwin refused, and Lucy refused to send Edwin back to their strict parents in Doncaster.

Several days later the Rev. Plummer arranged for Edwin to assist the schoolmaster as there were now more than 30 children attending the church school. A short while after this the Rev. Plummer arranged for Edwin to go by train to Basingstoke and to be taught to play the church organ. After a year or so he became organist at Fleet Parish Church and officiated for several years. The school beside the church became very busy and overcrowded with pupils. Edwin was sometimes left to look after 50 children as Mr. Ames, the master, complained of such severe migraines that he must leave and visit Dr. Slade at Chernocke House (now Fleet Library). This could be done by walking unseen across country, almost in a straight line. His return, much later, with alcoholic fumes meant that he by-passed the Surgery and visited the Oatsheaf.

Certified teacher A short time after this, the Rev. Plummer arranged for Edwin to go to Basingstoke by train for evening classes to become a certified teacher. While Fleet School was being built in Albert Street, the Rev. Plummer arranged for Edwin to be sent to teach at Crondall School, thus gaining much experience. Edwin bought an iron tyred bicycle and rode to and from Fleet and Crondall for two years. The cycle journey to Crondall was hard going with puddles in winter and two or three inches of loose grit in the summer. Usually there were one or two 'spills'. All roads were gravel and in poor condition.

When the Albert Street School was first opened, staff were advertised for. Mr. W. Prideaux, from the West Country was appointed as Head Master, as he was the only qualified teacher to apply. My father,

Mr. E.W. Edwards, was appointed at an initial salary (no such thing as pensions) of £88 per annum, paid monthly, later increased to about £123. A few years after the school opened, the Board of Education required all unqualified teachers to attend evening and holiday time classes held at Basingstoke (train fare one shilling return). Several teachers including my father became qualified with a rise of £10 per annum. One or two teachers remained unqualified and their salary was never much increased. In about 1912, a teachers' pension scheme was started from Winchester. In 1914 Lloyd George obtained a National Old Age weekly pension of 5 shillings for those of 70 years of age. Some teachers retained rights to both schemes. At that time it was optional to subscribe to both.

The Rev. Plummer had promised my father that, as soon as he had 10 years' experience, he would be recommended for head master. However, Mr. Walter T. Prideaux, a young head master on appointment, remained in his post until he retired at 65 years of age. My father taught at the school from its opening date and my brother for 20 years.

After my father died, I found this letter in copper-plate handwriting in his desk.

Church Road
Fleet
1887

To Mr. Wills Chandler (Ref: Crondall and Fleet Schools) Secretary to the Board of Guardians and the Parish Council of Crondall.

Dear Sir,
I have now completed four years teaching a class of forty boys and girls of eleven years of age. The present salary I receive is £88 per annum. I expect to be married in the near future. I believe my services have been satisfactory and it is respectfully requested that you will allow my application for an increase in salary to be placed before the Vicar and his Council.
Your humble and obedient servant,

Cricket team When the new church was well established with a congregation and choir, the Rev. Plummer talked to Edwin about forming a cricket team. On the east side of Church Road were meadows to Fleet Road running almost to Stockton Avenue. A beautiful set of polished boxwood wickets with brass tops and ferules, together with sets of bails, all in a carpet bag, were given to Edwin. The Rev. Plummer filled the bag with three cricket bats and several balls. (Note: The family of Edwards kept these gifts and the carpet bag until 1936). A team was soon playing in the meadow opposite the Parsonage – male choristers were given first opportunity – some of these players' names can be found on the cricket

score sheet found elsewhere in this book. A few years later, Edwin formed the first football team.

Although the Misses Watsons requested the pitches to be moved because of the noise, they still showed interest by supplying jugs of lemonade or tea, especially if their young visiting nephew was given a place in the team. This young man was Clement Attlee, a future Prime Minister.

Samuel and Martha Edwards In 1903 Samuel Edwards and his wife died in Fleet. The Doncaster property was sold and all the assets evenly distributed between the four children. There was ample means for each person to build a house. Seven houses were built in all. Now, with the exception of one on the left side of C. Harris in Albert Street, all the houses have disappeared.

Edwin Edwards and his three sisters all decided to stay permanently in Fleet. Edwin married Ellen Wright, a daughter of George Wright, of The Mill, Fleet. Five sons were born in an endeavour to obtain a baby girl, and Edwin lost his wife at the birth of his fifth son, named Gilbert. Two sons became school teachers, one enlisted as an apprentice upon the creation of the Royal Flying Corps in 1912, one became a builder and the youngest son became a grocer with a new shop built at the corner of Kenilworth Road and Avondale Road.

Heath House.

Index